# Cover Art y:

01 /

A: The Silver Mt.
   Zion Memorial
   Orchestra &
   Tra-La-La Band
T: Horses in the Sky
F: 12" LP
L: Constellation
I: Luc Paradis
Y: 2005

01 /

# Cover Art By:

New Music Graphics

Designed, written and edited by
Adrian Shaughnessy

Laurence King Publishing

# Contents

Contents

5

Abbreviations /

A: Artist

T: Title

F: Format

L: Label

D: Designer

P: Photographer

I: Illustrator

Y: Year

# The Initial Moment

by Adrian Shaughnessy

'An album cover is the initial moment of the
record. It's a doorway into the music.'
**Peter Blake**

I picked up a CD the other day. It was one I'd bought
in 1992. I doubt I'd played it more than two or three
times since then. I noticed the disc was severely
discoloured: it had turned a dull bronze, as if it had
been left out in the sun. I slotted it into my laptop.
It made an angry whirring noise. I removed it and
lobbed it into the CD recycling bin.

The mainstream music industry is a bit like
my faulty disc – off colour and in need of recycling.
Once a realm of wealth and prestige, it is now shot
through with indecision and a sense of its own demise.
The major labels are pairing off in a desperate attempt
to avoid implosion. Once there were five 'majors', now
there are four, and the smart money says there will be
three before long.[1] Venture capitalists are circling
overhead: the lights are going out in corporate
musicland and soon there will be nothing left except
the rhythmic patter of accountants' calculators as they
plan asset sales.

It would be naïve to think that record compa-
nies were once benign organizations solely preoccupied
with releasing high-quality music and the unselfish
development of talent. It's always been a ruthless
business, full of sharp operators who saw that easy
money could be made from us gullible punters craving
the next pop sensation. But there was a time when the
industry was populated by a few visionary individuals
who knew how to find, nurture and sell pop music, and
who – most importantly of all – understood pop's
cultural significance to successive generations
of postwar youth.

Most of these individuals – many of whom
had entered the music business in the more idealistic
1960s – became surplus to requirement in the conglom-
erization that took place in the 1980s and early 1990s.
Independent labels were bought and corralled into the
new corporate music industry: these included Island and
A&M (acquired by PolyGram, now Universal, in 1989),
Virgin (EMI in 1992), Motown (PolyGram in 1993) and Def
Jam (PolyGram in 1994).

The new corporatized record industry, with its
demanding shareholders, was created partly out of
a response to the seemingly endless demand for recorded
music and partly out of a strategic response to changes
in the media and business landscape. The most dramatic
change was the arrival of digital music in the shape
of the CD, but you could also add the arrival of MTV,
a new culture of mass retailing and the endless prolif-
eration of radio – not to mention the phenomenal rise
of stock markets the world over. The result, however,
was that music became a commodity.

The CD[2] gave the industry an unprecedented
injection of cash as everyone replaced their old vinyl
records with the new wonder discs. But the little shiny
disc marked the beginning of the end. After a decade or
so of infatuation, a process of disillusionment set in.
Once the music-buying public realized they could buy
blank discs for a few pence, and once they saw discs
given away free on magazine covers, suspicion grew
that the labels were profiteering. As the musician and
designer Fred Deakin noted in Creative Review (March
2007): 'you're essentially just getting a silver disc
that comes with a couple of bits of paper. They
[record companies] made lots of money this way but
they also shot themselves in the foot because, by doing
this, they were actually encouraging the audience not
to place any value in the package they were buying.'

The writer and critic Paul Morley is even more emphatic in his disdain for the CD: 'It has always seemed to be what it has turned out to be, a banal bastard stopgap between the perfection of vinyl and the moment when music is transported into our lives without the need for any object.' (Friday 1 August 2003, The Guardian)

This notion of labels devaluing the music they sold was fuelled further in more recent times by the rise of TV talent shows. These prime-time entertainment formats were devised (often as partnerships between broadcasters and record labels) to create revenue via advertising, premium-rate phone calls and record sales. Undeniably popular, they nevertheless revealed the starkly manipulative nature of the 'business'. When these shows were coupled with the marriage of convenience that had taken place between the music industry and adland (a song used in an advert usually guaranteed that the song would become a hit; conversely, dull products could be enlivened by association with seminal pop tunes), the effect was to sharpen the perception amongst huge swathes of the record-buying public that the music biz was cynical, calculating and a bit shabby.

The music industry was to experience the full extent of this disillusionment when it turned to the public for support in its biggest challenge to date, namely its fight against illegal P2P activity. Despite the undoubted injustice of music being freely exchanged on the Internet, the public simply didn't care; the only people who offered a shoulder to cry on were the corporate lawyers. The industry made ham-fisted attempts at arguing the merits of their case, and when this failed they resorted to issuing lawsuits to teenagers.[3] When an industry starts suing its potential customers, it's dead in the water.

The music industry urgently needs a new model. The old one plainly no longer works. We live in an era where the demand for music — in both its recorded and live forms — has never been greater. But music 'consumers' no longer want to acquire music in the traditional manner, and the record industry is not set up to deal with this demand from a mass audience. If the big labels are to survive they will have to jettison countless embedded conventions. The ideas that bands will be signed to labels, that powerful managers will continue to treat labels like banks, that the distribution and retail system retains its stranglehold, will all have to be rethought. Nothing can remain immune to this fundamental root and branch reinvention. Even the poor old record cover needs a radical rethink.

## Record sleeves? Are they still necessary?

It's frankly surprising that record sleeves haven't already gone the way of 78s, 8-track cartridges and tape cassettes. The major labels still commission cover art, but it's rare to find examples with any resonance or originality. When we do encounter meaningful cover art it's usually because of strong-minded musicians demanding a visual corollary to their music. Radiohead are a good example of this: signed to a major label, they retain fierce control over their cover art and videos, and through their association with the designer and illustrator Stanley Donwood, they have created a substantial body of distinctive cover art. It's rare to find this sort of auteurism in current pop acts, but the artist Lily Allen's commissioning of newcomers Check Morris (page 242) to create a striking fusion of photography and graphic elements for her Alright Still album cover showed that it is musicians who are doing as much as anyone to keep sleeve design alive as a vibrant art form.[4]

Left to their own devices, the big labels are generally unwilling to stray from the safe formula of glamorous and heavily styled artists' pictures and retail-friendly layouts (i.e. no lettering in the top right-hand corner, an area reserved for the retailer's price stickers). In addition, diminishing record sales mean that money no longer exists for adventurous packaging or innovative art direction. When I'm asked by design students how to become a designer of record covers, I point out that sleeve design for the major labels is no longer a graphic designer's medium. I advise training as a photographer, stylist, or becoming a marketing executive in a label.

The biggest factor in all this, however, is the simple fact that the traditional primacy of the record cover as the principal visual component of a band or musician's image no longer holds true. When the great album covers of the past exerted their magic it was because they were all there was. Today there are many ways to experience music — TV, the Internet, live gigs, movies, festivals, clubs, countless radio stations and even mobile phones. The result is that the album cover is now only one of many platforms for the visual expression of a band's identity. And for a new generation growing up in an era of downloading, the record cover is increasingly likely to be viewed as an irrelevancy. As Paul Morley notes: 'If I show [my daughter] a 7" single by New Order, I can see it is like my grandfather showing me a George Formby 78. She wonders how much it might make on the Antiques Roadshow.'

And yet, record covers refuse to die. There's even a place where they thrive. Cover art is still valued and still regarded as an integral part of the experience of music in the world of micro-labels. These small independent labels, often run by one or two individuals, have no money to commission lavish promotional campaigns for their records, and instead rely on a combination of word of mouth, websites and beautifully crafted, heavily coded album covers to announce their presence. Closer to the output of private presses and artist's books, the sleeves of the new micro-labels are generally produced in tiny runs, often handmade and nearly always visually daring and inventive. In recent years we have seen the rise of the CD-R label: small labels where music is 'burned to

order', often with a handmade or laser-printed
cover. It's a new-era cottage industry kept alive
by a touching reverence for the 50-year-old culture
of recorded music.

    Amongst graphic designers the currency of
record sleeves has retained its value. So much so, in
fact, that it's possible to put forward the argument
that it's graphic designers who are keeping sleeve
design alive – or at least stopping it from stagnating.
Some of the most inventive labels are run by designers.

01 /

## The dematerialization of music

Any attempt to define the way music is purchased, sold
and packaged today is undermined by the pace of change
and the turmoil that is widespread within the global
music industry. The international music business stands
at a bleak-looking crossroads. While it scratches its
head, uncertain which road to take, it is being over-
taken by Internet phenomena like MySpace, iTunes, bands
using websites to self-fund recordings[5] and dozens of
sites selling legal downloads. For all we know, the
big record labels of the future might be Apple,
Microsoft, Amazon and News International – a thought
to strike terror into the hearts of genuine music
fans everywhere.

    Meanwhile, the independent sector distances
itself further from the major labels by a rugged
determination not to lose the material aspect of music.
In the world of micro-labels, packaging still matters.
This dualistic approach to the enjoyment of music is
neatly expressed by designer and Ghost Box label owner
Julian House: 'The visual and the aural are inseparable
within Ghost Box. I've never believed you can listen
to music devoid of visual references anyway. And the
bookish feel of our releases, the strange allusions and
hints of arcane backgrounds, the collectibility, are
all important elements, I don't think people come to
us and just want the music.' For Jon Wozencroft, a
designer, writer, photographer, teacher and co-founder
of Touch, it's a matter of attention to detail: 'You
need some kind of holistic, reconciling agent alongside
the music, some editorial aspect that functions as a
gentle storytelling device alongside the invisible
force of the music.'

    The notion of materiality – of tactility –
is a recurring theme in the pages of this book. Many
of the designers interviewed refer to the need to
'hold' and 'smell' something. As Jan Lankisch, art
director of the Tomlab label, notes: 'I'm addicted to
paper and the smell of printed artwork when it comes
back fresh from the printer. Getting something nice
done on beautiful paper is one of my main reasons
for doing what I do.' But with the arrival of the MP3
format and the staggering popularity of the iPod, it's
becoming increasingly unlikely that packaged music will
be produced at the level it has been for the past three
or four decades. For a new generation growing up with
downloaded music, the album cover and the CD package
are already going the way of the horse-drawn carriage.

    As an enthusiastic downloader of music, I've
surprised myself by how quickly I've become acclima-
tized to the absence of cover art. As long as a band or
label has a good website with lots of information about
the music they release, then I don't miss the sleeve.
I've come to love the instant hit of a downloaded
track. I love the fact that I can read about a piece
of music and then find it online – legally – in a matter
of minutes. I still like browsing in record shops, and
I still like to own a properly packaged and manufac-
tured physical copy of the music – but while others
find the new digital immateriality unacceptable, I'm
perfectly content to have music sitting invisibly on
my laptop or iPod.

    So how did we reach the point where our
enjoyment of music is mediated through cover artwork?
It's not strictly logical. Music's greatest attribute
is that it is abstract and intangible. When I want to

really absorb a piece of music, I listen to it in the dark with no visual stimuli. In a recent issue of Eye magazine, editor and music writer John L Walters wrote: 'However much designers want to create design for music, the fear remains that the album cover – perhaps albums themselves – may prove to be a historical blip, a short detour in the long history of music. The Rite of Spring didn't need sleeve design, nor did Duke Ellington's East St. Louis Toodle-Oo. With hindsight, the 78s of early jazz and folk music, with their ever-changing formats and anonymous paper bags (festooned with ads for hardware stores) are closer to today's downloads than more recent product.' The validity of Walters' point can be seen in the way the iTunes website is 'festooned with ads' just like the 78s he mentions, except this time selling music rather than ironmongery.

Perhaps the little adverts on iTunes have become the album covers of the future? As Stones Throw designer Jeff Jank notes (page 94), amongst the many things the modern designer has to consider when designing an album cover now is what it 'looks like as a 150-pixel JPEG? Something that would probably seem insulting to the cover designers of the past.' For Fred Deakin, unless the packaging is good, he'd rather not bother with it: 'I buy lots of white labels and downloads; they don't have any packaging or artwork. So I think it's either zero artwork or incredible packaging: the stuff in between is bullshit isn't it?'

Attempts to find ways of packaging downloaded music are so far unconvincing. I was determined to find examples for this book, but nothing excited me, except perhaps Delaware's neat little digital films to accompany their own digital music (page 32). I invited most of the contributors to these pages to cite successful examples, but no one pointed me towards anything much beyond PDFs or bits of Flash animation. As designer James Goggin (page 70) noted: 'I bought the last Yo La Tengo album on MP3 (instant gratification again – I was about to catch a plane and wanted to hear the new album) and noticed it came with an "Interactive Booklet" consisting of extra photography, links to printable PDF posters on Matador's website and full production credits. In itself it was poorly put together and took some messing around in iTunes to make it work. But I really think labels and companies like Apple should do more of this: include print-quality PDFs or JPEGs with digital releases, additional material, videos etc.' He goes on to lament the death of the sleeve note: 'You still get the odd band who values this, St. Etienne commissions writers like Douglas Coupland or Simon Reynolds to write essays for their albums, or labels like Honest Jon's with its great London Is The Place For Me series with fully researched notes and photography. But the days of lying on the floor, poring over a record's back cover notes while it plays on the stereo seem largely to be over.'

With his inability to offer compelling alternatives to the traditional record cover, James Goggin speaks for most of the contributors to this book. There's an elegiac tone in many of the comments deploring the possibility of the end of sleeve design. And perhaps this nostalgic yearning will persist until the generation of sleeve designers who grew up in the era of vinyl and CD packaging – and let's not forget cassettes – is superseded by a new generation who's grown up in the digital download era.

People born into the digital realm have a new definition of materiality. Electronic media surrounds us. It envelopes us. For many it is the new reality. And for the children of the digital realm, this new 'media materiality' is every bit as tangible as a dusty album cover from 1973. The screen is the new 'initial moment'. But not for everybody, if the contributors to Cover Art By: have any say in the matter. ◼●

1 At the time of writing, the four major labels are: the merged Sony BMG, Universal, Warner and EMI. This situation is predicted to change.

2 In 1981, the Austrian conductor Herbert von Karajan was amongst the first people to be allowed to listen to a CD by its inventor, Philips. 'This is a technological advance,' he announced, 'that is comparable with the changeover from gas lamps to electric light.' In August 1982 the first manufactured CD was a recording of Karajan conducting An Alpine Symphony by Richard Strauss. In the same year a handful of titles were released in the USA. By January 1983, half a million CDs had been made.

3 The website vnunet reported in 2005 that the campaign by the Recording Industry Association of America (RIAA) to sue music downloaders had suffered a setback after the trade body withdrew from a case in the US. Candy Chan, a mother from Michigan, had been facing a heavy fine after she was sued for file sharing. But the court dismissed the case against Chan after she pointed out that it belonged to her 13-year-old daughter. Judge Lawrence P Zatkoff said in the court report: 'Chan opposed the motion and asserted that the plaintiffs used a "shotgun" approach to pursue this action, threatening to sue all of Chan's children and engaging in abusive behavior to attempt to utilise the court as a collection agency.'

4 It is significant that both Radiohead and Lily Allen are signed to EMI, the last British major label. EMI still conducts itself like a record company that has respect and affection for the music it releases. In August 2007 the BBC reported that the private equity group Terra Firma had succeeded in its bid to buy music firm EMI.

5 SellaBand website offers wannabe recording artists a way of bypassing record labels and appealing directly to audiences for funding. Members of the public are invited to buy a share in a band or artist for around $10. When $50,000 is raised SellaBand provides 'an experienced A&R person to guide your recording process. Together with a top Producer you get the chance to record a collection of your best songs in a state-of-the-art Studio.'

010

Ian Ilavsky /
Constellation

Musician /
Label Owner

Montreal,
Canada

# Ian Ilavsky / Constellation

**Name:**
Ian Ilavsky

**Occupation:**
Co-founder of
Constellation and
Musician (Sofa,
Re:, A Silver
Mount Zion, Diebold)

**Label:**
Constellation

**Location:**
Montreal, Canada

**Website:**
www.cstrecords.com

**Biography:**
Constellation was
founded by Don Wilkie
and Ian Ilavsky in
Montreal in 1997.
Their first releases
came in entirely
handmade packaging in
initial runs of 500 to
1,000 pieces, with music
by bands like Sofa,
Godspeed You! Black
Emperor, Exhaust, Do
Make Say Think and Fly
Pan Am. Constellation
does not work with con-
tracts, and most of the
bands on their roster
are based in Montreal.
Local production is
a cornerstone of their
activity.

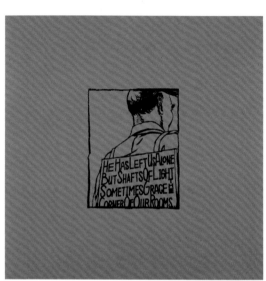

01 /

Ian Ilavsky /
Constellation

Musician /
Label Owner

Montreal,
Canada

011

**Constellation adopts a strong ethical stance. On your website you are critical of major labels and describe their 'infuriating transparency and shamelessness'. How do you avoid falling into the same trap?**

By continually reminding ourselves that sustainable and respectful behaviour in the music industry cannot be guided by the maxim, 'I just want to get my music heard by as many people as possible.' We make all sorts of mundane decisions that limit sales, limit the number of potential listeners we might reach, limit the accessibility and availability of our records, and limit our 'market penetration'. We don't do this to be wilfully difficult or obscure. We do it because the music industry, like any major industry, is entangled with general global death machinery, and their nihilistic values need to be challenged, not championed. Affirming sustainability and human-scale production necessarily implies various limits on sales and requires an ever-renewing definition of success in non-economic terms. We rely on a modicum of active and conscious engagement by music fans to discover our bands and our catalogue. Our ethical stance derives from the desire to preserve some degree of substantive discourse surrounding artistic quality and exchange. Putting money into artwork and locally sourced packaging production is the most obvious and fulfilling way to ensure we have almost nothing left over for marketing. And constructing our release budgets so that even 3,000 sales can generate some small surplus for the artist is central to what we do.

**As the music industry produces an ever-more standardized 'product', you move in the opposite direction with hand-assembled covers and locally sourced, non-standard manufacturing. What is your reasoning for this – surely life would be simpler if you used the standard packaging formats?**

Surely it would, and a lot more boring, and a lot more complicit. We won't push the argument too far, but we truly believe that non-standard packaging and an emphasis on the recording as an object can help create some small break in the smooth and effortless flow of consumption – not only in our own daily experience of production at the label, but hopefully in the consciousness of the consumer as well. Package fetishization is not strictly an end unto itself; anchored to small-scale production and distribution techniques, our emphasis on non-standard packaging and hand assembly carries its own humble critique of mechanization and disposability, and its own affirmation of human-scale exchange. It's a way of asserting other values, such as slowing down, denying instant gratification (it takes many days and many hands to assemble a few thousand records at Constellation), and perhaps inspiring a similar moment of genuine un-coerced attention from a handful of music fans. Another important point: we keep everything in print, on both CD and LP formats, with all or most of the original packaging elements; we are not creating limited editions to serve a collector's market that would see our records trade privately for higher than retail price.

**How is sleeve design managed within Constellation?**

We are fortunate to have a roster of bands with no shortage of good album artwork ideas. We always expect the bands themselves to generate artwork, and they always do. Don and myself at the label then weigh in with layout suggestions and propose various print techniques, which sometimes co-determine the artwork choices. The physical design of the packaging templates themselves, and all the technical specifics of rendering artwork properly, is our work and responsibility. We've never hired an outside 'designer', though we often engage artists and artisans for illustration, etching and various manual printing processes.

**How do you accommodate the wishes of musicians?**

Their wishes are our commands, as long as they are wishing for the same things we are! In terms of album art direction, every record is an extended conversation, requiring multiple sessions, and is generally done with the artist(s) present (one of the advantages of working primarily with local and regional groups). It's almost invariably a fun, serious, collaborative process, and almost invariably ends with that one last element being nudged over that one last sixteenth of an inch.

**What is the purpose of cover art – is it to depict the music?**

'Depict' might be too strong or too narrow a term, but certainly the purpose of cover art is to establish a context for the sounds contained within.

**You use a lot of illustration rather than photography. Why is this?**

We use a lot of photography, too. We've also reproduced painting and collage by musicians and local artists on a number of records. Illustration is very conducive to print techniques like silk-screening, foil printing and embossing, and insofar as such techniques often drive the artwork, illustrations and etchings are often sought out.

**Are you in any way interested in creating a label identity?**

Sure. We care about curating a solid catalogue, not putting out too much stuff, not over-producing (in all senses), and documenting one slice of local artistic activity for a slightly wider audience. We care about our reputation as a diligent and well-managed enterprise based on non-contractual handshake deals with artists and a dedication to the viability of small-scale economics of CD and LP sales.

**On your website you say that 'MP3 action is on the horizon'. Can you explain your reluctance to rush into digital releases?**

MP3s are the most effortless, immediate, degraded and disposable 'format' in the history of recorded music. As a tool for discovering new sounds, the Internet and compressed digital file exchange is a wonderful thing. As a commodity, MP3s and the Internet-driven marketing they inspire can be pretty heinous. We are deeply sceptical about iPod and broadband culture, but rather than deny it outright, we have recently decided we will operate at its margins, by making our catalogue available on a few independent MP3 sites for those who really truly would rather pay 10 bucks for a file than 13 bucks for a CD packaged in the band's artwork.

**Do you envisage a time when the download format is the only format, or will there always be a stubborn rump of traditionalists which resist the dematerialization of music?**

We have faith in the stubborn rump. The 'stubborn rump' cohort is a key demographic for us. Far more reliable than 'new urban bohemians' or 'tweens'.

**Can you name some other cover art you admire?**

Other Montreal labels like Intr_version, Alien8 and Squint Fucker Press have done nice work. We also see self-made CD and LP jackets every week that blow us away. Anything that takes its lead from paper, scissors, glue and people figuring it out for themselves...
■◗

■O
013

Ian Ilavsky /
Constellation

Musician /
Label Owner

Montreal,
Canada

01 /
A: A Silver Mount Zion
T: He Has Left Us
   Alone but Shafts
   of Light Sometimes
   Grace the Corner
   of our Rooms...
F: 12" LP
L: Constellation
D: Efrim Menuck
I: John Tinholt
Y: 2000

02 /
A: Do Make Say Think
T: Goodbye Enemy
   Airship: the
   Landlord is Dead
F: CD
L: Constellation
D: Do Make Say Think
P: Stephanie Small
   (street art
   installation by
   Stefan Philippa)
Y: 2000

03 /
A: Sofa
T: Grey
F: CD
L: Constellation
D: Sofa
P: Brad Todd
Y: 1997

04 /
A: Fly Pan Am
T: Fly Pan Am
F: 2xLP
L: Constellation
D: Fly Pan Am
Y: 1999

05 /
A: Do Make Say Think
T: Do Make Say Think
F: CD
L: Constellation
D: Do Make Say Think
Y: 1999

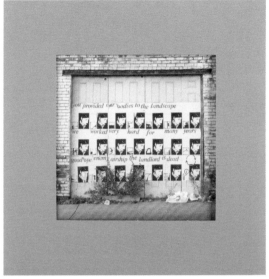

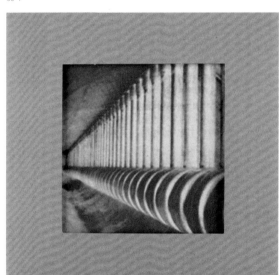

02 /

03 /

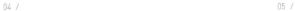

04 /

05 /

06 /

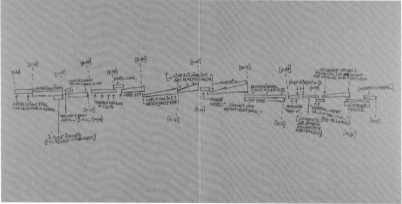

07 /

015

Ian Ilavsky /
Constellation

Musician /
Label Owner

Montreal,
Canada

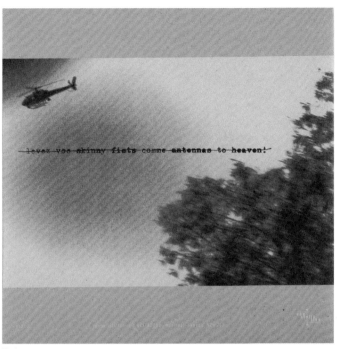

08 /

09 /

10 /

016

Ian Ilavsky /
Constellation

Musician /
Label Owner

Montreal,
Canada

11 / 12 /
A: The Silver Mt.
   Zion Memorial
   Orchestra &
   Tra-La-La Band
   With Choir
T: "This is our
   Punk-Rock," Thee
   Rusted Satellites
   Gather + Sing
F: 2xLP
L: Constellation
D: Efrim Menuck
Y: 2003

13 / 14 / 15 /
A: The Silver Mt.
   Zion Memorial
   Orchestra &
   Tra-La-La Band
   With Choir
T: "This is our
   Punk-Rock," Thee
   Rusted Satellites
   Gather + Sing
F: LP Booklet
L: Constellation
D: Efrim Menuck
Y: 2003

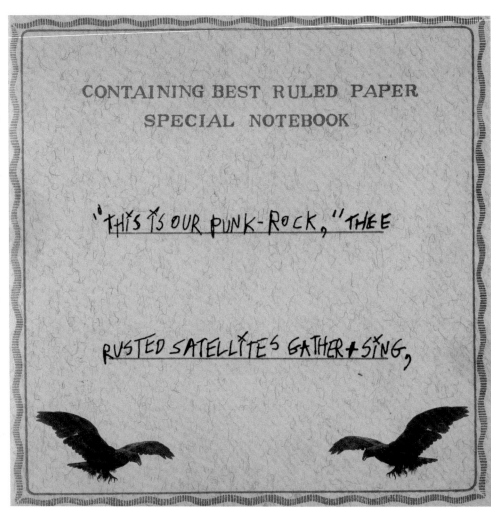

11 /

12 /

017

Ian Ilavsky /
Constellation

Musician /
Label Owner

Montreal,
Canada

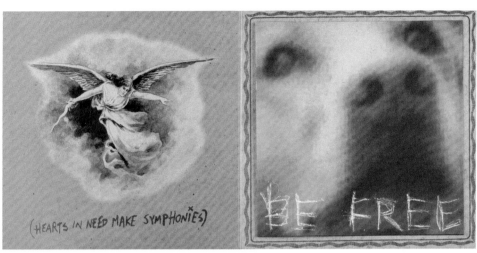

13 /

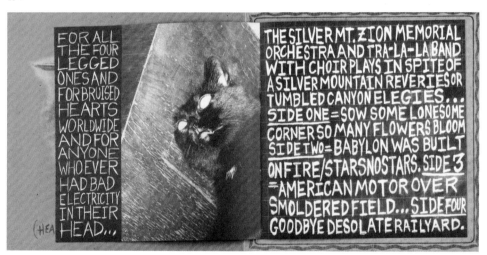

14 /

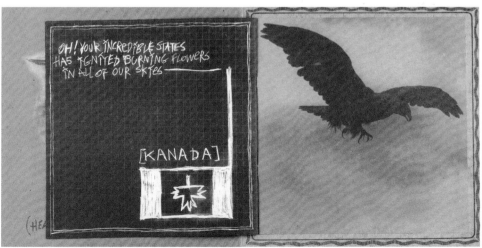

15 /

Ian Ilavsky /
Constellation

Musician /
Label Owner

Montreal,
Canada

16 / 18 /
A: Frankie Sparo
T: Welcome Crummy
   Mystics
F: 12" LP
L: Constellation
D: Chad Jones
   (aka Frankie Sparo)
Y: 2002

17 / 19 /
A: Frankie Sparo
T: Welcome Crummy
   Mystics
F: LP Inserts
L: Constellation
D: Chad Jones
   (aka Frankie Sparo)
Y: 2002

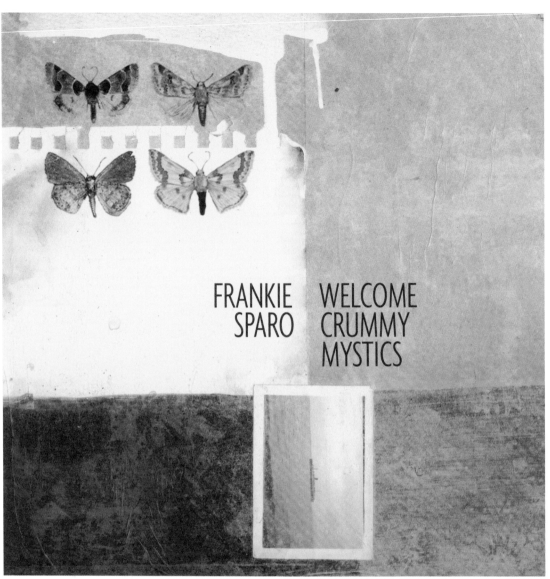

FRANKIE    WELCOME
SPARO      CRUMMY
           MYSTICS

16 /

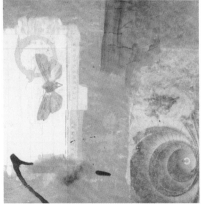

17 /

019

Ian Ilavsky /
Constellation

Musician /
Label Owner

Montreal,
Canada

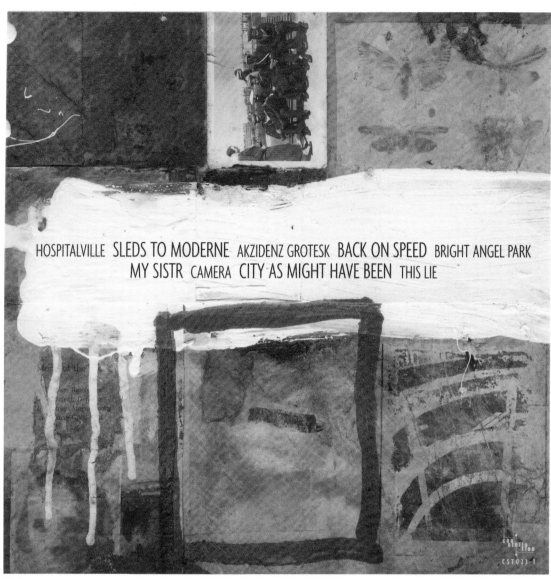

HOSPITALVILLE SLEDS TO MODERNE AKZIDENZ GROTESK BACK ON SPEED BRIGHT ANGEL PARK MY SISTR CAMERA CITY AS MIGHT HAVE BEEN THIS LIE

18 /

19 /

Ian Ilavsky /
Constellation

Musician /
Label Owner

Montreal,
Canada

20 / 21 /
A: Carla Bozulich
T: Evangelista
F: 12" LP
L: Constellation
D: Nadia Moss
Y: 2006

22 /
A: Carla Bozulich
T: Evangelista
F: Insert
L: Constellation
D: Nadia Moss
Y: 2006

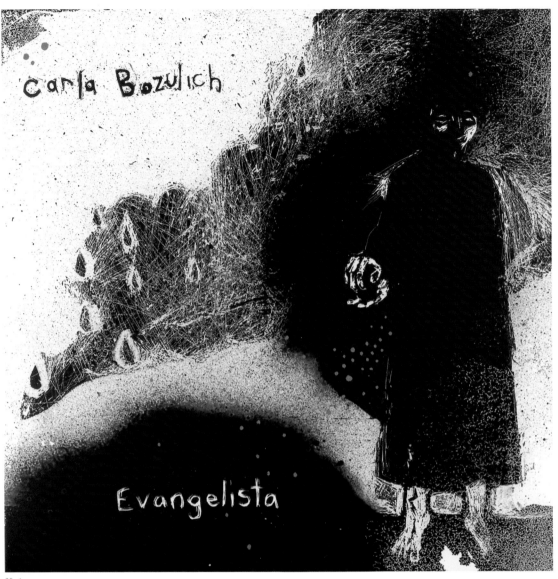

20 /

21 /

22 /

Ian Ilavsky /
Constellation

Musician /
Label Owner

Montreal,
Canada

021

23 / 24 /
A: Black Ox Orkestar
T: Ver Tanzt?
F: 12" LP
L: Constellation
D: Front cover,
   found artwork.
   Rear cover,
   drawing by
   Scott Gilmore
Y: 2004

25 /
A: Black Ox Orkestar
T: Ver Tanzt?
F: Insert
L: Constellation
D: Found artwork
P: Jessica Moss
Y: 2004

26 /
A: Black Ox Orkestar
T: Ver Tanzt?
F: Insert
L: Constellation
D: Found artwork
Y: 2004

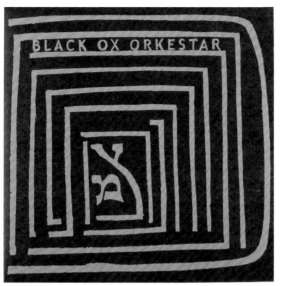

23 /

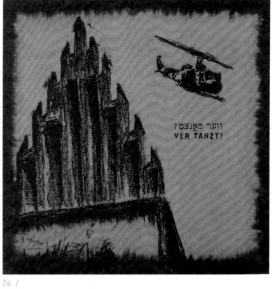

24 /

25 /

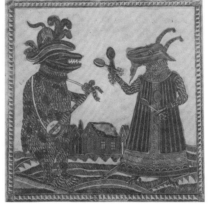

26 /

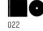

022

Ian Ilavsky /
Constellation

Musician /
Label Owner

Montreal,
Canada

27 /
A: Sandro Perri
T: Plays Polmo Polpo
F: 12" EP
L: Constellation
D: Sandro Perri
Y: 2006

28 /
A: Eric Chenaux
T: Dull Lights
F: 12" LP
L: Constellation
D: Marla Hlady
Y: 2006

29 /
A: Polmo Polpo
T: Like Hearts
   Swelling
F: 12" LP
L: Constellation
D: Nadia Moss
Y: 2003

30 /
A: Black Ox Orkestar
T: Nisht Azoy
F: 12" LP
L: Constellation
D: Black Ox Orkestar
   & Ian Ilavsky
   [from found
   imagery]
Y: 2006

31 /
A: Elizabeth Anka
   Vajagic
T: Nostalgia/Pain EP
F: 12" EP
L: Constellation
D: Elizabeth Anka
   Vajagic
Y: 2005

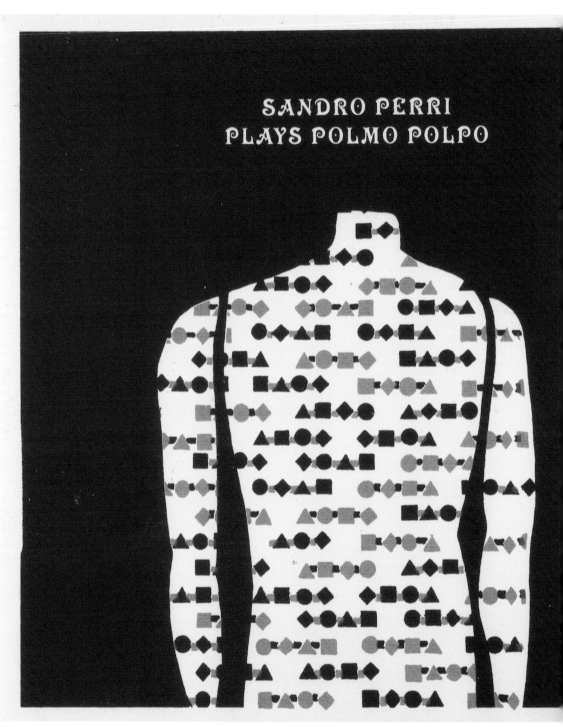

27 /

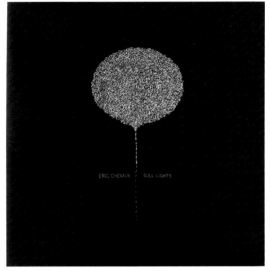

28 /

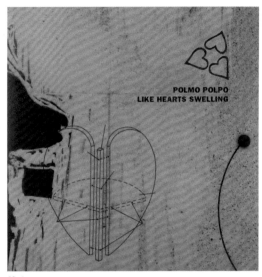

29 /

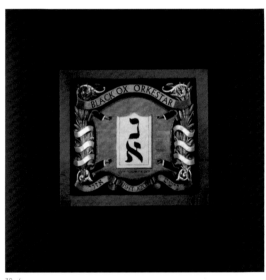

30 /

31 /

Thaddeus Herrmann /
City Centre Offices

A&R /
Label Owner

Manchester, UK /
Berlin, Germany

024

# Thaddeus Herrmann / City Centre Offices

**Name:**
Thaddeus Herrmann

**Occupation:**
A&R and Label Owner

**Label:**
City Centre Offices

**Location:**
Manchester, UK
and Berlin, Germany

**Website:**
www.city-centre-offices.de

**Biography:**
When music lover
Thaddeus Herrmann met
music lover Shlom Sviri
in Manchester in 1998,
they had 'a glass of
wine and started a
label'. Herrmann is
a trained journalist,
currently working as an
editor for De:Bug, one
of the biggest music
magazines in Germany.
Sviri runs the biggest
mail-order site for
electronic music in
the UK, boomkat.com.
Herrmann has said:
'Every record we put
out makes us proud.'

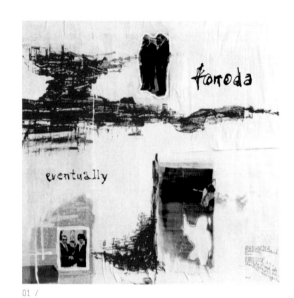

01 /

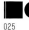

025

Thaddeus Herrmann /
City Centre Offices

A&R /
Label Owner

Manchester, UK /
Berlin, Germany

**Can you describe the City Centre Offices' musical philosophy?**
When we started out, we had this idea that we wanted to release electronic pop music. We had both grown up with pop music on the radio and we then went out and bought the songs on 7". We wanted to transport this format into the age of electronic music. We still consider what we do as pop, which means that the releases have to grab us instantly, and shake our hearts and feelings. This is what pop has always been about. We were never happy with terms like 'IDM' or 'experimental'. What does that mean anyway? Music is music and you either like it or you don't. We like accessible stuff.

**What is your policy regarding cover art at City Centre Offices?**
Music needs artwork and we get it done.

**Well, that's pretty clear-cut. How do you choose the graphic designers you want to work with?**
Most of the designers we work with are friends. This is what you do when you run a small label and have to watch budgets very closely. We are in a situation where we happen to know many very talented and very successful designers who are happy to do artwork for us. When we started the label, we had another guy on board. He came up with the original design of the 7"s we started out with and also designed our first two full-length releases. After that, the people at Artificial Duck Flavour took over and did most of the jobs. We have a couple of other people

doing artwork for us on a regular basis. We usually recommend to the musicians a certain designer for their album, because we assume that the designer is into the music. Then, either the designer comes up with ideas or the musician has certain things in mind he wants to use. Coming up with artwork is a very close interaction between the designer and the artist.

**How much freedom do you allow the musicians to choose their own cover art?**
We have to like it as well. Some artists are really excited about certain photographs they took on their last holiday, but which turn out to be pretty useless, either when it comes to blowing them up for the vinyl version, or if there is nothing to match them with, or if the designer simply is not inspired by them. However, generally speaking, we are happy if the artist has an idea to start the whole process.

**To what degree do you allow commercial considerations to influence your sleeve designs?**
Funnily enough, a few years ago I would never have thought about things like that. But the longer you run a label, the more you become aware of possible 'problems'. So we make sure that if the artist's name is not clearly visible on the artwork, we put a sticker on the finished product to make the buyers aware that this is the new album of an artist they might like. But this is as far as we go.

**Is the purpose of your record covers to describe the music – or is it to define the label?**
Covers should always go with the music. It rarely happens that some kind of visual label identity is so strong that it can represent different artists' output. We always approach it the opposite way. Having said that, of course we do like certain things more than others. Personally, a strong yet simple photograph does much more than sophisticated font-trickery. However, that's just me.

**Can you talk about the role of the website in running a label? Is there a sense in which it does a lot of the work that sleeves used to do, such as providing information and band pictures, and so on?**
I'm still surprised by the fact that artist pictures are important with the music we do. I never would have thought that we would need budgets for photo shoots, etc. But a good website is really important. I don't think that it replaces the sleeves, but it should keep people up to date and maybe link to things important to the artists.

**What is your view on audio downloads? Is there any need to provide visuals to accompany them?**
First of all, downloads are very important for us. We have a lot of people buying our releases on a strictly digital basis. At the same time, for me buying MP3s is something very abstract. So yes, I do feel that if you buy an album as MP3, you should at least get a hi-res JPEG of the front cover.

For me personally, even a CD is too small to represent the original artwork. However, the success of MP3 shops proves that the music seems to be a vehicle of its own these days and that many people do not care about quality artwork anymore.

**Can you name some labels that you think have good cover art?**
I have to stick with the classics here. People like Vaughan Oliver and his work for 4AD still blow me away. I still like early Designers Republic stuff. ■●

■◻● 

026

Thaddeus Herrmann /
City Centre Offices

A&R /
Label Owner

Manchester, UK /
Berlin, Germany

01 /
A: Fonoda
T: Eventually
F: CD
L: Büro
D: Matthias
   Neufeind
Y: 2007

02 /
A: I'm Not a Gun
T: Our Lives On
   Wednesdays
F: CD
L: City Centre Offices
D: Michael Zorn
P: Markus Knote
Y: 2004

03 / 04 /
A: Donato Wharton
T: Body Isolations
F: CD
L: City Centre Offices
D: Artificial Duck
   Flavour
Y: 2006

05 /
A: Arovane
T: Lilies
F: CD
L: City Centre Offices
D: Artificial Duck
   Flavour
Y: 2004

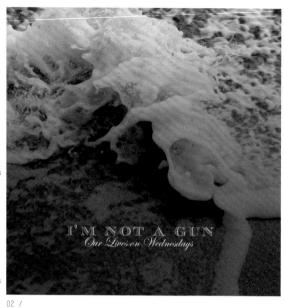

02 /

03 /

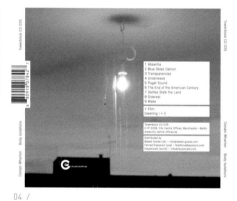

04 /

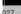

Thaddeus Herrmann /
City Centre Offices

A&R /
Label Owner

Manchester, UK /
Berlin, Germany

05 /

Thaddeus Herrmann /
City Centre Offices

A&R /
Label Owner

Manchester, UK /
Berlin, Germany

06 / 07 /

A: Boy Robot
T: Rotten Cocktails
F: CD
L: City Centre Offices
D: Strange
   Attractors Design
Y: 2005

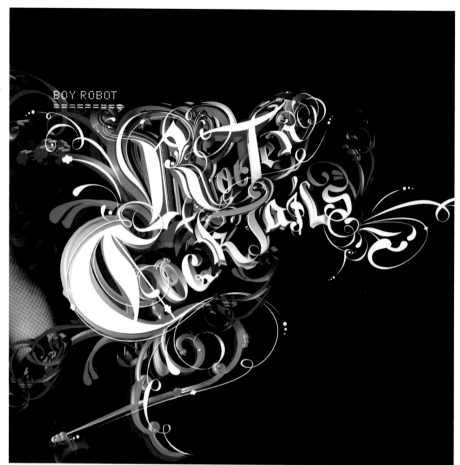

06 /

07 /

Thaddeus Herrmann /
City Centre Offices

A&R /
Label Owner

Manchester, UK /
Berlin, Germany

08 /
A: Static
T: Re: Talking About
   Memories
F: CD
L: City Centre Offices
D: Julia Kliemann &
   Robert Lippok
Y: 2005

09 /
A: Marsen Jules
T: Les Fleurs
F: CD
L: City Centre Offices
D: Mike Fallows
P: Adeel Ahmad
Y: 2006

10 /
A: Marsen Jules
T: Herbstlaub
F: CD
L: City Centre Offices
D: Jan-Rikus Hillmann
Y: 2005

11 /
A: Dub Tractor
T: Hideout
F: CD
L: City Centre Offices
D: Artificial Duck
   Flavour
Y: 2006

08 /

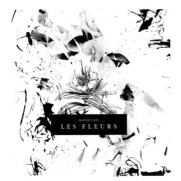

09 /

10 /

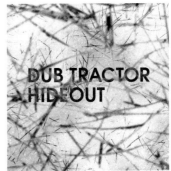

11 /

030

Thaddeus Herrmann /
City Centre Offices

A&R /
Label Owner

Manchester, UK /
Berlin, Germany

12 /
A: Porn Sword Tobacco
T: New Exclusive
   Olympic Heights
F: CD
L: City Centre Offices
D: Artificial Duck
   Flavour
P: Henrik Jonsson
Y: 2007

13 /
A: I'm Not a Gun
T: We Think as
   Instruments
F: CD
L: City Centre Offices
D: Artificial Duck
   Flavour
Y: 2006

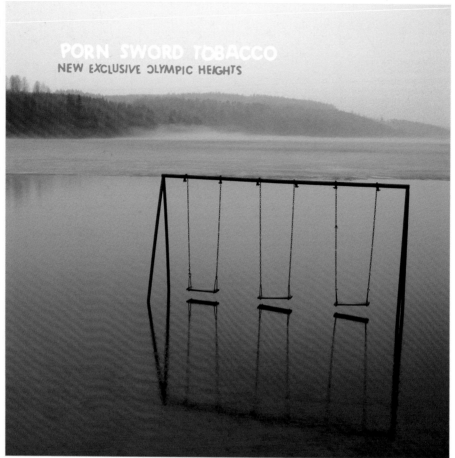

12 /

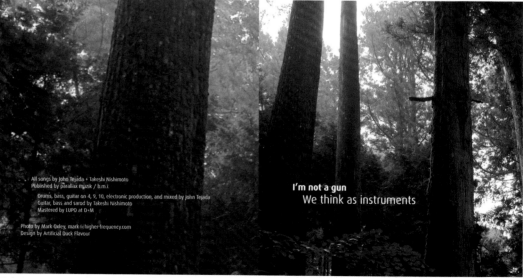

13 /

Thaddeus Herrmann /
City Centre Offices

A&R /
Label Owner

Manchester, UK /
Berlin, Germany

14 /
A: Miwon
T: Pale Glitter
F: CD
L: City Centre Offices
D: Jan-Rikus Hillmann
P: Axel Martens
Y: 2006

15 /
A: Dictaphone
T: Vertigo II
F: CD
L: City Centre Offices
D: Andreas Prossliner
P: Felix Broede
Y: 2006

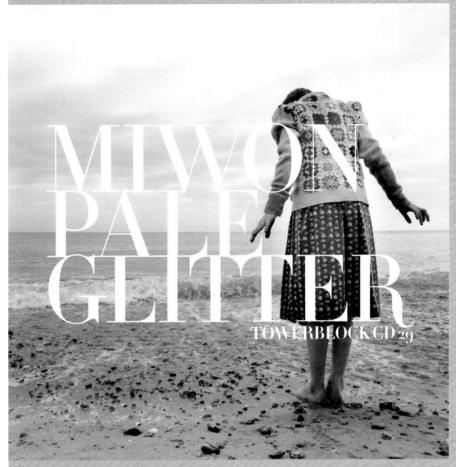

14 /

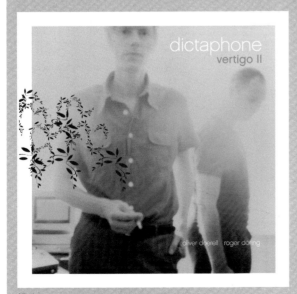

15 /

032

Masato Samata /
Delaware

Artoonist

Tokyo,
Japan

# Masato Samata / Delaware

**Name:**
Masato Samata

**Occupation:**
'Artoonist'
(Cartoon + Art = Artoon)

**Studio:**
Delaware

**Location:**
Tokyo, Japan

**Website:**
www.delaware.gr.jp

**Biography:**
A Japanese supersonic group that 'designs music and musics design'. In 2001, they held their first exhibition on the i-mode Mobile Gallery. In the same year, they held an exhibition and perform- ance at P.S.1/MoMA, New York. Other shows include a solo show at RAS gallery, Barcelona, 2004 and D-Day Design Today, 2005 at the Centre Pompidou, Paris. They have released seven music albums and published Designin' In The Rain with ACTAR, the Barcelona publisher.

01 /

**I'm intrigued by the name Delaware: why did you choose it?**
Hardware. Software. Delaware!?

**How many people in Delaware?**
Sometimes one, sometimes four or five.

**Most of your work is digital: are you more comfortable working in the digital domain?**
Yes. Delaware cannot be without the digital.

**Can you tell me about the Japanese music scene – are there lots of opportunities for designers?**
We are not sure because we are not in the music scene in Japan.

**Do you work for any non-Japanese record labels?**
No, none at all.

**People are saying album covers are a thing of the past, but perhaps you've found an alternative with your 'animated album covers'. Is this your way of dealing with the download question?**
We like both music and visuals. From this point of view, records and CDs have always been very attractive media. But now, we feel reality is to be found on the web.

**When you work on a music project do you work closely with the band?**
No opportunity.

**Who are the great Japanese record sleeve designers?**
Tadanori Yokoo, Hajime Tachibana.

**Which American or European record sleeve designers do you admire?**
Andy Warhol, Jamie Reid. Red Rose Speedway by Paul McCartney and Wings is a great cover!

**What advice would you give to a young graphic designer starting out and wanting to design record covers?**
500 years on from Leonardo da Vinci, 400 years on from Shakespeare, 250 years on from Mozart, 100 years on from Dada, 60 years on from R&R, 60 years on from Pop Art, 50 years on from The Beatles, 40 years on from hip hop: we live in the future. Furthermore, we can get to know the process of their work from record albums, videos, museums or books. We know or experience more than Marcel Duchamp, Stanley Kubrick or James Brown. Even though we are less talented we have much more information. So, we can sample their 'technique', 'practice', 'idea' or 'sense' to skip the steps the famous artists have already done. We'll spend our time doing what they haven't done yet, without spending the time gaining the traditional technique, and just go one step further.

We like R&B or hip hop music because it is relatively 'easy' to make so long as you have some sense. That is the reason why we use bitmap; because since we decided to use bitmap, we can't practise so much to gain more technique [laughter]. So we can take the next step towards the future.

01 /
A: Delaware
T: Can I Lava? Lava?
F: 7" Vinyl
L: Hot-Cha Records
D: Delaware
Y: 1999

02 /
A: Delaware
T: (All You Need Is)
   Hell No Beer Yeah
F: Online Album
D: Delaware
Y: 2006

03 / 04 /
A: Delaware
T: Virginity
F: Online Album
D: Delaware
Y: 2006

05 /
A: Delaware
T: Slow Train
F: Online Album
D: Delaware
Y: 2006

06 /
A: Delaware
T: Join Us? No!!
F: Online Album
D: Delaware
Y: 2006

02 /

03 /

04 /

05 /

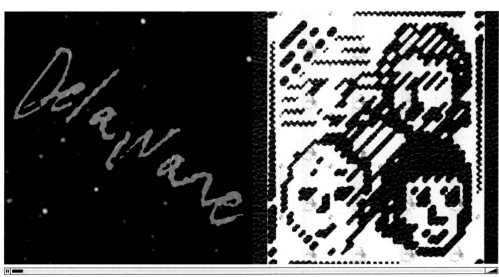

06 /

Masato Samata /          Artoonist                              Tokyo,
Delaware                                                        Japan

07 /
A: Delaware
T: Private CD
F: CD
L: Self release
D: Delaware and
   Young V
Y: 1996

08 / 09 / 10 /
A: Delaware
T: AmeN
F: CD
L: Self release
D: Delaware and Koh
   Chihara
Y: 2004

07 /

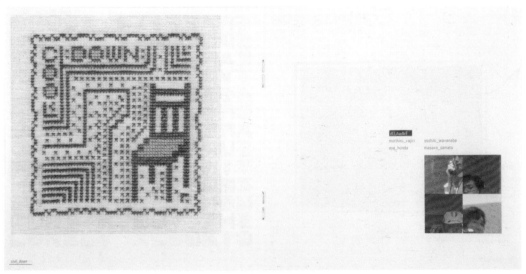

08 /

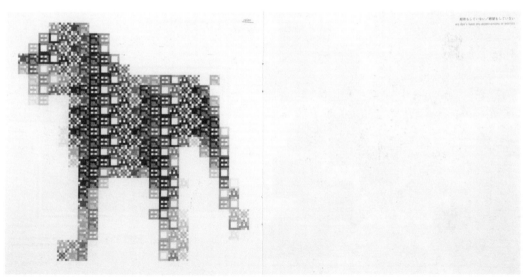

09 /

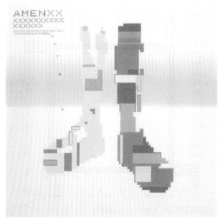

10 /

038

Julian House & Jim Jupp /
Ghost Box

Graphic Designer /
Label Owners

London,
UK

# Julian House & Jim Jupp / Ghost Box

**Names:**
Julian House and
Jim Jupp

**Occupations:**
Graphic Designer and
Label Owners

**Label:**
Ghost Box

**Location:**
London, UK

**Website:**
www.ghostbox.co.uk

**Biography:**
Julian House is a
graphic designer working
for the London-based
design company Intro.
He has designed record
covers for Primal
Scream, Stereolab
and Broadcast, amongst
many others. Jim Jupp
is a composer and
an architectural
technician. In 2004,
House and Jupp formed
the label Ghost Box.
Both record for the
label (House under the
name The Focus Group,
and Jupp under the name
The Belbury Poly).
The label now has a
catalogue of eight
titles, with more in
the pipeline.

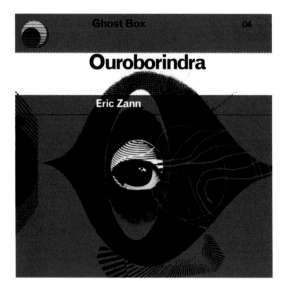

01 /

039

Julian House & Jim Jupp /
Ghost Box

Graphic Designer /
Label Owners

London,
UK

**How would you describe Ghost Box, the label?**

JH: Ghost Box came into being as an independent record label. We needed a way to put out our music and it seemed the logical way to do it. We shared musical obsessions (Radiophonic Workshop, early electronic music, library records, weird folk, soundtracks, etc.), but also we are both into HP Lovecraft and Arthur Machen, weird tales, cosmic horror, British TV sci-fi and the strangeness of a certain part of postwar Britain. We wanted the label to be dense, full of allusions and references...an audio-visual identity. Lately it seems to have taken on a life of its own, through the things that have been written about it. It's as if it's creating its own mythology, willing us to move into other areas – film, illustrated books, strange events.

JJ: Ghost Box is a DIY label. It's not going to be our main source of income, but it's a consuming passion. So, even after a few fairly successful releases and reviews we still feel like enthusiastic amateurs rather than part of the music industry.

**How do you divide up your duties?**

JH: Obviously we have our own musical projects, but generally Jim runs the label and I'm in charge of the visual side. This includes the CD covers, flyers, etc., but also creating photography for the label and working on short films. We get together regularly to talk about script ideas, things we can try out in the future. When I'm putting CD artwork together we'll often meet to work on imagery and discuss layouts together.

JJ: Apart from writing our own music, I run the business (from production to mastering to bookkeeping), and Julian is responsible for all design work. Sometimes I'll sit on Julian's shoulder (like a nightmare client) and we'll work together on the layouts he's putting together. We also collaborate on copy and quotations for the CDs.

**There's clearly a Ghost Box look – is this because Julian designs all the sleeves, or because there is an ethos that is being espoused?**

JH: Obviously having one designer makes a difference, but we knew from the beginning that there was a particular look that the label would have. Our love of old pulp paperbacks and Penguin books was a starting point. Penguin belongs to a particular postwar consensus that we're drawn to, a particularly British, modernist culture for the common man sensibility. But also the look alludes to strange books found in junk shops, libraries, missing volumes. Ghost Box is about forging a link between British modernism and something arcane and lost. I always loved the colour-coded repetitions of library albums, the sort of occult quality of something that's repeated over and over, with slight changes each time. The other touchstone was old school textbooks – I liked the way we could fill the picture boxes with strange images, in addition to quotes and footnotes, creating our own weird fictions. Also, we always saw our releases as bizarre Open University modules, so this through-the-looking-glass educational aesthetic made sense.

**When Ghost Box started it was a CD-R burn-to-order label, but recently you've moved towards manufactured CDs – why was this?**

JJ: We've gradually moved towards CD because the demand was too high for me to keep up with making and printing CD-Rs at home. We still do fairly small runs of CDs, which may be a bit more expensive, but we don't feel the need to get bogged down with distributors and desperately trying to market boxes and boxes of CDs stacked up in our homes. Apart from a few hundred pounds on a printer when we started out, we've never risked any money in the label, and we plough all the proceeds back in so that we can make higher quality packaging and CDs. The beauty of this is that we're not tied in to anything at all. We can release whatever we want, in whatever quantity we want, and withdraw anything we want. Having said all that we're just starting to work with other more professional musicians and the need for contracts and licensing etc. is inexorably turning us into a more standard indie label. At this point I suppose we'll have to tread carefully to maintain our creative freedom and not let the whole thing turn into a big bloody chore.

**How do you accommodate the other musicians who release CDs on Ghost Box – do they have any input into their covers?**

JH: As with any design brief, the artists may have references, things they want to put across, but there's an understanding that the finished cover will be in keeping with the Ghost Box ethos.

JJ: So far we've worked with Jon Brooks (The Advisory Circle) and he was more than happy to let us come up with the design and copy for his EP. The concept of the music itself was so clear that I think he trusted us to get it. At the moment we're working with Drew Mulholland, the man behind Mount Vernon Arts Lab, for a reissue of his album Seance at Hobs Lane. This was always an important album for Julian and me so we're keen to work as closely as possible with Drew. Amongst other things, Drew writes on and lectures in psychogeography and his interests dovetail nicely with the Ghost Box world. The way Ghost Box is, I don't think we could work with an artist who didn't already know and like Julian's work or share our reference points and obsessions. So each artist really adds something to the overall aesthetic. I suppose it's like a club or mutual appreciation society rather than a label. We're hoping to work with James Cargill and Trish Keenan of Broadcast later this year, and also Jonny Trunk of Trunk Records.

040

Julian House & Jim Jupp /
Ghost Box

Graphic Designer /
Label Owners

London,
UK

**What do you say to people who say that Ghost Box is about nostalgia and the British obsession with the past – is it the record collecting equivalent of the National Trust?**

JH: I agree that there's an element of nostalgia, but it's more about unconscious half-remembered things, or forging strange links between things you remember, strange invisible lines connecting areas of forgotten culture. It's not about pastiche, which is a very ironic, everything-in-the-light way of approaching the past. For us it's more about creating imaginary places. There's a quote by K-Punk (a writer and weblog theorist) that sums up our attitude to the past perfectly: 'Ghost Box conjure a past that never was. Their artwork fuses the look of comprehensive school textbooks and public service manuals with allusions to weird fiction, a fusion that has more to do with the compressions and conflations of dreamwork than with memory.'

JJ: We used to studiously deny the nostalgia element of Ghost Box. But lately we've been saying, fuck it, what's so bad about nostalgia? So long as it's done with a bit of style, i.e. it's not Heartbeat or Horse Brasses. I think the past is up for grabs to be re-imagined and reconfigured into parallel worlds rather than just re-enacted. We manage to find something new and quirky when we recombine old photographs, synths, magazines, samples or obsolete musical styles. We're not just willing Bagpuss and the Radiophonic Workshop back into being.

**Julian, how does your Ghost Box work impact on your work for other bands and labels? Does it attract people to commission you to design for them?**

JH: Some clients may be aware of the Ghost Box work alongside other things, it hasn't specifically made any difference to my working practice. Maybe it has unconsciously, it's probably more true to say that the way I approached Ghost Box was defined by what I've learned working commercially. How to create a series of sleeves that change just enough each time, the use of repetition and references to draw the audience in, creating worlds/fictions, things that can generate cult appeal.

**Where does Ghost Box stand on the audio download issue? Shouldn't we all just accept that record covers are a thing of the past and start downloading without a thought for visual collateral?**

JH: The visual and the aural are inseparable within Ghost Box. I've never believed you can listen to music devoid of visual references anyway. And the bookish feel of our releases, the strange allusions and hints of arcane backgrounds, the collectibility, are all important elements. I don't think people come to us and just want the music.

JJ: Last year our entire catalogue became available on iTunes. The downloads do OK, but we sell much, much more of our material on CD. Our audience prefers a physical product. I think there's still room for both at the moment,

but that will probably change. Design and packaging are such an important part of some kinds of music, such as ours, but by no means essential for everything. The challenge for us is to deliver both to our audience. Maybe in the future labels like ours will have to do that: release our own publications and merchandise in tandem with downloads. Meanwhile, as long as there's an audience willing to buy our music on a disc we'll keep doing it.

**Which other small independent labels do you admire?**

JJ: Oggum was one of the labels that inspired us to start up. They do simple photocopied sleeves on home-burned CD-Rs in a way that seems totally uncompromised and pure. Larkfall are the same. Not quite a small label any more, but I love Rune Grammofon for the quality, beauty and sheer collectibility of their records. Even with their success there's something unique about them that feels like they have nothing to do with the music industry but are more of a pure artistic endeavour.

■●

Julian House & Jim Jupp /
Ghost Box

Graphic Designer /
Label Owners

London,
UK

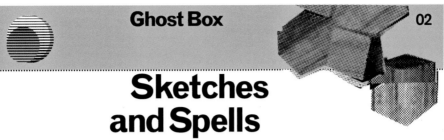

Ghost Box        02

# Sketches and Spells

The Focus Group

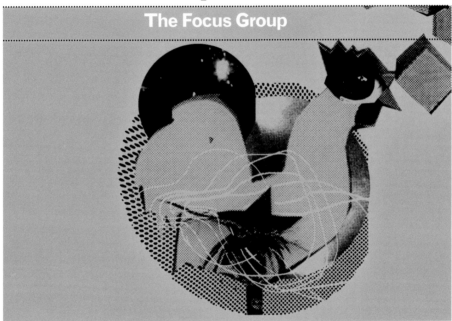

02 /

Ghost Box        02

## Sketches and Spells

| | | |
|---|---|---|
| 01 Stringed winds | 18 Underwater pries | 'A collection of individuals... |
| 02 Verberations | 19 Jass Tarp | an empty church hall, hoofprints, |
| 03 Open the Gate | 20 Hocusing Ice | mirrors, echoes, sequences of |
| 04 Activity and Scales | 21 What are you seeing? | ordered greenery, televisual |
| 05 Corn Holes | 22 Bromiding place | images, fonties and ovtres. |
| 06 Verberations exp. | 23 Kasratu | They make sounds for what we |
| 07 Bells hazes | 24 Swirling paths | see, experiments with wood, glass |
| 08 Alsh | 25 Starry wisdom | and air for half-formed things. |
| 09 Hocusing fee | | These small shards and move- |
| 10 Colouring Toys | | ments can be scooped up together |
| 11 Danse & Atoms | Written, performed and | and rolled into a shape something |
| 12 Free psych & mirrors | produced by The Focus Group | like a place or a landmark'* |
| 13 Verberation int. | (C) & (P) 2004 Ghost Box | |
| 14 Jout sections | FocusGroup@ghostbox.co.uk | |
| 15 Geometree hou | www.ghostbox.co.uk | |
| 16 Sun groof | Cover Design Julian House | |
| 17 Diagonalam | | |
| | GBX002 CD | * The Tangled Beams M.S. Devoi |

03 /

■□ ●

042

Julian House & Jim Jupp /
Ghost Box

Graphic Designer /
Label Owners

London,
UK

04 / 05 / 06 / 07
A: Mount Vernon
   Arts Lab
T: The Séance at
   Hobs Lane
F: CD
L: Ghost Box
D: Julian House
Y: 2007

04 /

## The Séance at Hobs Lane

04

Taking part in the Séance were:

Drew Mulholland –
EMS VCS3 (Putney),
Theremin, guitar, effects
Isobel Campbell –
cello on The Black Drop
John Cavanagh –
harpsichord and clarinet on
The Black Drop
Norman Blake –
guitar on The Mandrake Club
Raymond MacDonald –
saxophone on The Vauxhall
Labyrinth and Percy Toplis
Adrian Utley –
ARP2600 and minimoog on
Warminster 4
Morag Brown –
flute on Warminster 4

Hobgoblins remixed by Coil
The Submariner's Song remixed by
Barry 7

Produced and recorded by Drew
Mulholland and John Cavanagh

The Mandrake Club by
Mulholland/Blake
© Mulholland/Blake
Dashwood's Reverie by
Mulholland/Cavanagh
© Mulholland/Cavanagh
Warminster 4 by
Mulholland/Utley
© Mulholland/
Chrysalis Music Ltd.
All other tracks by Mulholland
© Mulholland

Original sound recording
copyright Drew Mulholland 2001

Thanks to Peter, Jhon, Norman,
Isobel, Adrian, Steve, Martin O'Neill,
Raymond, Barry, Morag, Talbot,
Sheena and Dr. Matthew Roney

Special Thanks to John Cavanagh
for support and encouragement.

05 /

## The Séance at Hobs Lane

01

Waves lengthen. Frequencies fall. We are all heading down at nine point eight-something metres per second per second to the centre of Planet Earth. The ground that holds us up also drags us down and our common destination on this push-and-pull globe is the big place under our feet.

** Luckless scaffolders, skydivers and well-diggers know this from experience. For the rest of us, Drew Mulholland of Mount Vernon Arts Lab gathered a crew of sub-Argonauts and set sail. In place of oars they wielded guitars, cellos, saxophones, harpsichords, flutes and naturally synthesizers. Their waystations were mixing desks manned by the likes of John Balance of Coil, Barry 7 of Add N to X, Adrian Utley of Portishead and Norman Blake of Teenage Fanclub. What country might these intrepid souls discover?

** Imagine a landscape of sets built for a never-quite-produced British science fiction film of the 1950s. Hobs End was the invented tube station in Quatermass and the Pit (an MVAL touchstone). The Séance at Hobs Lane is a late-night gathering, convened to reconnoitre this subterranean world.

** "The album is all about underground London," remarks its creator. "Victorian skullduggery, opium dens, underground shelters built during the war, secret societies..."

** Submarines were once built along the banks of the Thames. Production stopped when they got too big to fit under Hammersmith Bridge. One, it seems, remains in operation, travelling beneath the river through the midst of London's hobgoblins, the volatile weather (fog, with explosions) and the seductive menace of the Mandrake Club. There the black drop of the opium-eater awaits an eccentric gallery of characters. Percy Toplis is better known in his disguise as the onetime monocled mutineer. Sir Keith at Lambeth may be the Glimmer Twin 'Sir Keef'. Dashwood remains an enigma.

** Their world is a soundscape in which synthesizers burble and thrum. Strange crashes sound from the bottom of shafts. Acoustic instruments take on a brightened lyric role. Isobel Campbell's cello sounds like the last one in the world. We are visiting somewhere genuinely strange. We listen to ourselves there.

** Tom Stoppard said drama was always better on the radio: the scenery was so much more convincing. How else but by ear may we delve beneath our familiar streets to the abandoned bunkers, rumoured underground railways, tunnel networks, the dens and their denizens?

** Every genius needs a problem. Newton had gravity. Quatermass had his Pit. Now, courtesy of Drew Mulholland and his intrepid crew, we can listen on the rumbling depths. The Séance at Hobs Lane digs a hole deep enough for all of us. It's the underneath underneath our feet. Don't fall in. Jump.

** Lawrence Norfolk
London
2007

043

Julian House & Jim Jupp /
Ghost Box

Graphic Designers /
Label Owners

London,
UK

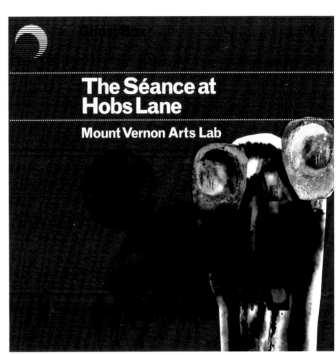

Ghost Box

The Séance at
Hobs Lane

Mount Vernon Arts Lab

'...the forthcoming end of the world will be hastened by the construction of underground railways burrowing into infernal regions and thereby disturbing the Devil.'

Rev. Dr. John Cumming 1860

**Ghost Box**
www.ghostbox.co.uk
Original sound recording copyright
Drew Mulholland 2001
Cover Design Julian House
Liner notes © Lawrence Norfolk 2007
GBX009 CD

01 The Fog Detonator
02 Hobgoblins
03 The Mandrake Club
04 Dashwood's Reverie
05 The Black Drop
06 Sir Keith at Lambeth
07 The Submariner's Song
08 The Vauxhall Labyrinth
09 While London Sleeps
10 Warminster 4
11 Percy Toplis

06 /

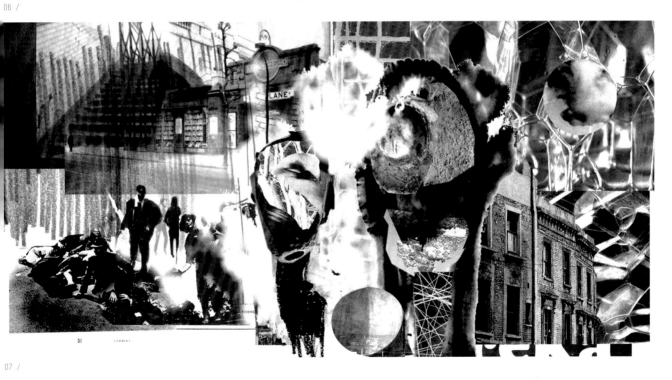

07 /

08 / 09 /
A: The Focus Group
T: Hey Let Loose
   Your Love
F: CD
L: Ghost Box
D: Julian House
Y: 2005

10 /
A: Belbury Poly
T: The Willows
F: CD
L: Ghost Box
D: Julian House
Y: 2004

11 / 12 /
T: General Flyers
L: Ghost Box
D: Julian House
Y: 2006

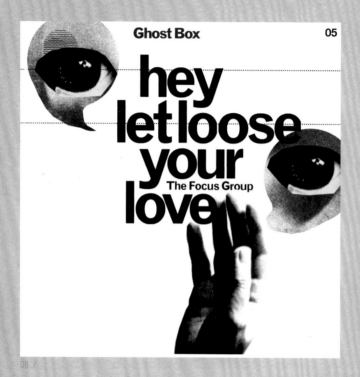

08 /

**Ghost Box**          05

01 Icicle wheel
02 You do not see me
03 Clockbell
04 Echo release
05 Xylophone signal
06 Modern Harp
07 Inside the rubber box
08 Lifting away
09 Today's rhythm people
10 Hey let loose your love

11 String Sine romance
12 The Moon Ladder
13 Planning for urban green
14 Swinging phantom
15 The Thre
16 Jam-jar carnival
17 Baroque face
18 The Leaving
19 Reflected message

Written, performed and
produced by The Focus Group
(C) & (P) 2005 Ghost Box
focusgroup@ghostbox.co.uk
www.ghostbox.co.uk

GBX005 CD

'This is after all what connects the
weird power of after-images and
the strange glamour of phosphor.
The day to day output of this
machine is a synthesis of ancient
dreams and light entertainment.'*

* A Microphone in the Hedgerow MB Devoi

09 /

**Ghost Box** 03

**Ghost Box** 03

# The Willows

# The Willows

**Belbury Poly**

01 Wildspot
02 The Willows
03 Caermaen
04 A Thin Place
05 Farmers Angle
06 Insect Prospectus
07 A Warning
08 Monstroon
09 Thorn
10 The Absolute
   Elsewhere
11 Far Off Things

Written, performed and
produced by Belbury Poly

(C) & (P) 2004 Ghost Box
belburypoly@ghostbox.co.uk
www.ghostbox.co.uk
Cover Design Julian House

GBX003 CD

"It's the sound of their world,
the humming in their region.
The division here is so thin that
it leaks through somehow. But,
if you listen carefully, you'll find
it's not above so much as around
us. It's in the willows." *

"...if this technique is really
successful , the Belbury people
have for all practical purposes
discovered a way of making
themselves immortal." **

\* The Willows Algernon Blackwood
\*\* That Hideous Strength C.S. Lewis

## 06....

Module 06
The Advisory Circle     Mind how You Go

Timely advice from
The Circle
Remember, electricity can
not be seen or heard.
Harmful, invisible forces
surround us everywhere
we go.

October 2005

## 01-03

Modules 01-03
The Focus Group
Belbury Poly

The Willows
Sketches & Spells
Farmers Angle

Hey, Let
loose your Love

A varied program of
musical activities
for educational and
ritual use.

Starts January 2005

**Ghost Box.co.uk**

13 / 14 / 15 /
A: Belbury Poly
T: The Owl's Map
F: CD
L: Ghost Box
D: Julian House
Y: 2006

**Ghost Box**     07

# The Owl's Map

**Ghost Box**     07

# The Owl's Map

1 Owls and Flowers
2 Rattler's Hey
3 The Moonlawn
4 Music, Movement & Meaning
5 Wetland
6 Tangled Beams
7 The People
8 The New Mobility
9 Pan's Garden
10 Lord Belbury's Folly
11 Scarlet Ceremony
12 Your Way Today

Written, performed and
produced by Belbury Poly

(C) & (P) 2006 Ghost Box
belburypoly@ghostbox.co.uk
www.ghostbox.co.uk
Cover Design Julian House

GBX007 CD

"And the noise and the singing
would go on and on for a long
time, and the people who were
in a ring swayed a little to and
fro; and the song was in an old,
old language that nobody knows
now, and the tune was queer." *

"Are ghosts 'television' pictures
carried by the force of resonance
from a projecting machine in
one mind to a receiving machine
in another ?" **

* Arthur Machen The White People
** T.C. Lethbridge Ghost and Ghoul

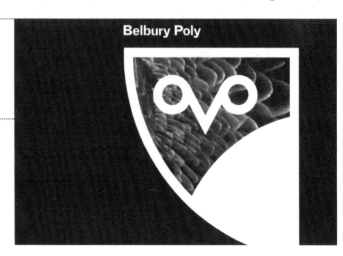

**Belbury Poly**

Julian House & Jim Jupp /
Ghost Box

Graphic Designer /
Label Owners

London,
UK

07

14 /

07

The Owl's Map
Field Guides to British Towns
and Villages.
Volume 7.

# Belbury

07

Hidden away in border country, the ancient market town of Belbury has much to recommend it. Although a highly unlikely target, the medieval town centre was badly damaged by an opportune air raid in 1940. The picturesque 11th century church of St.Oswalds however, survives intact, as does the quaint 18th century Market Hall. Of particular interest is the manor house of Belbury Hall with its reputedly haunted Baroque folly.

During the post war period much of Belbury was replanned with the addition of some notable modernist architecture including the Polytechnic College, Public Library and the striking Community Fellowship Church.

Legend surrounds the foreboding Iron Age ramparts of Belbury Hill, which dominate the rolling agricultural landscape around the town. Also of interest to the antiquarian is the nearby Neolithic stone circle, Thornwood Ring, located on the manor estate, but fully accessible to the general public all year round.

Some feel that Belbury is an uneasy mix of ancient and modern, but it is, nonetheless, a fascinating town to visit for the casual tourist and amateur historian alike.

15 /

048

Julian House & Jim Jupp /
Ghost Box

Graphic Designer /
Label Owners

London,
UK

16 / 17 / 18 / 19 /

A: The Focus Group
T: We are all
   Pan's People
F: CD
L: Ghost Box
D: Julian House
Y: 2007

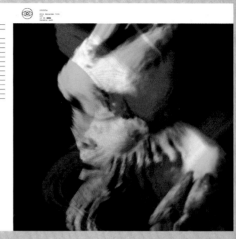

16 /

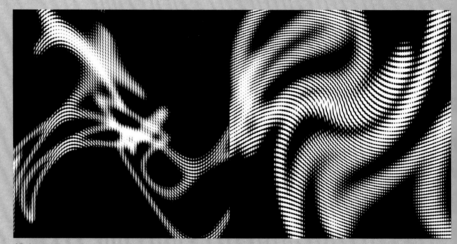

17 /

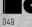

049

Julian House & Jim Jupp /
Ghost Box

Graphic Designer /
Label Owners

London,
UK

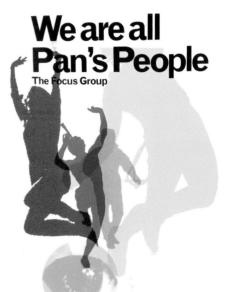

**Ghost Box**    08

# We are all Pan's People
### The Focus Group

△ 08

◎

' I do not know whether any human being has ever lifted that veil; but I do know,

Clarke, that you and I shall see it lifted this very night from before another's eyes. You may think this all strange nonsense; it may be strange, but it is true, and the ancients knew what lifting the veil means. They called it seeing the god Pan.' *

*Arthur Machen 'The Great God Pan'

01 Dancing Horse (Logotone)
02 LOOK HEAR NOW!
03 The New Activity
04 Salty Sun Tales
05 Elmford (Logotone)
06 Falling Leaf Beat
07 Backyard Rituals and Spare Times
08 Willowedge Vision (Logotone)
09 Albion Festival Report
10 Oakston Associated (Logotone)
11 Wake up! He's here
12 The Bohm Site
13 Hob's Rumble
14 The Harmony Programme
15 Pan Calling
16 Through the Green Lens

17 Sinistralle (Logotone)
18 HANG ALONG!
19 _____ (Logotone)
20 Soho > St.Ives > Tangier
21 The Other Birds
22 We are all Pan's People
23 Shining Stone (Logotone)
24 The Green Station Haunt
25 Leaving Through

Written and produced by The Focus Group
(C) & (P) 2007 Ghost Box
thefocusgroup@ghostbox.co.uk

18 //

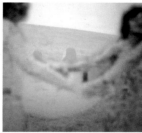

19 /

# Magnus Voll Mathiassen / Grandpeople

**Name:**
Magnus Voll Mathiassen

**Occupation:**
Graphic Designer

**Studio:**
Grandpeople

**Location:**
Bergen, Norway

**Website:**
www.grandpeople.org

**Biography:**
Magnus Voll Mathiassen,
Magnus Helgesen and
Christian Strand
Bergheim started using
the name Grandpeople
while studying at the
Bergen National Academy
of the Arts, Norway. In
2005, after graduation,
Grandpeople became a
full-time design studio.
Still located in Bergen,
the company works with
clients nationally and
internationally from
industries such as art,
advertising, music and
fashion. They are
featured regularly
in the design press.

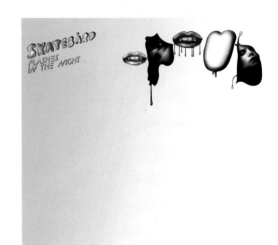

01 /

051

Magnus Voll Mathiassen /
Grandpeople

Graphic Designer

Bergen,
Norway

**Were record covers important to you when you were studying?**
Record covers have always been important to me, and, yes, even more important to me when I studied design, although the magic disappeared when I started to look at them with 'professional' eyes. That's the sad part. I remember, as a youngster when I was a hardcore ZZ Top fan – I must have been about seven years old – the artwork for the Afterburner and Eliminator covers was the coolest thing on earth. Record covers have always been very important to me, and they are important to me now in a way I dislike, compared with how I felt about them before.

**I know what you mean, it would be nice to enjoy sleeves as a fan again, rather than as a professional designer. Which designers inspired you in those early days?**
I have always been more interested in how creative people think and how they have become providers of distinctive visual and conceptual solutions rather than creative people who try to be the zeitgeist. By that, I mean people who don't follow the trends but have a very personal and special view of design – people whose personalities really burst through in their work. Julian House is that sort of designer. But what has been most important to me, though I haven't really followed it up, is sculpture and related disciplines. I think I've been too cowardly not to follow my desires. Graphic design is the 'easy solution' – you do quick projects, you get paid, you move on to the next one. On the other hand, these

interests are reflected to a certain extent in the music graphics we make. I have forced myself to like design (and that means I really like it), but designers I've got to know through record covers make such good work that I would have liked it anyway, whether I became a lumberjack or a designer. But before I studied design, the Norwegian artist, musician and graphic designer Kim Hiorthøy inspired me to do something other than get a regular office job. He has been a great inspiration for young people in Norway for many years now.

**Are the Norwegian labels you work for based in Oslo?**
Oslo and Bergen, mainly. In Bergen you've got a small healthy music community that works closely with other creative professions. Actually, I've just come from a meeting with a new small label that we will be working with. And as for the other labels I've got connections with, I tend to be interested in the whole process. I don't want to just make sleeve designs for them, I want to know what goes on in their heads. It ends up with me being a part of the labels. Hopefully I will get into this new label as well, but don't tell them I said that! We work with people who are nice and smart, and who appreciate what we give them, which of course makes us work just a little bit harder for them. Also, some years ago, with help from friends, I started a small label myself, releasing compilations with music made by friends. It was sort of a documentation project, trying to preserve what

my closest friends had been making. It ended up with records with music by friends of friends and selling merchandise and so on. For now, the label is on ice. It is a huge job dealing with the business side of things. All respect to people running labels.

**Do you work for any non-Norwegian labels?**
No, but it would be nice. We are interested in music and it widens our perspectives to work with people from various musical camps and traditions.

**What proportion of your work is music related?**
I would say probably 40%. We do a lot for music festivals, from small ones to mid-sized ones. The percentage varies from year to year. If we could, we'd probably enjoy just doing covers full-time.

**Tell me about the Norwegian design scene?**
Hmm, what to say? The scene is different from what it was a few years ago. To be honest, my experience is that it has been a little bit dull. I feel that in recent years something has happened and designers are feeling that they are making design of international quality. And there are many who are extremely talented, for example Martin Kvamme. We aren't exactly the people you should ask. We do our thing and we're very bad at following what is happening around us. We are situated in Bergen, a town full of advertising agencies plus a few design agencies. It's quiet here, nothing much happens and probably because of that we're a bit introverted.

**I wouldn't say that the Grandpeople style is introverted. How would you describe your style?**
Naïve, serious, colourful, psychedelic, minimalistic. I think it's everything in between. We are three people with various preferences and these different interests have been mixed together. This was probably easier to spot before, since we now make things that have a more homogenous, more consistent look. I may be wrong, but it feels like that. We are balanced between doing exactly what we want and exactly what the clients want. I think we possess a great diversity. It is all about the briefs we get. The general style might be very different in two years time. And hopefully that's what is going to happen.

**Grandpeople's style is highly distinctive. Does having a strong style sometimes discourage some labels from commissioning you?**
In some cases it can be an advantage. The label knows what they are getting, and you don't have to go through endless meetings. It doesn't necessarily mean that we do the same things over and over again, but they know how we can provide something that will be 'up their alley'. We do have labels we regularly work with who just hire us to do their 'special' releases. And that is a bit frustrating, since we do want to make things that are more 'streamlined' and 'correct'. We want to develop our formal typographical knowledge. I think we blend what you refer to as our 'distinctive style' with 'appropriateness' just to learn the best from both camps.

01 /
A: Skatebard
T: Flashes in
   the Night
F: 12" Vinyl
L: Kompakt Records
D: Grandpeople
Y: 2006

02 /
A: Alog
T: Catch That Totem!
F: Poster
D: Grandpeople
Y: 2005

**Do you have to like the music to design a good sleeve? Could you design a cover for music you didn't like?**
Yes, we've done design for records we haven't really enjoyed. We try to like them. But sometimes you have to admit for your own sake that all music isn't worth spending time on. That doesn't mean you aren't able to 'interpret' the content. It's like having a discussion where you really don't agree with the other person but you see their point of view. Musical empathy – can you call it that?

**I'd like to ask you about empathy. How do you accommodate the views of the musicians in your sleeve work?**
When we start on a record cover we are interested in four things: capturing the music, reflecting the musicians' interests and personalities, creating an autonomous look and creating 'a package'. The feel of all these parts becomes one product, a mood, you might say [terrible word isn't it?]. We tell this to the musicians and we ask them some personal questions. We might ask them some non-musical questions. We are interested in their preferences and why they have these preferences. Often we find common ground that we can work with aesthetically and conceptually. This makes the job easier and it leads to fewer compromises. A record for us isn't just about the music, but also the stories behind the music.

**How would you cope with a commercial project – a big star who wanted their picture on the front cover – would you turn down this sort of project or would you try and get something good out of it?**
Sounds like a good job. I would try to get the best out of it. But in the long run, working like that sounds quite boring. Yet all records with a typical 'face-on-the-cover' aren't bad. There are a lot of examples where this has been executed extremely well. And it works – a face on the cover is easy to spot in a store amongst experimental electronic acts with arty avant-garde abstract covers. All things that have been well executed will look like they have been well executed, whether it's a design for a Hungarian folk music band or for the latest Elton John album, though I don't know if a good Elton John album design exists...

**There were some quite good Elton John covers. I always liked his 80s covers. Now the question I'm asking everyone. What is your view on the download question?**
A total extinction of packaging? The human race is still a hunter and gatherer culture – always hunting for formats and collecting them. Record covers will probably be around for a while. Hard to tell. I've gone from MP3s to records again, but I haven't thrown my old records out like I dump MP3s into the computer's waste bin. ■●

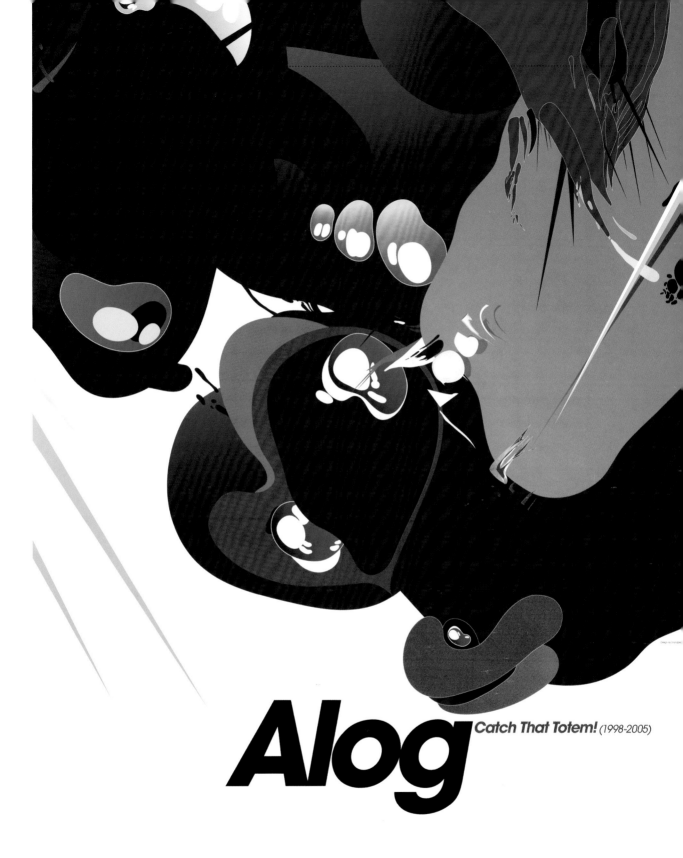

Alog *Catch That Totem!* (1998-2005)

Magnus Voll Mathiassen /    Graphic Designer                    Bergen,
Grandpeople                                                     Norway

03 / 04 / 07 /
A: Alog
T: Catch That Totem!
F: CD
L: Melektronikk
D: Grandpeople
Y: 2005

05 /
A: Alog
T: Islands of Memory
F: Sticker
D: Grandpeople
Y: 2006

06 /
A: Alog
T: Islands of Memory
F: CD
L: Creaked Records
D: Grandpeople
Y: 2006

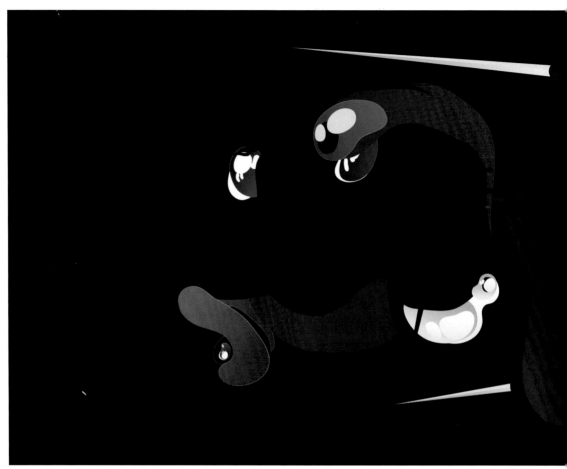

03 /

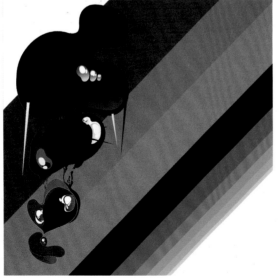

04 /

Magnus Voll Mathiassen /      Graphic Designer                                    Bergen,
Grandpeople                                                                        Norway

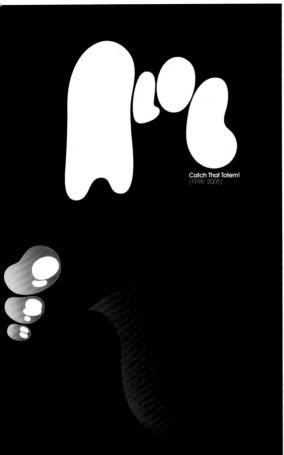

Catch That Totem!
(1998-2005)

05 /

06 /

07 /

056

Magnus Voll Mathiassen /
Grandpeople

Graphic Designer

Bergen,
Norway

08 / 09 / 10 / 11 /

A: Bergen
   Mandolinband
T: Brättne Skyline
F: CD
L: Bmb Records
D: Grandpeople
Y: 2005

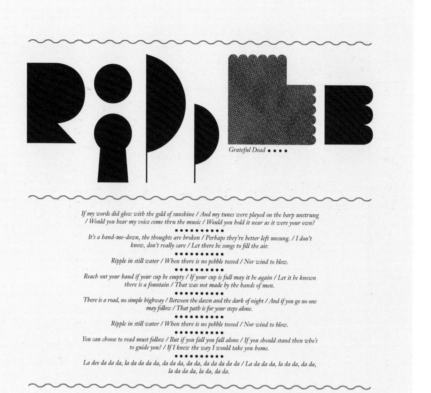

08 /

09 /

Magnus Voll Mathiassen /
Grandpeople

Graphic Designer

Bergen,
Norway

057

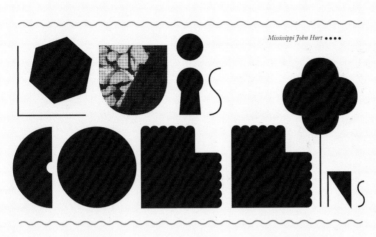

Mississippi John Hurt ●●●●

Mrs. Collins weeped, Mrs. Collins moaned, to see her son Louis leavin' home
The angels laid him away

The angels laid him away, they laid him six feet under the clay
The angels laid him away

Mrs. Collins weeped, Mrs. Collins moaned, to see her son Louis leavin' home
The angels laid him away

Oh, Bob shot once and Louis shot too, shot poor Collins, shot him through and through
The angels laid him away

Oh, kind friends, oh, ain't it hard?, to see poor Louis in a new graveyard
The angels laid him away

The angels laid him away, they laid him six feet under the clay
The angels laid him away

Oh, when they heard that Louis was dead all the people they dressed in red
The angels laid him away

The angels laid him away, they laid him six feet under the clay
The angels laid him away

Mrs. Collins weeped, Mrs. Collins moaned, to see her son Louis leavin' home
The angels laid him away

10 /

Gante ●●●●

Things are not meant to be easy, you said and ran away / I rather be dead than lonely, so there was no time to pray

But we are not here to lose / Who will your shotgun choose

We flew like the wind over a mossre, through a forest and a field / But a shot was heard from behind us and you dropped like a stone

But we are not here to lose / Who will your shotgun choose

But tell me friend / Is this the end? / Or is it a start / On something strange and apart?

Solo

The blood came streaming like tears, on my little badgerfriend / I'm just a mouse but sometimes, I wish I had been God

But we are not here to lose / Who will your shotgun choose?

My feet disappeard and my body, was lying on the ground / At the pain

screamed in my head, and my eyes they filled with blood

But we are not here to lose / Who will your shotgun choose?

But tell me friend / Is this the end? / Or is it a start / On something strange and apart?

Trad / Hobart Smith ●●●●●

Railroad Bill, so mean and so bad, he whipped his mammy shot a round his dad, one morning just before day

Early one morning a shower of rain, around the curve come a time- train, oh ride, ride, ride

Railroad Bill, he's standing on the hill, a rolling cigars out of ten dollar bills, oh ride, ride, ride

If the bum's going to bend the, there'll be nobody there to tell the tale, oh ride, ride, ride

Plata er spelt inn live i BmB studio med Anders Bustad bak spakane
Design av Grandpeople / www.grandpeople.org

11 /

12 / 13 / 14 / 15 /
A: Andreas Meland &
   Lasse Marhaug
T: Brakhage
F: CD
L: Melektronikk
D: Grandpeople
Y: 2005

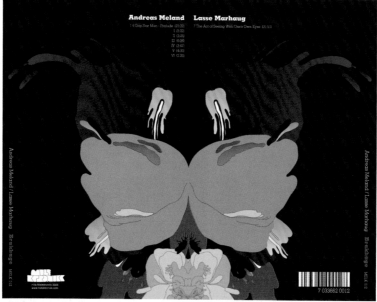

12 /

13 /

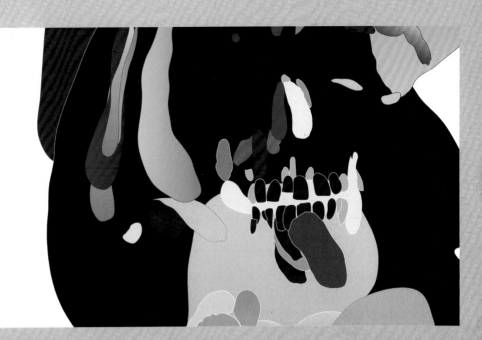

14 /

15 /

Magnus Voll Mathiassen /        Graphic Designer                                    Bergen,
Grandpeople                                                                         Norway

16 /
A: Arne Nordheim
T: Draumkvedet
F: CD
L: Simax Classics
D: Grandpeople
Y: 2006

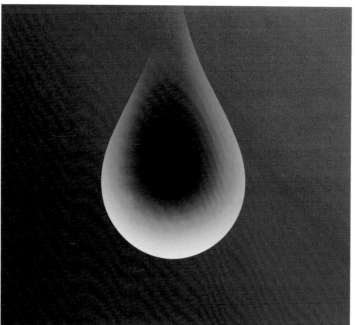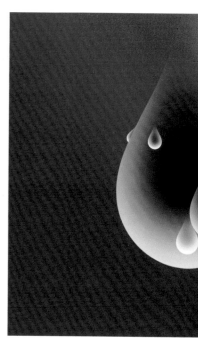

16 /

Magnus Voll Mathiassen /
Grandpeople

Graphic Designer

Bergen,
Norway

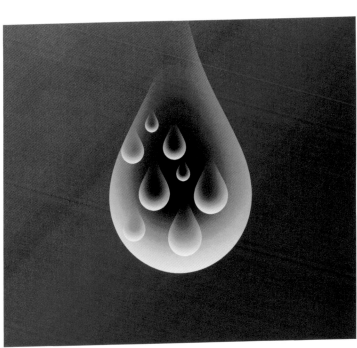

062

Klas Augustsson /
Häpna

Graphic Designer /
Label Owner

Stockholm,
Sweden

# Klas Augustsson / Häpna

**Name:**
Klas Augustsson

**Occupation:**
Graphic Designer and
Label Owner

**Label:**
Häpna

**Location:**
Stockholm, Sweden

**Website:**
www.hapna.com

**Biography:**
Klas Augustsson was
born in 1972, and has a
background in physics,
computer science and
philosophy. His interest
in the natural sciences
led him to research such
topics as interstellar
dust, social insects and
self-organizing systems.
After discussing music
for several years,
musician Johan Berthling
and Augustsson started
Häpna in 1999.

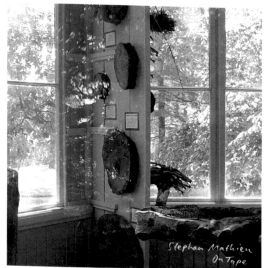

01 /

**You are both designer and label owner, how do you manage to combine both roles?**
When running a small company you have to try to manage everything that comes with it. When we started Häpna we didn't know all the details of the tasks involved. Designing covers was just one of many things that had to be done if the label was going to work. Neither of us had any experience of graphic design, but it ended up being me that took the main responsibility in this area.

**Do you design all Häpna's sleeves?**
Yes, but I always gather opinions from Johan and the artist involved.

**Can you describe Häpna's musical ethos?**
One of the central things is to stay out of musical genres, I think. Genres tend to streamline musical expression and make it less interesting, so we like the things that don't fit in elsewhere. This 'genre-lessness' is a common denominator in most of the music we find exciting and original. Sound-wise, many of our releases use diverse sound sources freely and mix field-recordings, electronic sounds and traditional instruments. The line between popular and experimental music is often blurred, with song-structures and more inaccessible parts existing side by side. This is nothing unique to our releases, but something we encourage nevertheless.

**I read that the name Häpna comes from a Swedish sci-fi magazine. Is this true?**
Yes – the sci-fi magazine Häpna! (printed in our home town of Jönköping) did pioneering work to spread sci-fi in Sweden during the 1950s and 1960s. It was in the era of Arthur C Clarke, Isaac Asimov and the like. The Häpna! magazine had similarities with some of the American magazines at this time, like Amazing Stories and Astounding (the Swedish word 'Häpna' means 'be astonished').

**How is this sci-fi connection reflected in the design?**
I don't think it's reflected in the design, but maybe – in a more general way – in the spirit of the label. As noted above, we don't want to be operating in a well-specified niche. We want to be unpredictable and open to change. So if someone is astounded by the new musical direction we have taken with a release, we may have succeeded in staying close to our original sci-fi/Häpna spirit.

**Many early Häpna covers were a sheet of folded card placed in a plastic sleeve. Now you use mainly digipaks. Why did you make the transition?**
We did our first 30 CDs in this way, with folded paper in a plastic sleeve. We wanted to do something outside of the industry standard. It was a nice packaging solution that worked very well for a long time, but as the label grew it became too time consuming to assemble every CD by hand. Orders were held up because we had to sit and fold the covers for half a day.

So now we mostly do digipaks. It was a switch we had to make sooner or later.

**Is there a Swedish aesthetic in your design work?**
Probably there is but it is not a conscious move. The design is kept clean and simple, often with motifs inspired by nature in one way or another; maybe this can be considered typically Swedish. But phenomena in nature and the science investigating them is my greatest interest, so what can I do?

**Yes, I can see this in your work. Describe the way a Häpna sleeve is designed.**
It's a little bit different each time. For some of the covers, the artist, Johan, or me, suggests a photo or graphics of some kind, often based on intuitive connections to the music. Then I do the handwriting and the final layout. Other covers, like the collages for the Tape CDs, involve a wider range of techniques like collecting objects from nature or illustrations from books to scan, taking photos, making drawings and arranging the parts into a satisfying whole. These covers take more time but are often more fun to make since they are investigations of themes and ideas that lie closer to my personal interests.

**I'm fascinated by your use of handwriting. Why do you use it so extensively?**
From the beginning, we wanted to have some common design elements in all our releases. We wanted Häpna to have some identity of its own and be something more than a colourless channel between the artist and the public. Handwriting in itself is very versatile: it can feel both homemade and down to earth as well as handmade and exclusive. It felt right for us and looked good with the kind of imagery we used.

**Which other labels do you admire?**
I'm not that up to date with current labels unfortunately, but when we started, we were inspired by experimental labels such as Table of the Elements, Touch/Ash International and Mego. They released music we liked and they had some kind of thought-out aesthetic profile. Looking back, the latter fact wasn't unimportant to us.

**I'm always struck by the enduring interest in record cover art, especially amongst young graphic designers. Do covers still matter in the age of the invisible download?**
As long as music is sold physically, the design and packaging will matter. An image-world brings something to the musical experience, and there is always the commercial factor and the way a congenial cover helps the music to find its audience. But if the physical object is marginalized, or disappears altogether, young designers may have to find other ways of expression than cover design, I'm afraid.

01 /
A: Stephan Mathieu
T: On Tape
F: CD
L: Häpna
D: Klas Augustsson
P: Klas Augustsson
Y: 2004

02 /
A: Tape
T: Rideau
F: CD
L: Häpna
D: Klas Augustsson
Y: 2005

03 / 04 /
A: 3/4 Had Been
   Eliminated
T: A Year of the Aural
   Gauge Operation
F: CD
L: Häpna
D: Klas Augustsson
P: Samuel Roy
Y: 2005

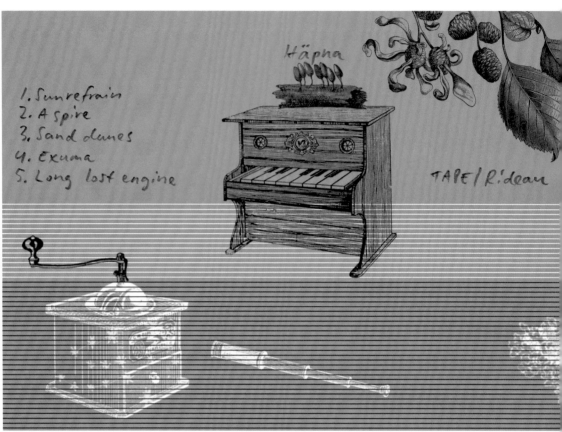

02 /

03 /

065

Klas Augustsson /
Häpna

Graphic Designer /
Label Owner

Stockholm,
Sweden

01 /

Tony Arrabito: drums, percussion
Stefano Pilia: electric guitar, double bass,
                acoustic instruments, field recordings
Claudio Rocchetti: turntables, electronics, objects
Valerio Tricoli: tape loops, synthesizer,
                acoustic instruments, vocals

Recorded, mixed and mastered in our flat
in Bologna 2004. Pilia, Rocchetti, Tricoli © SIAE.
www.shiftingposition.org

Photos by Samuel Roy.
CD design by Klas Augustsson.

H.26: © 2005 3/4 Had Been Eliminated, ℗+© 2005 Häpna,
All rights reserved.

04 /

Klas Augustsson /
Häpna

Graphic Designer /
Label Owner

Stockholm,
Sweden

05 /
A: Tape
T: Milieu
F: CD
L: Häpna
D: Klas Augustsson
P: AnnSofie Börjesson
Y: 2003

06 /
A: Patrik Torsson
T: Kolväteserenader
F: CD
L: Häpna
D: Klas Augustsson
Y: 2004

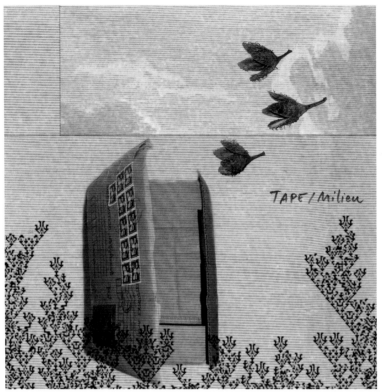

05 /

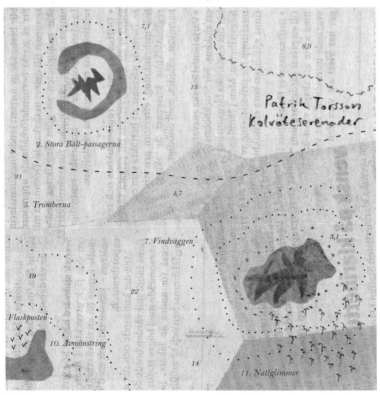

06 /

Klas Augustsson /
Häpna

Graphic Designer /
Label Owner

Stockholm,
Sweden

07 / 08 /
A: Tape
T: Opera
F: CD
L: Häpna
D: Klas Augustsson
Y: 2002

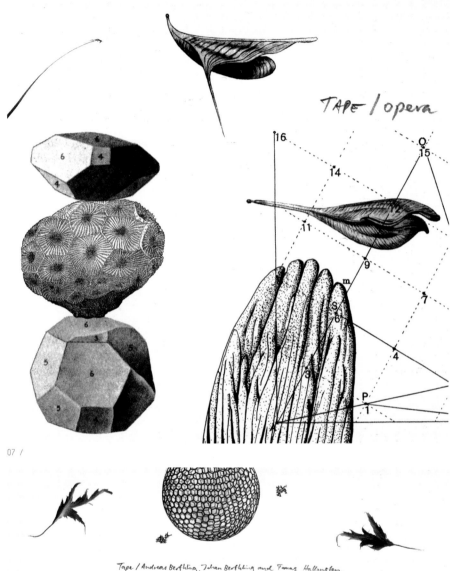

07 /

08 /

Klas Augustsson /
Häpna

Graphic Designer /
Label Owner

Stockholm,
Sweden

09 /
A: Patrik Torsson
T: Gästhamnar
F: CD (8cm)
L: Häpna
D: Klas Augustsson
I: Helge Mattsson
Y: 2004

10 /
T: Häpna Festival
F: Poster
D: Klas Augustsson
Y: 2005

11 /
T: Collage
F: Website
D: Klas Augustsson
Y: 2004

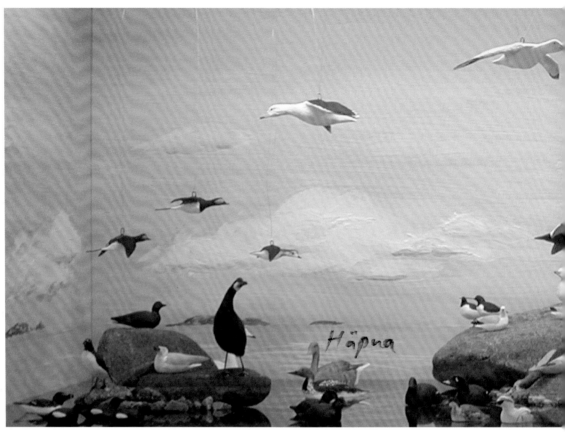

09 /

069

Klas Augustsson /
Häpna

Graphic Designer /
Label Owner

Stockholm,
Sweden

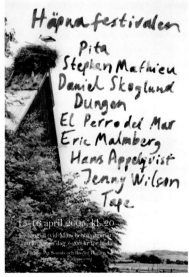

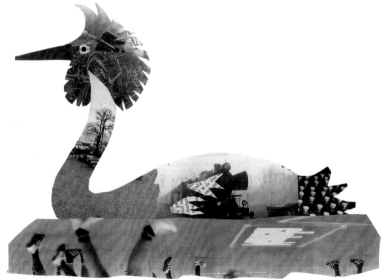

10 /

11 /

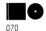

# James Goggin /
# Practise

**Name:**
James Goggin

**Occupation:**
Graphic Designer

**Studio:**
Practise

**Location:**
London, UK

**Website:**
www.practise.co.uk

**Biography:**
James Goggin set up
Practise, his design
studio, in 1999, after
completing an MA in
Graphic Design at
London's Royal College
of Art. Focusing
mainly on typography and
print-based projects,
such as books, posters,
typefaces, identities
and stationery, he also
works across various
media, creating anything
from exhibition design
and signage to short
films, title sequences
and websites. He runs
Practise alongside
his duties art directing
and designing the music
magazine The Wire.
Goggin's first sleeve
commission was for
Berlin-based musician
and artist Momus' 2005
album Otto Spooky.

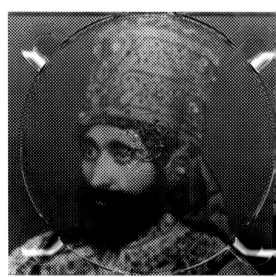

01 /

**You're not really known as a record sleeve designer, but I've always felt that your work is well suited to cover design. Is it an area that you want to do more work in?**

The reason I wanted to be a graphic designer in the first place stemmed from my teenage desire to design record covers. But a long-standing interest in contemporary art, books, posters, etc. tipped my work in that direction and my studio became busy with arts clients, leaving me with no time to chase record labels and bands. I seem to have more contacts within the art world than with musicians. I would love to design more sleeves, but I also worry that perhaps I've missed the boat: they seem to have less and less importance in two conflicting ways. Purchased downloads come with either bad quality reproductions or no cover at all, while falling CD sales give labels less of a financial incentive to commission intelligent or radical design and packaging, the reason one might actually want to own the CD object in the first place. There are of course many independent labels still doing interesting things with cover design so I haven't given up hope just yet.

**Your work as the art director of The Wire must give you a valuable insight into the radical music sector — is music one of your interests?**

Along with my wish to design record covers, my other teenage dream was to start a band. I played the drums and messed around making beats on cheap keyboards and computers, but the fact that my family moved country every two years when I was growing up made the band thing a bit difficult. Now with more than five years of working predominantly with arts clients, I was very happy to be asked to take over art direction of The Wire as I had been a regular reader for several years. It brought me back to the world of music in an unexpected way: not through record sleeves, but magazine design and art direction. It's worked out very well for me. I spend one week every month in their office, listening to and discovering lots of music both old and new, talking with musicians and photographers organizing shoots, designing the issue itself and reading all the articles and reviews in advance.

**Do you see a link between the work you do for arts organizations and design for music?**

So far, with the few music-related clients I've had, as with some of my arts projects, there has often been a similar lack of the usual commercial or marketing focus one has to expect with more corporate clients. My own design approach is always the same with music or culture: focus on the content and the project's intended function — leave ideas of preconceived consumer demographics out of the equation. With music there is more scope for image-making and commissioning — specifically with The Wire there's a fantastic chance to regularly commission photographers I admire. Conversely, with many arts projects the image is the content: photography is more documentation of art, the design co-exists with another visual layer: that of the artist. But then again, the level of constraint necessary in art is also one I apply to The Wire on certain levels. The magazine's strengths lie in its intelligent and in-depth writing, interesting subject matter and strong commissioned photography. There is a delicate balance that I feel needs to be struck in the design being striking and distinctive, but not disrupting the content with unnecessary decoration. The way I art direct and design The Wire is completely different to the way I might approach the design of a fashion or design magazine or even a different kind of music magazine. There's an awareness of its history and what the magazine means to its readers. In all my projects, the aesthetic is always very much determined by content and context.

**Can you talk about your work with Momus. Is it a plus having someone as design literate as him as a client?**

Both covers I've designed for Momus have been collaborative for this very reason, and enjoyably so. There are certain reference points we can both understand without questioning, ideas are bounced back and forth. Sketches sent to him often appear on his Livejournal weblog the next morning, so there's an element of the design being published earlier than one expects. Manifestations of our discussions and references can be seen on both Otto Spooky and Ocky Milk. I've designed them as a series: same typeface for spine and back cover, similar black backgrounds. Both albums have fluorescent CDs, something Momus talked about once. We appointed patron saints for each album, figures we had both referred to during the course of each album's production which appear half-toned in the CD tray. Architecture and pop culture theorist (and for us — cycling around London in the 1960s on his Moulton, with sandals and beard — style guru) Reyner Banham oversees Otto Spooky, while Emperor Haile Selassie I graces Ocky Milk, again possibly more for style reasons than political or philosophical. Ocky Milk's cover conflation of [Bruno] Munari and [Milton] Glaser was again a visual translation of several email conversations over time.

**Would you be interested in doing a commercial music project for an act signed to a major label?**

I'd love to. Friends who have worked on such projects invariably complain about over-zealous marketing and sales departments getting in the way, but a lot of my work is about dealing with such constraints and finding both diplomatic and devious ways around them. I am constantly surprised by how frequently one sees incompetently designed covers for major pop stars, for whom you'd expect a decent promotional budget for good production, design and photography. I'm sure it's not that simple, but there seems to be huge scope to do interesting work.

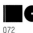
**Can you name some sleeve designers or labels that you admire?**
There are many, maybe I'll keep the names current. My 20th-century list could go on and on (post-punk band Wire's first three album covers, for example). I very much like the idea of a record label having both a strong musical and design aesthetic and right now my favourite is Häpna, a Swedish label with simple hand-written typography on all releases, wrapped in card with Tyvek mesh CD pockets (see page 62). The artwork matches their improvised tape and field recording aesthetic perfectly. I could also mention Frauke Stegmann's beautiful foilblocked-fauna-on-Manila for John Coxon's Treader label. Laurent Benner's mix of ethereal photocopied landscape photography (Frauke again, actually) and schnitzel-technik cut'n'paste clip art on his AM/PM and Secondo sleeves for their Dreck label. Kim Hiorthøy's Rune Grammofon poetic scrapbooks. Trevor Jackson's strong monotone compositions for Output. Occasional Stones Throw brilliance (Jaylib, Aloe Blacc etc). The muted covers of Chicago label Kranky. Ghostly International (I like the label's simple logo and geometric compilation cover compositions so much I bought slip mats for my studio turntable). The recent resurgence in small editions or series of 7" releases by the likes of Stereolab's Duophonic label and Berlin's Morr Music has yielded some fresh artwork in a tactile format. I'm happy to see that many labels and musicians are keeping the tradition of 7" and 12" vinyl alive.

**I think there's an emerging generation who don't give a fig for album covers — they are happy with downloading. Where do you stand on the MP3 question?**
I play MP3s all the time, but the loss of materiality is a great shame. I grew up with vinyl and CDs, even cassettes, and discovered many bands purely on the strength (or oddness) of their cover art. I have found myself recently buying both the MP3s (for instant grati-fication) and the vinyl (when I realize I like the cover) as I somehow don't feel like I 'own' the music unless I have a tangible version. With iTunes' Digital Rights Management-locked files, it's arguable whether people do actually fully own their MP3s anyway. I think it's terrible that iTunes provides such low-quality artwork with their files. I was disappointed that even Bleep.com, with some amazing TDR Warp covers among others, doesn't always get this right. Emusic doesn't even provide artwork at all with their MP3s. On the other hand, file sharing and downloading has led to me buying a lot more music than before, so personally invisible downloads ironically lead to bigger record collections.

**Have you seen anyone who is doing something interesting in the way of providing visual material to accompany downloaded music?**
I bought the last Yo La Tengo album on MP3 (instant gratification again — I was about to catch a plane and wanted to hear the new album), and noticed it came with an 'Interactive Booklet' consisting of extra photography, links to printable PDF posters on Matador's website and full production credits. In itself it was poorly put together and took some messing around in iTunes to make it work. But I really think labels and companies like Apple should do more of this: include print-quality PDFs or JPEGs with digital releases, additional material, videos etc. I lament the death of well-written sleeve notes. You still get the odd band who values this: St. Etienne commissions writers like Douglas Coupland or Simon Reynolds to write essays for their albums, or labels like Honest Jon's with its great London Is The Place For Me series with fully researched notes and photography. But the days of lying on the floor, poring over a record's back cover notes while it plays on the stereo seem largely to be over. ◼●

01 /
A: Momus
T: Ocky Milk
F: CD
L: Analog Baroque
    Records
D: James Goggin,
    design assistance
    Julie Kim
P: James Goggin
Y: 2006

02 / 03 /
A: Momus
T: Otto Spooky
F: CD
L: Analog Baroque
    Records
D: James Goggin,
    design assistance
    Julia Gorostidi
Y: 2005

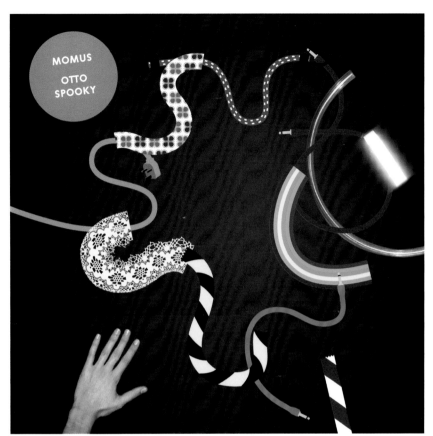

02 /

03 /

04 /
A: Various
T: Critical Notice
F: CD-book
L: Unknown Public/
   Bmic
D: James Goggin,
   design assistance
   Johanna Kallin
Y: 2006

05 /
A: Various
T: The Wire Tapper 15
F: CD
L: Wire
D: James Goggin
Y: 2006

06 /
A: Various
T: The Wire Tapper 16
F: CD
L: Wire
D: James Goggin
Y: 2006

07 /
A: Momus
T: Ocky Milk
F: CD
L: Analog Baroque
   Records
D: James Goggin,
   design assistance
   Julie Kim
P: James Goggin
Y: 2006

08 /
A: Various
T: The Wire Tapper 17
F: CD
L: Wire
D: James Goggin
I: Samuel Nyholm/
   Reala
Y: 2006

| Track | Time | Performer *Title* | Composer |
| --- | --- | --- | --- |
| 01 | 05:58 | **Apartment House** *Wallis* | Richard Ayres |
| 02 | 02:35 | **Stephen Gutman** *Mostly Bach* | Andrew Toovey |
| 03 | 04:18 | **Czardas Duo** *...into a several world* (extract) | John Webb |
| 04 | 05:39 | **Three Strange Angels** *Angelus* | Richard Baker |
| 05 | 14:33 | **CHROMA** *Ardent* | Graham Fitkin |
| 06 | 07:25 | **Catherine Beynon** *Regenstimmen* | Martyn Harry |
| 07 | 02:04 | **Stephen Gutman** *Magenta Cuts* part iv | Luke Stoneham |
| 08 | 02:42 | **New Music Players** *Light Cuts Through Dark Skies* part iii | Ed Hughes |
| 09 | 07:02 | **Evelyn Ficarra** *Isle Remix* | Evelyn Ficarra |
| 10 | 13:09 | **Ensemble Exposé** *Visions of a Floating World* | Joe Cutler |
| 11 | 10:17 | **Apartment House** *Riis* | Laurence Crane |

# Critical
# Notice »»»»»»

New work by British composers /
CD-book compiled by Unknown Public for Bmic

04 /

**The Wire
Tapper 15**

**The Wire
Tapper 16**

05 /                              06 /

07 /

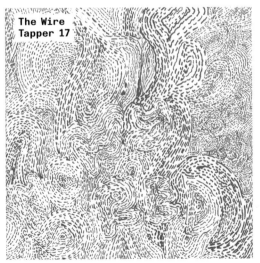

08 /

076

Jan Kruse /
Human Empire

Graphic Designer

Hamburg,
Germany

# Jan Kruse /
# Human Empire

**Name:**
Jan Kruse

**Occupation:**
Graphic Designer

**Studio:**
Human Empire

**Location:**
Hamburg, Germany

**Website:**
www.humanempire.com

**Biography:**
After gaining a degree
in Visual Communication
at the University of
Kassel (Germany), Jan
Kruse began working in
various design studios
and as a freelancer.
In 2000 he founded the
design studio 08design
in Hanover. In 2003 he
moved to Hamburg and
founded Human Empire
with Malte Kaune. In
2006 they moved to an
old store in Hamburg
and opened the Human
Empire Shop, running it
in conjunction with the
Human Empire studio.

01 /

Jan Kruse /
Human Empire

Graphic Designer

Hamburg,
Germany

077

**Can you talk about your relationship with Morr Music?**
Thomas Morr and I have known each other since our school days and have been best friends ever since. Today the Morr Music office is in Berlin and the Human Empire studio and store is located here in Hamburg. But we all still work closely together.

**Some of the best cover art is done when a designer and a label enter a long-term relationship. Would you say that your design has benefited from your relationship with Morr?**
Totally. As a graphic designer (and in other professions too) you need someone who supports you and gives you the chance to improve your skills. As a young designer, without a big portfolio, it can be a problem trying to find a client that you can develop a relationship with. But after you've worked with a label and gained some confidence, it becomes easier to try out new ideas and realize them.

**Does your relationship with Morr limit you in any way? Are there other labels who might shy away from using you because they think your style is too closely associated with Morr?**
This might sometimes be a problem. I realized this a few weeks ago when I did a cover artwork for a friend. He told me that he was questioned about my work being too closely associated with Morr. But, in fact, I get a lot of new contacts through the Morr Music connection so it can't be too much of an obstacle.

**Is it a good idea for a label to have a strong 'look'?**
I wouldn't recommend it to every label. In our case it has worked, but there are a few things that do need to be considered. For example, before we start the design we ask the musicians to give us their ideas (if they have any). We try to be flexible and undictatorial with our ideas. Generally we think it helps to give a label or company a 'face'. Morr works with many friends and we see it as a kind of family. We like it if people can identify with the music and also with the appearance of the label. This doesn't mean we like conformity, but in a family you also have similarities between the relatives. On the other hand, every band and musician wants to keep their own character.

**Tell me about your studio, Human Empire.**
We are a small studio. Three friends working in different fields of graphic design and illustration. Malte and I are designers/illustrators and Wiebke cares for the shop and lots of other things.

**I notice more and more (no pun intended) designers are doing entrepreneurial things like opening shops and selling their work online. Is your shop successful?**
It depends on how you define successful. We are really happy with it because it has turned out much better than we expected. Of course, it can't be compared to big labels and online shops. But that's how we like to work.

**Can you describe the process you go through when designing a typical record sleeve?**
At the start I ask the musicians if they have any preferred photos, styles, typefaces, ideas etc. that they'd like to have included in their cover artwork. Sometimes I get the freedom to start work with almost no input. As a next step I work out the details and send them a version by email. Sometimes it needs only a few steps, on other occasions the process can last weeks, with lots of emails, before the artwork is finished. Morr Music doesn't try to exert too much influence, which of course makes it much easier. The more people who try to influence the design the longer it takes and the more complicated the process becomes.

**You make strong use of illustration in your work. What do you think a cover with an illustration says about the music? Don't people want to see a picture of the person who is making the music?**
I use illustrations and graphics instead of photos of the artists for several reasons. When we started in the late 1990s, the reason for not using band photos was that traditional cover art with a band shot seemed boring. Like many other labels from the independent scene we preferred to use graphics, illustrations or just typography for our covers. Also we often had no time and no budget for photo shoots. Another reason is that we like a simple and bold style and often 4-colour photo covers look very uncharismatic and arbitrary.

**I see interesting undercurrents in your work – American cartoons, 1950s kitsch – what are your influences?**
At university I was influenced and impressed by the reduced Swiss/International style. I still love bold, simple graphics. But I think people buying an 'emotional product' like music also expect some emotion in the cover art. I found warmth and authenticity, for example, in posters, books and other graphic works from the period 1950 to 1980, especially poster artworks from the Swiss Basel school and Zurich school between 1950 and 1965. This work influenced me a lot. Of course there are other influences: Japanese character design, retro designs, kitsch from all periods and typography from all centuries.

**Do you see covers being around in the next 5–10 years? Surely we'll all be downloading music digitally and have no need for expensive cover art?**
I don't hold out much hope that there will be a need for good cover graphics in 10 years time. That's one reason why we are running our shop. People will always need clothes and things like pictures and posters for their homes to make them feel good. Of course, music will also be sold, but I am not sure if labels will still be distributing it on LP or CD. ■●

01 /
A: Electric President
T: You Have the
   Right to Remain
   Awesome: Vol.1
F: 7" Vinyl
L: Morr Music
D: Human Empire
Y: 2006

02 / 03 /
A: Isan
T: Trois Gymnopedies
F: 7" Vinyl
L: Morr Music
D: Human Empire
Y: 2006

04 /
A: Benni Hemm Hemm
T: Beginning End
F: 7" Vinyl
L: Morr Music
D: Audur
   Jorundsdottir
   & Human Empire
Y: 2006

05 /
A: The Year Of
T: Slow Days
F: LP
L: Morr Music
D: Human Empire
Y: 2006

02 /

03 /

04 /

079

Jan Kruse /
Human Empire

Graphic Designer

Hamburg,
Germany

Jan Kruse /
Human Empire

Graphic Designer

Hamburg,
Germany

080

06 /
A: Morr Music promo
   sleeve Vol.1
T: Morr Music
F: CD
L: Morr Music
D: Human Empire
Y: 2006

07 /
A: Morr Music promo
   sleeve Vol.2
T: Morr music
F: CD
L: Morr Music
D: Human Empire
Y: 2006

08 /
A: Benjamin Gibbard &
   Andrew Kenny
T: Home EP
F: LP
L: Morr Music
D: Human Empire
Y: 2005

09 /
A: Isan
T: Plans Drawn in
   Pencil
F: LP
L: Morr Music
D: Human Empire
Y: 2006

06 /

07 /

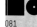

081

Jan Kruse /
Human Empire

Graphic Designer

Hamburg,
Germany

08 /

09 /

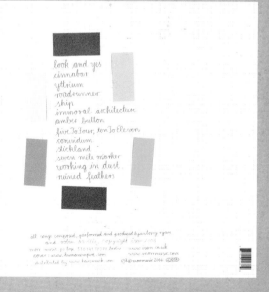

10 / 11 /
A: Guther
T: Sundet
F: LP
L: Morr Music
D: Human Empire
P: Trine Skraastad
Y: 2006

12 / 14 /
A: Populous
T: Breathes the Best
F: 7" Vinyl
L: Morr Music
D: Human Empire
Y: 2006

13 /
A: Couch
T: Figur 5
F: LP
L: Morr Music
D: Human Empire
Y: 2006

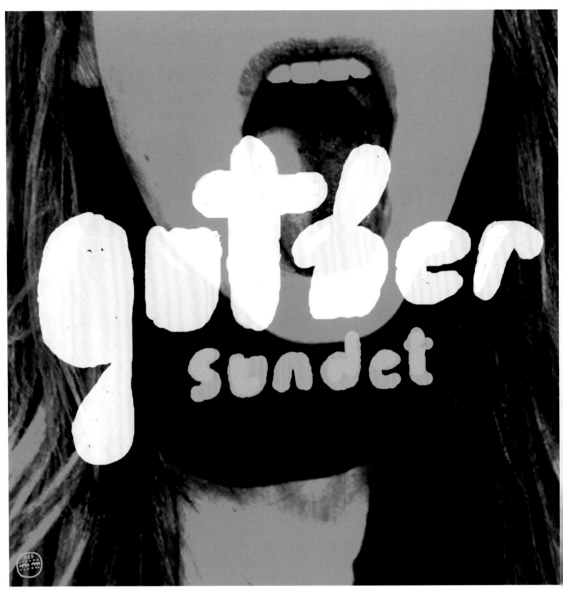

10 /

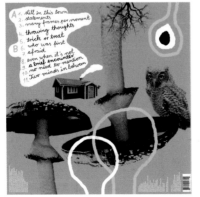

11 /

Jan Kruse /
Human Empire

Graphic Designer

Hamburg,
Germany

12 /

13 /

14 /

# Jason Kedgley /
# Tomato

**Name:**
Jason Kedgley

**Occupation:**
Graphic Designer

**Studio:**
Tomato

**Location:**
London, UK

**Website:**
www.tomato.co.uk

**Biography:**
Jason Kedgley was born
in London ('In the
same hospital as my
eldest son,' he states
proudly). He grew
up in St. Albans,
Hertfordshire, to the
north of London. He
did an MA at Central
Saint Martins College
of Art & Design, where
his external tutor was
Tomato founding member
John Warwicker. In
1994, Kedgley assisted
Warwicker on a project
and has remained at
Tomato ever since. As
a member of the Tomato
collective, Kedgley
has worked on numerous
moving-image projects,
including the influential
Trainspotting title
sequence (working with
Dylan Kendle). He has
worked extensively on
Tomato's books, and has
recently been asked,
along with Warwicker,
to design a new magazine
for The Economist.

01 /

**Your relationship with Underworld is unique. Karl and Rick are members of Tomato, so presumably this creates a very happy working relationship. But are there any drawbacks?**
Karl and Rick were part of the original Tomato crew back in 1991 and still remain involved. For me, the only drawback that springs to mind is that you have to work twice as hard because they are friends. There's no easy way out, or they'll tell you. The work needs to be strong. And I think it always has been.

**You seem to be the main Underworld designer, but other Tomato members get involved. How is it decided who gets involved?**
Same process as most projects within Tomato: schedule availability and passion. Looking back at the artwork it was often a case of many hands. For example Karl and I chopped up his drawings and reformed them into huge blueprints, then Dylan [Kendle] designed the typography on the final sleeves. Each release seemed to naturally select its own crew.

**How does the design process work typically? Do you begin by listening to the music?**
Always. The boys have always thrown down sounds and ideas. Sometimes we spend an afternoon at their studio catching up. Then when they get focused on a vibe they send it through for us to listen to. It's always different from the final outcome but it ignites the flame.

**Underworld sleeves are very abstract. It's hard to persuade labels to move away from artist pictures and big type these days — how do you avoid this with Underworld?**
That's the last thing the boys would want. And it wouldn't do them any favours anyway. Both Rick and Karl and all the other people involved at the labels have always been into being surprised at the artwork ideas. I'm not saying that they always liked what we did, but they were open to us making interesting work.

**There's no attempt to create an Underworld 'brand identity' — something that is very common in sleeve design currently. Can you talk about the diversity of Underworld sleeves?**
Branded bands...kinda goes against being a musician/producer/artist, for me. The last thing you would want is the awful logo that you had last time on every piece of music or art that you make. With Underworld it's always been about making something new.

**You are well known for your film and moving-image work. Have there been instances when you have been able to merge the print graphics you do with Underworld into videos and concert projections?**
Most of the print I've made has been reworked into moving pieces for use at Underworld shows. It was just an extension of the print for me. Underworld shows are seamless, two or three hours non-stop, so to VJ at their shows was a major buzz for me. They have no tracklist, they just jam it, so it was even more interesting

throwing things into the mix visually, and hoping that images on the monitor that Rick and Karl could see would influence what they played. It became a two-way thing.

**I read an interview with former Underworld member Darren Emerson and he said that part of Underworld's appeal in Japan is the popularity of Tomato. Does this make you an equal partner in the designer/musician relationship?**
He's being very kind. But he's right! Tomato is very popular in certain Japanese circles and that has made it even more important for me to produce exciting graphics work, both still and motion. Our relationships have always been open and fraught with passion and desire, always forming unexpected results. As for equal partners, I doubt very much whether the boys would listen to my musical ideas...and they'd be right not to.

**How can a band like Underworld deal with the digital future? Do you see a time when all their music will be download only?**
Actually, Underworld have been at the forefront of this approach for a while. They have a site where they make music, stream it and sell it. They also do live radio shows and gigs that allow them to reach their audience, which is spread far and wide. They still release limited vinyl and CDs to producers and people they like. Personally I think there will always be a need for a piece of plastic or a CD in a DJ's hands...but I'm getting old. ■●

Jason Kedgley /
Tomato

Graphic Designer

London,
UK

01 /
A: Underworld
T: Beaucoup Fish
   (Sampler)
F: CD
L: Junior Boy's Own
D: Tomato
Y: 1998

02 /
A: Underworld
T: Push Upstairs
   (Radio Edit)
F: CD
L: Junior Boy's Own
D: Tomato
Y: 1998

03 /
A: Underworld
T: Beaucoup Fish
F: CD
L: Junior Boy's Own
D: Tomato
Y: 1998

04 /
A: Underworld
T: Push Upstairs
F: CD
L: Junior Boy's Own
D: Tomato
Y: 1998

02 /

03 /

04 /

05 /
A: Underworld
T: King of Snake
F: CD
L: Junior Boy's Own
D: Tomato
Y: 1999

06 /
A: Underworld
T: Push Upstairs
F: CD
L: Junior Boy's Own
D: Tomato
Y: 1998

07 /
A: Underworld
T: Bruce Lee
F: CD
L: Junior Boy's Own
D: Tomato
Y: 1999

08 /
A: Underworld
T: Jumbo
F: CD
L: Junior Boy's Own
D: Tomato
Y: 1999

09 /
A: Underworld
T: King of Snake
F: CD, Maxi-Single
L: Junior Boy's Own
D: Tomato
Y: 1999

10 /
A: Underworld
T: Jumbo
F: CD
L: Junior Boy's Own
D: Tomato
Y: 1999

05 /
06 /

07 /
08 /

09 /
10 /

11 / 12
A: Underworld
T: 1992-2002
F: 12" Vinyl Box Set
L: Junior Boy's Own
D: Tomato
Y: 2003

Jason Kedgley /
Tomato

Graphic Designer

London,
UK

12 /

Jason Kedgley /          Graphic Designer                                    London,
Tomato                                                                      UK
..........................................................................................................................

13 / 14 / 15 / 16 /
A: Underworld
T: 1992-2002
F: 12" Vinyl
L: Junior Boy's Own
D: Tomato
Y: 2003

13 /

14 /

Jason Kedgley /
Tomato

Graphic Designer

London,
UK

15 /

16 /

17 /
A: Underworld
T: Vanilla Monkey
F: 12" Vinyl
L: Smith Hyde
   Productions
D: Tomato
Y: 2006

18 /
A: Underworld
T: Jal to Tokyo
F: 12" Vinyl
L: Smith Hyde
   Productions
D: Tomato
Y: 2006

19 /
A: Underworld
T: Peggy Sussed
F: 12" Vinyl
L: Smith Hyde
   Productions
D: Tomato
Y: 2006

20 /
A: Underworld
T: Play Pig
   (Pig and Dan
   Re-Mixes)
F: 12" Vinyl
L: Smith Hyde
   Productions
D: Tomato
Y: 2006

21 /
A: Underworld
T: Play Pig
F: 12" Vinyl
L: Smith Hyde
   Productions
D: Tomato
Y: 2006

17 /

18 /

19 /

20 /

21 /

Jeff Jank /
Stones Throw Records

Art Director

Los Angeles,
USA

094

# Jeff Jank / Stones Throw Records

**Name:**
Jeff Jank

**Occupation:**
Art Director

**Label:**
Stones Throw Records

**Location:**
Los Angeles, USA

**Website:**
www.stonesthrow.com

**Biography:**
Jeff Jank comes from
Berkeley, California.
He currently lives in
Los Angeles and works
with Stones Throw
Records. Jank is a
self-taught graphic
designer. He started
work at Stones Throw
in 1991. His first task
was to design demo
tape covers for the
rap group Charizma and
Peanut Butter Wolf. As
he explains: 'They were
hand drawn, printed on a
Kodak 1575 copier, and
assembled at a Taco Bell
over two consecutive
afternoons.' Jeff Jank
is not his real name.
'The story about my
name is long and super
boring,' he notes, 'so
I'll just lie and say
it's the name the CIA
has given me to protect my
real identity.'

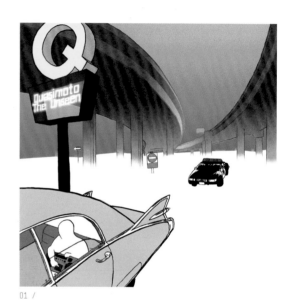

01 /

095

Jeff Jank /
Stones Throw Records

Art Director

Los Angeles,
USA

**You're self-taught.
How did you learn
your craft?**
It was a long process
that started with
functional projects
like demo tape covers
and putting together
photocopied fanzines.
I did this for years
and somehow developed
an interest in typogra-
phy, but I never thought
of it as 'design' until
I was beginning to work
professionally. When I
got my first assignment
to design and lay out a
record cover it was the
kind of thing I'd been
doing for years, but I
hadn't any knowledge of
printing and didn't know
the difference between
a Mac and PC. In short,
I learned the craft
through a combination
of fun, frustration and
embarrassing mistakes.

**Your covers seem to
avoid the usual hip-hop
clichés.**
When I started doing
covers, hip-hop had
become big business
with the kind of tried
and true methods that
produces a lot of copy-
cats and less freedom of
experimentation. In the
1990s, gangsta rap had
become the popular cliché
of hip-hop, but this
culture simply didn't
ring true for many fans
and musicians. A lot of
the independent hip-hop
music was beginning
to react against this,
but on the design front
things seemed boring.
Stones Throw began at
this time. What Peanut
Butter Wolf was doing
with his album My Vinyl
Weighs A Ton and Madlib
with his Quasimoto and
Lootpack albums in the
earlier days of Stones
Throw did a lot to fill
in the cultural void I
felt in rap as a fan.
With that as my setting,
designing with the usual
hip-hop clichés was
never a consideration.

**Can you describe your
role at Stones Throw?
Are you free to work for
other labels?**
The label was just one
person before our label
manager and I joined
at the same time. I'd
done a couple of covers
already, but my role
didn't start until a
casual conversation
that went, 'maybe you
can do it full time...
make covers, or what-
ever'. Not having a job
description has caused
a few problems as the
company has grown, but
I was presented with
the unique opportunity
of designing for music
that I'd watched evolve
(in some cases by people
that were sleeping on
my couch), or going and
teaching myself web
design when we had a
need for a website, or
working in the studio
on rare occasions, or
leading the company
into its first digital
sales because I was the
only guy with an iPod...
things like that. In my
current situation I'm
free to work with other
labels and there are
many artists I'd love to
work with, but the vast
majority of my work is
with Stones Throw, 5 to
7 days a week.

**Can you describe a
typical sleeve design
process? Do you always
have conscious objec-
tives in mind?**
It's a different process
each time for me, even
if the end product might
look the same as another
one. I don't have a
house style, so it
starts with the music,
then a thought about
the format — like will
it be a CD release or a
more underground vinyl
thing? Whoever has an
idea or an agenda chimes
in, but when it comes
to my own ideas I want
to do something for the
music rather than impose

myself all over the
cover. Madlib is usually
hands off, and most of
my covers are for his
projects. Sometimes the
artists have specific
ideas, sometimes the
exec producer does. If
I'm using a photo, maybe
the photographer does —
B+ and Eric Coleman
have shot a number of
Stones Throw artists and
they're just as attuned
to our artists and what
we do as a label. If
it's a project where
I'm doing my own thing,
I like to work on one
idea until it works; if
I'm working to please
someone or a group, it's
more a case of having
to come up with several
ideas and present them.
Other designers I talk
to seem to think I'm
fortunate not to have to
deal with that system
on a regular basis, but
a few times I've found
that it really helps the
work in the end. Most
of all, when I like a
record, I really just
like to do something
I'm proud to look at
and listen to after
it's been pressed. And
there's all kinds of
uninteresting things
to consider — what a
CD will look like on
a shelf among 5,000
others, whether or not
there will be a retail
sticker, is it going to
print the same way in
the US and Australia?
Another concern is what
it looks like as a 150-
pixel JPEG? Something
that would probably seem
insulting to the cover
designers of the past.

**Do you find it easy to
accommodate the wishes
of musicians?**
This seems to be
dictated by the type of
label. With Stones Throw
it's usually a situation
where the musician is a
partner who we assume
has certain wishes for
the artwork. But most

musicians have an easy
attitude that ultimately
says, 'I do music, you
do your thing' — they
just want something
that's going to impress
their crew and look
cool, not embarrass them.

**Are there any other
influences that people
might not pick up
immediately from
your work?**
I steal liberally. If
people can't pick up on
the sources, I don't
want to ruin it. I'm
also a big lover of many
painters, photographers,
typographers, design-
ers, film-makers and so
on, but what influence
there may be is usually
unconscious.

**Your passion for drawing
is reflected in your
design work. Would you
rather be called an
illustrator? Why do you
think illustration has
become fashionable?**
Calling me an
illustrator would not
be accurate, although I
have been drawing all my
life. Even with homemade
comic books or some-
thing else I might do
involving illustration,
I don't consider it
illustrating exactly —
I like the story, the
art, the publishing to
be all together. Either
way, I don't think
I could take the
competition — there
are so many fantastic
illustrators out there!
I could guess that
illustration has
become more popular
again because it's
the antithesis of the
widespread design that
is conceived and executed
on the computer screen.

096

Jeff Jank /
Stones Throw Records

Art Director

Los Angeles,
USA

**How do you envisage album artwork in the future. Will it be replaced by wallpapers, ringtones and video clips?**
It's already been replaced, for the most part. The culture of the album cover was made in the days of vinyl. Videos didn't replace album covers in the 1980s, but CDs sure changed them. I've seen a bunch of great album covers in the past 10 to 15 years, but these are usually CD packages – more than just a front and back cover. In regards to the digital revolution, when I was designing my second or third 'digital-only cover' it struck me how much this job has changed in just the few years I've been doing it. Album artwork can't be replaced literally by wallpaper, ringtones, etc. – those are different, intangible things – but the method of putting an image or a package to music changes entirely. I can sound pessimistic about this, saying that the era that elevated the album cover to art has ended, but I don't completely feel that way. It reminds me of the way the film industry changed with the advent of TV, or the belief that movie theatres would eventually close down after VCR and DVD. People love to go out and see a film together. At the same time, music fans like the feeling of a record, a physical and cultural icon in their hands.

**Can you name some sleeve designers or labels that you particularly like?**
Too many! I remember staring for hours at the inner sleeves of Fleetwood Mac's Tusk as a kid. The photomontages by Peter Beard. When I met him years later I mentioned that record and he proceeded to wax poetic about working with them – not about the art, but all the cocaine in Malibu in the late 1970s. Beatles covers have gotten more than their due, but Revolver has always been one of my favourites. The crazy hair drawing and cut-out photos... most of all I liked the artist Klaus Voorman putting his own name and picture between a couple of strands of George Harrison's hair. Being the type of kid who read credits, I'd see his name playing bass on later Beatles albums and wonder how the guy got around.

**Revolver is emerging as a very influential album cover.**
Later on I played bass on Madlib's album for Blue Note, and I also did the cover. While going over label copy, the editor became really surprised and said there were no designers in Blue Note's history to play on an album. Reid Miles and Francis Wolff's covers for Blue Note albums go without mentioning, and Peter Saville's for Factory and New Order. I find myself loving artists who do their own covers, especially the ones that don't look too professional – MF Doom did his own cover for Black Bastards, which got him kicked off Elektra. Morrissey did those consistent Smiths joints. Edan is a newer hip-hop artist who has done covers for himself using finger paints and press-on letters. And my favorite of all time, Schoolly D's illustration for his debut EP. It's a drawing that he probably couldn't sell as an artist but it makes the perfect album cover. Recent personal favourites are DJ Shadow's Private Press by Keith Tamashiro and Broadcast's Haha Sound by that guy whose name I can never remember even though I'm constantly talking about that album and its cover.

**It's by Julian House, his label Ghost Box is also featured in these pages. I worked with him at Intro.**
Julian House at Intro, it all makes sense now. I remember that he'd been involved in the Sampler books. I also love the record cover he did for Primal Scream with the wild colours and half-tones as well as the other Broadcast records, but Haha Sound is extra special, plus I love the album. I didn't know about Ghost Box. There are a million records I love with anonymous cover illustrations and sub-par printing... and a million classic headshot covers done by good photographers with designers who didn't get in the way. You can't beat the simplicity of just using the face of the person who made the music.

**Do you still do any non-music work now? You used to self-publish magazines and comic strips...**
I had a very flexible job at a library which allowed me to do all that stuff. It's always been music related, although indirectly at times. Right now I'm busy with my work at Stones Throw.

**What advice would you give to young aspiring album cover designers who plan on striking out on their own?**
I do meet a few and see work from people who want to work for record labels, magazines or something similar. I tell them to look for a company that has bad art and to be the one to make it better.

Jeff Jank /
Stones Throw Records

Art Director

Los Angeles,
USA

097

01 /
A: Quasimoto
T: The Unseen
F: CD
L: Stones Throw
   Records
D: Jeff Jank
Y: 2005

02 /
A: Stark Reality
T: 1969
F: LP
L: Now Again
D: Jeff Jank
Y: 2003

03 /
A: Stark Reality
T: Shooting Stars
F: 7" Vinyl
L: Stones Throw
   Records
D: Jeff Jank
Y: 2002

04 /
A: Stark Reality
T: NOW
F: CD
L: Stones Throw
   Records
D: Jeff Jank
Y: 2003

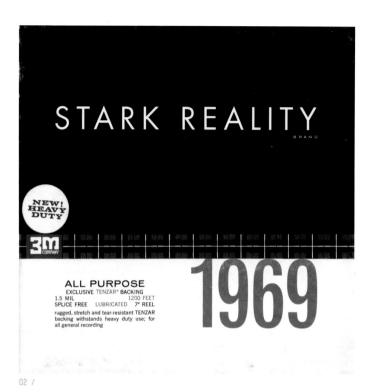

02 /

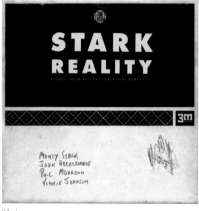

03 /

04 /

■◖ ●

098

Jeff Jank /
Stones Throw Records

Art Director

Los Angeles,
USA

05 /
A: Quasimoto
T: The Further
   Adventures of
   Lord Quas
F: CD
L: Stones Throw
   Records
D: Jeff Jank
Y: 2005

06 /
A: Quasimoto
T: Bully's H!t
F: 7" Vinyl
L: Lord Enamel's Wax
D: Jeff Jank
Y: 2005

07 /
A: Quasimoto
T: Bus Ride
F: 12" Vinyl
L: Lord Enamel's Wax
D: Jeff Jank
Y: 2005

08 /
A: Quasimoto
T: Fatbacks
F: EP
L: Stones Throw
   Records
D: Jeff Jank
Y: 2005

09 /
A: Koushik
T: One in a Day
F: EP
L: Stones Throw
   Records
D: Jeff Jank
P: B+
Y: 2003

05 /

06 /

07 /

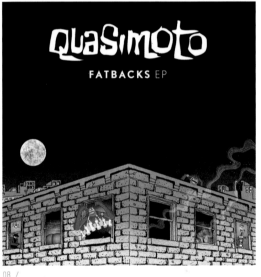

08 /

Jeff Jank /
Stones Throw Records

Art Director

10 /
A: Prozack
T: Death, Taxes &
   Prozack
F: CD
L: Out of Work
   Records
D: Jeff Jank
Y: 2004

11 /
A: Medaphoar
T: What U in it For?
F: 12" Vinyl
L: Stones Throw
   Records
D: Jeff Jank
Y: 2003

12 /
A: MF DOOM
T: MM FOOD
F: CD
L: Rhymesayers
D: Jeff Jank
I: Jason Jagel
Y: 2004

13 /
A: Madvillain
T: Madvillainy
F: CD
L: Stones Throw
   Records
D: Jeff Jank
P: Eric Coleman
Y: 2004

10 /

11 /

12 /

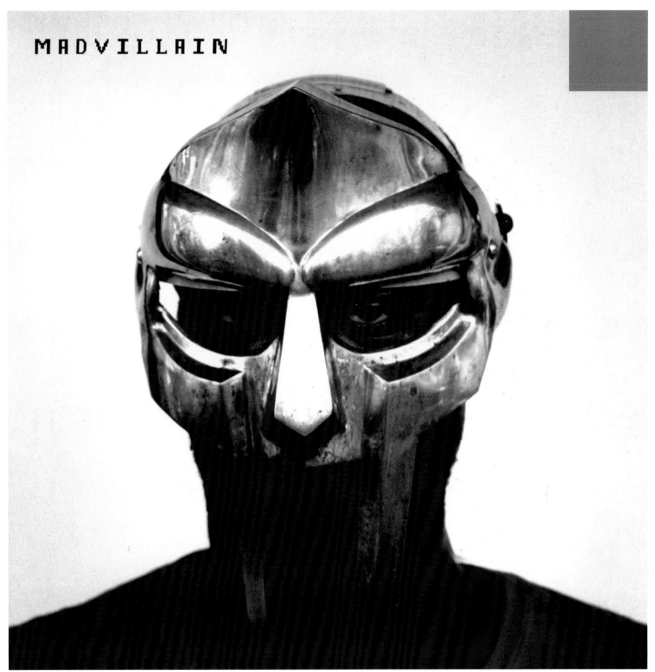

102

John Twells /
Type Recordings

Label Owner

Manchester /
Birmingham, UK

# John Twells /
# Type Recordings

**Name:**
John Twells

**Occupation:**
Label Owner

**Label:**
Type Recordings

**Location:**
Manchester/
Birmingham, UK

**Website:**
www.typerecords.com

**Biography:**
John Twells was brought up in Walsall in the Black Country, England, and began playing musical instruments and learning music theory early in life. By the time he was a teenager he knew he wanted to be in bands, and spent 'a few years giving the whole punk/metal/indie band thing a go before tripping over into more experimental realms'. Through DJ'ing in Birmingham, Twells met Stefan Lewandowski, who shared a similar leaning towards the odder side of music, and they started a club night together called Default. Around this time he started to release music under the Xela moniker and he was offered the opportunity to start a label. He and Lewandowski had 'the right people around us to put something interesting together'.

01 /

**Type is run by you (a musician) and Stefan Lewandowski (a graphic designer). Do you look after the music and Stefan the graphics?**
Actually I'm an ex-art student so it's not so cut and dried. Initially the idea was that Stef would handle the design, incorporating some of my photography, but since he has a great deal of other commitments, it became that I handled the art direction. We have a team of collaborators who I'm in regular contact with and I try and choose who will be best for the job, then it's a process of working back and forth with the musicians and visual artists to find something we are all happy with.

**Does Type employ any full-time staff?**
Unfortunately no, I have to fit the Type stuff in part-time alongside my other work (which is luckily all music related).

**Why did you call your label Type Records?**
It felt like a very open name for a label, I felt we could slip in and out of genres inconspicuously this way. At the time when we came up with the name there were a lot of very sort of 'techno' sounding labels out there, you knew what they were doing from merely the sound of their name. We just wanted something a bit more open, but still solid sounding.

**How do you decide who is going to design one of your covers? You use different people to design them, I notice.**
It's something I have to think long and hard about each time; often the musician will tell me what they have in mind and I'll work out what I think works best.

**How much do you consult with the musicians about their covers? Do they have the final say?**
It's almost always a mutual decision; of course they have the final say to a degree, but we have a certain layout and visual style that they are always happy to adhere to.

**Your covers are a mix of photography and illustration. What factors determine your decision to use photography or illustration?**
Good question. I guess with me it depends on what sort of imagery the music evokes within me. Also, I have to say, I like to mix things up a bit. I don't want a run of 10 covers that all have photographs on them. It's nice to keep people on their toes in regard to artwork just like it is in regard to the music.

**You use digipaks – do you have an aversion to jewel cases? And you sometimes use stickers to carry the name of the artist and album title – why do you do this?**
We actually use both: the first runs of a Type album always come in digipaks (which is my preferred format), but subsequent runs are in jewel cases. This gives people an 'art edition' if you like, but allows us to keep re-pressing at a lower cost.

**You invite visitors to your website to download album artwork for free. Is this a way of adding a visual component to the digital download?**
Yes in a way, we also want people to enjoy the artwork we create, it's a really important part of what we do.

**Do you envisage a time when it is no longer viable to produce CDs, and Type will be exclusively a download label?**
It's probably going to happen at some point, but I don't necessarily see this as a bad thing. The way people consume music is changing rapidly but I think the connection between art and music, whether it's with video or static image, is not going to go away, it's just going to change.

**I like your website. It's stuffed with good things – information, audio, video, downloads. Is there a sense in which websites have come to fulfil the role of the old gatefold album cover – a cornucopia of visual material and information?**
Yes. When we started the label both of us envisaged a website that had a lot of meaty information to view and freebies; we were lucky though that one of us – Stef – was a web designer. Certainly I can say that I spend most of my time now looking for info on music websites rather than on record sleeves.

**Which other labels do you think have good packaging?**
I could go for some easy options here – Rune Grammofon always looks fabulous, and historically 4AD were maybe my biggest influence. But at the moment I'm enjoying nothing more than getting handmade or screen-printed limited-run stuff from the USA. There's a small scene of noise/psych-edelic/folk artists and labels putting out 10 to 200 copies of handmade CD-Rs and vinyl and some of it just looks incredible. Labels like Root Strata in San Francisco and Hospital in New York; when you get the records through it feels like you're buying a piece of art, a one-off...that's definitely a good thing for me. Putting the human element into digital releases is going to be very difficult I think as we move into the future. ▮●

104

John Twells /
Type Recordings

Label Owner

Manchester /
Birmingham, UK

01 /
A: Svarte Greiner
T: Knive
F: CD
L: Type
D: Erik K Skodvin
Y: 2006

02 / 03 /
A: Xela
T: The Dead Sea
F: CD
L: Type
D: Monika Herodotou
I: Matthew Woodson
Y: 2006

04 / 05 /
A: Svarte Greiner
T: Knive
F: CD
L: Type
D: Erik K Skodvin
Y: 2006

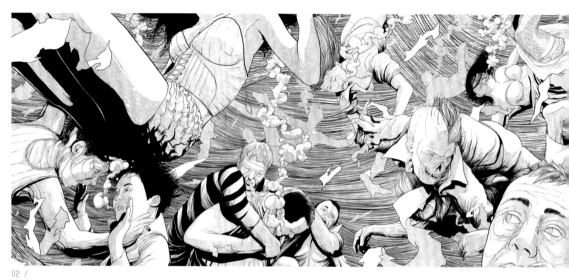

02 /

03 /

105

John Twells /
Type Recordings

Label Owner

Manchester /
Birmingham, UK

SVARTE GREINER

KNIVE

01. The boat was my friend, 02. Ocean out of wood, 03. My feet, over there, 04. Easy on the bones,
05. An ordinary hike, 06. The black dress, 07. Ullsokk, 08. The dining table, 09. Final sleep

*Music smelted by Erik K. Skodvin. Vocals and add. cello/sounds by Kristin Evensen Giaever.*
*Artwork and design by Erik KS at minamah. Recorded/lab by Type records. Mastering by Lupo at D&M*
*Thanks to : Kristin EG ( for lending of cello). Otto AT (add. field recordings), Stian WK (immense),*
*LM ( for lending of el-guitar), John T (blood and gore)*

*www.typerecords.com - www.minamah.com - www.deafcenter.net/sg*

*c+p 2006 Type records*

04 /

°Type

TYPE016 : CODE 182270000291

05 /

06 /
A: Helios
T: Eingya
F: CD
L: Type
D: Monika Herodotou
I: Matthew Woodson
Y: 2006

07 /
A: The North Sea &
   Rameses III
T: Night of the Ankou
F: CD
L: Type
D: Monika Herodotou
P: Liam Frankland
Y: 2006

08 /
A: Deaf Center
T: Pale Ravine
F: CD
L: Type
D: Erik K Skodvin
Y: 2005

06 /

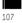

John Twells /
Type Recordings

Label Owner

Manchester /
Birmingham, UK

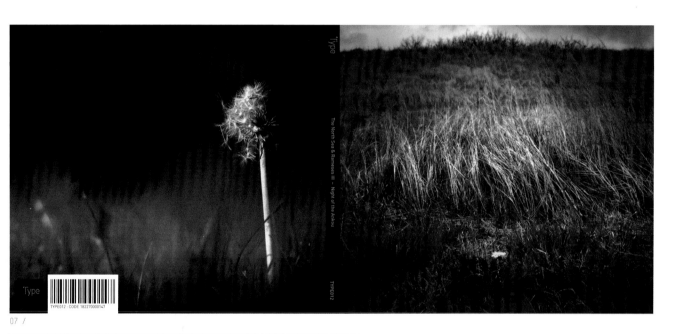

07 /

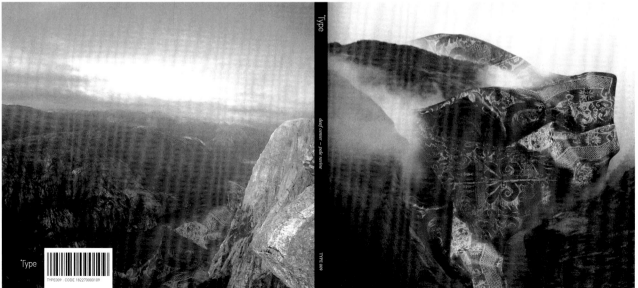

08 /

John Twells /
Type Recordings

Label Owner

Manchester /
Birmingham, UK

09 / 10 /
A: Xela
T: For Frosty Mornings
   and Summer Nights
F: CD
L: Type
D: Monika Herodotou
I: Matthew Woodson
Y: 2007

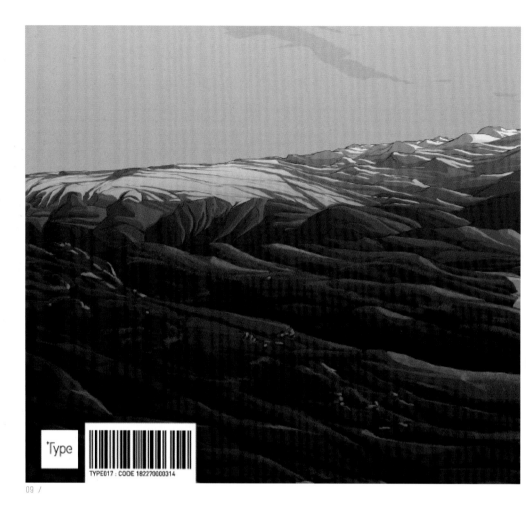

Type

TYPE017 : CODE 182270000314

09 /

John Twells /
Type Recordings

Label Owner

Manchester /
Birmingham, UK

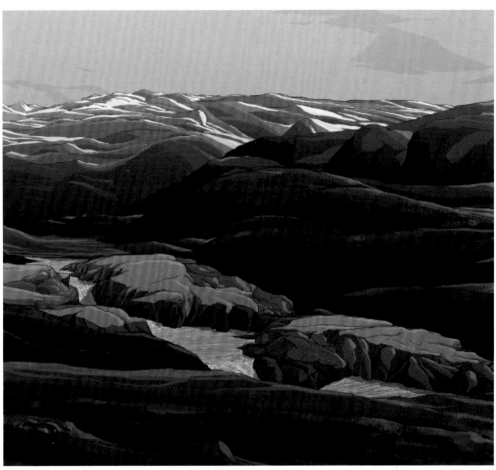

10 /

110

Jon Wozencroft /
Touch

Designer / Editor /
Label Originator

London,
UK

# Jon Wozencroft / Touch

**Name:**
Jon Wozencroft

**Occupation:**
Designer, Editor and
Label Originator

**Label:**
Touch

**Location:**
London, UK

**Website:**
www.touchmusic.org.uk

**Biography:**
Jon Wozencroft founded
Touch in 1982. He worked
for many years with
Neville Brody on books,
exhibitions and events,
and started the FUSE
project in 1990. He
published Touch & Fuse in
1999, and is currently
senior tutor in the
School of Communications
at the RCA (The Royal
College of Art, London).

biosphere.
dropsonde

01 /

111

Jon Wozencroft /
Touch

Designer / Editor /
Label Originator

London,
UK

I read that you like to call Touch an 'audiovisual' label. What is the role of the 'visual' within Touch?
To counterpoint the music — to push and extend what a record cover is able to show, and (latterly, as download culture takes hold) to underline the importance of these visual forms alongside the music.

**Would graphic design and typography be as vibrant without the showcase that record and CD covers offer as a way of exploring new ideas?**
Various of our near-contemporaries had taken cover design a long way in relation to both the music and to record label identity/aesthetics in the late 1970s. One of the ideas that inspired us at the time was Kandinsky's Blue Rider almanac from 1913–14. There were also numerous references in our early cassette magazines to Dada and Constructivism, whose artists did not follow such strict divisions between music/painting/photography/film/design/etc.; this was a notion we wanted to regenerate. The sound and vision, time and space reversibility also came from Burroughs' and Gysin's work, from having been affected by its renewal in Cabaret Voltaire and Throbbing Gristle's approach to film and print media. Factory Records was an influence, but we didn't want to work as a record label. We've rarely worked with bands because this demands an approach that runs counter to our capabilities. Actually, when we started it was somewhat easier to work with unusual formats and mixed media; since the dawn of CDs and the

steady erosion of retail diversity, we faced resistance — distribution problems whenever we released special editions like the Hafler Trio series, Fennesz's Forty Seven Degrees, Spire, etc. So the sequence of releases look more format-specific by default (digipaks are just about OK in relation to jewel cases, it's all in relation to the book format, hardback/paperback, and bringing music closer to the domain of words and images). It's hard to maintain this distinction. When people say 'Touch Records' it annoys us, but it's perfectly understandable that we get cast as a record label...we've never been that keen on explaining ourselves.

**Does your work as a teacher of design inform your running of Touch?**
Yes, because that is one of the things I do and they are all connected in one way or another. But it is more in the sense that my work at the RCA is informed by the experience of working with many brilliant artists and musicians, and the ability to pass on some of these things to a younger generation who are often quite jaded by the supposed diversity of approaches that they can take in getting work published...
The great 'multiple choice' question of new media obscures a deep conformism at the core of the system. So it's better to say that running Touch with Mike Harding informs my work as a teacher, rather than vice versa. I am inspired by students who reject the soft option. To see work that makes me surprised and jealous is a good education for

me. If I have had some hand in it, so much the better, but I guess one thing I can do is act as a new kind of librarian.

**Through your work with Neville Brody, you've become linked with the notion of typography as a medium for expression. Yet in your Touch work, typography is understated, almost an absence: it conveys information with a deadpan expression.**
Neville is a great artist. He's made strong interventions with type design that 'lead' his visual language, so I wasn't about to try and do the same thing! We do talk a lot about 'absence'. One of the projects that predated FUSE, 'The Death of Typography', was our instinctive response to the computerization of graphic design (and popular culture). Many of the ideas/texts/designs that ended up in the second Thames & Hudson book (The Graphic Language of Neville Brody: vol. 2) stemmed from this partially realized (and ongoing) project. In my work, I'm not intending to present information with 'a deadpan expression'. The idea is primarily one of scale... typography at a homeopathic level. Maybe Kim Hiorthøy's typography for Rune Grammafon, or the ECM aesthetic, is what you must have been thinking of. I think a lot of my type is fairly 'hot', actually. I try to do something with it even on this level of the miniature. I did say once in Storm Thorgerson's book that I did the information more like subtitles to a film; now I find it's more about stillness, finding a contemplative space for the sound and music.

OK, I withdraw 'deadpan'. But what about your photography? I like its studied calm. Yet I'm often unable to link it to the music. Can you talk about your attitude to photography in music packaging?
It's difficult to explain, which is why I use photography rather than typography at the forefront. Firstly, I want there to be a subject. Something physical (a place, an experience) but of a perceptual quality that is quite universal, which is why I'm not interested particularly in after effects and digital rendering - or photos of the artists (except in rare circumstances). The whole notion of linking the photographs to the music is extremely limiting and boring, in any event, it's the music that is linked to the photographs, and it's an almighty challenge in this sense because of course the audience most often sees the cover before he/she hears the music. So it's configured around the fact that the cover 'illustrates' the music and that it's meant to be some image of one's hearing the music. A crucial distinction that I've said to my students over the years is the difference between illustrating something and expressing it in a poetic way. Poetry has the twin enemies of sentimentality and the maudlin. I'm trying to create some kind of visual poetry whilst avoiding this...you have to trust your instincts and your imagination and then try to work well with what you come across. Common denominators of my photographs are light and movement and, yes, colour is a huge

Jon Wozencroft /
Touch

Designer / Editor /
Label Originator

London,
UK

112

factor. I work very much with time-based ideas with what are so obviously (but not always) still photographs. The photos on the front and back of the latest release by KK NULL are 30 seconds apart, on the Fennesz Sakamoto CD they're 18 months apart. The music we work with is primarily instrumental and in a genuine sense I am trying to give it a voice, a clear reference to the human condition rather than using abstract imagery (though not always).
I'm also trying to challenge our perception and involvement with what we can accept as being beautiful (in as unmediated a form as possible), a large part of which is the attempt to communicate care and understated passion. The best compliment ever paid to me was that my photography is musical in its tone and calibration...I wouldn't know why and how that is, if it is.

**Are you using digital photography?**
I have to use digital photography if I want to work unobstructed, which is a total conundrum, because digital origination is fraught with disappointment. I held out for as long as I could, because the optic of 35mm Fuji Provia film is much warmer than the digital option. However, the removal of film-making from the repro process finally ruined any distinction there was to be seen in the printed factory result, so I found myself making excessive efforts to make hi-res scans of slides without any proofing support or proper dot-screen quality at the print-ers, so yes, I bought

a digital camera. The Leica model I have has the advantage of working in TIFF and RAW formats, so it could be worse, and there is of course the convenience of being able to photograph something in the blink of an eye, and import it onto your computer. I have to do a lot more work on digital photo files than I ever did on 35mm slides in terms of colour and tonal calibration, the dreaded RGB to CMYK conversion tables. Still, the main drawback is the loss of a subtlety that many might not notice has gone. Printing was better 10 years ago when analogue origination and 4-colour litho pushed digital design and composition into a better appreciation of the medium. Now it's very default-conscious and difficult to experiment with, except at great expense and/or time.

**As the Touch designer, is there a sense in which you are foisting your own aesthetic preoccupations onto the musicians you are working with?**
I don't and I try not to. If I knew what my aesthetic preoccupations were it would help! For me there are big differences between the covers I do for each artist, but I also want there to be a narrative between them, in an spirited way. I think the musicians see and understand what the idea is. There are plenty of times where I will adapt things follow-ing feedback from them, but the magic thing is that few have ever presented me with a 'use this' starting point. I think you're right that musicians have a high awareness of visual possibilities,

but often they can be their own worst enemies in being too close to the pictures they have set in their minds, from having made the music, which is of course in itself 'visualizing'. For example, look at the difference between the emotional impact of the film canister Metal Box by PiL (material, non-image) and the subsequent Second Edition (manipulated photographs of the band). The latter does nothing for the music, whereas the former places it exactly in another dimension. Today we have the problem that music is increasingly uncontextualized, which might in one sense be liberating ('music wants to be free') but we can also see that there is a dire problem in terms of its 'value' and 'distinction'.

**You mentioned that MP3 files are not able to capture the sonic detail in some of your releases. Does this make you reluctant to embrace the digital distribution of music?**
No, we already do in a very progressive area, with Touch Radio. We just don't want to reduce complete and authored music to a bitmapped snapshot of its former self, but inevitably this is the way of things. Music exists these days to be reduced to something else. Hopefully we offer some kind of haven for a longer term view of the situation.

**And what about the 'packaging' of MP3 files – is there a way of keeping the audio and the visual yoked in the digital realm?**
Anything can happen, but I'd not be the one to want to yoke them together, that would be a disaster. Maybe it's already taken place. I can't see us being distributed on mobile phones, but footage of the Touch 25 concert last October was on YouTube within a day. We're already yoked to computers; I think the way forward is to look at the distinctiveness of each medium. What is the space between photography and film? Or to put it another way, a lot of people get quite excited about the notion of synaes-thesia, this is a very digital condition, as is the whole virtual set-up. The mental health issues of your question are too enormous. Which is why many people are scared to ask them and talk about all this. Attention to detail is the key thing. To be able to do this, you need some kind of holistic, reconciling agent alongside the music, some editorial aspect that functions as a gentle storytell-ing device alongside the invisible force of the music. For me it is a form of service. ■●

Jon Wozencroft /
Touch

Designer / Editor /
Label Originator

London,
UK

113

01 /
A: Biosphere
T: Dropsonde
F: LP
L: Touch
D: Jon Wozencroft
P: Jon Wozencroft
Y: 2007

02 /
A: Fennesz
T: Plays
F: Postcard
L: Mego
D: Jon Wozencroft
P: Jon Wozencroft
Y: 2006

03 /
A: Oren Ambarchi
T: Grapes from
   the Estate
F: LP
L: Touch
D: Jon Wozencroft
P: Jon Wozencroft
Y: 2004

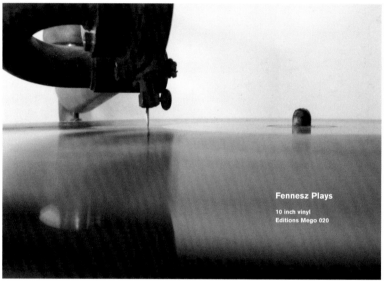

**Fennesz Plays**

10 inch vinyl
Editions Mego 020

02 /

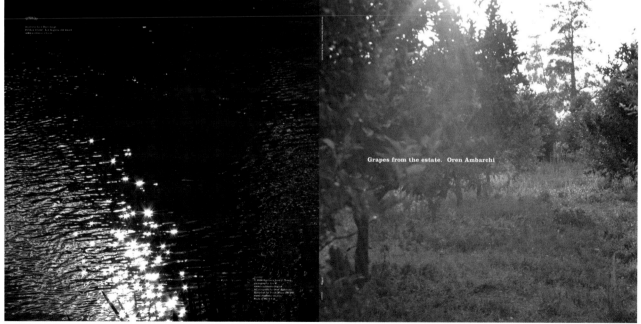

Grapes from the estate.  Oren Ambarchi

03 /

04 /

A: Fennesz
T: Liquid Music
F: DVD*
L: Touch
D: Jon Wozencroft
P: Jon Wozencroft
Y: 2006

1. ¬ 31:48   Gardner Arts Centre, Brighton, England   18 May 01
2. ¬ 39:39   Norberg Festival, Norberg, Sweden        30 July 04

The footage for Liquid Music originates from Prague, Paxos, Crete, Cephalonia, Messinia, London and one short clip from Monterey Bay. It was filmed on Hi-8 and mini-DV between 1995 and 2001 and the first edit was a 29 min. version made for the Touch 2001 tour in May. No filters or after-effects were used. The video was subsequently expanded with new footage from Crete and Bohemia as Fennesz's live sets became longer in duration.

These performances were never intended as a sync of sound and image in the conventional sense: the idea is that they work in parallel, more like a conversation. A single slide projection was used at the end of the concert to extend any shortfall between the moving image and the music. Our website has additional information...

Audio mastered by Denis Blackham, Skye Mastering. PAL–NTSC transfer at The Garden
With thanks to Steve Connolly, Kamal Ackarie, Andrew Lagowski, & Philip Marshall at Rebels In Control

www.fennesz.com
www.touchmusic.org.uk/liquid.html

* Unreleased due
to problems with
DVD compression
codes

115

Jon Wozencroft /
Touch

Designer / Editor /
Label Originator

London,
UK

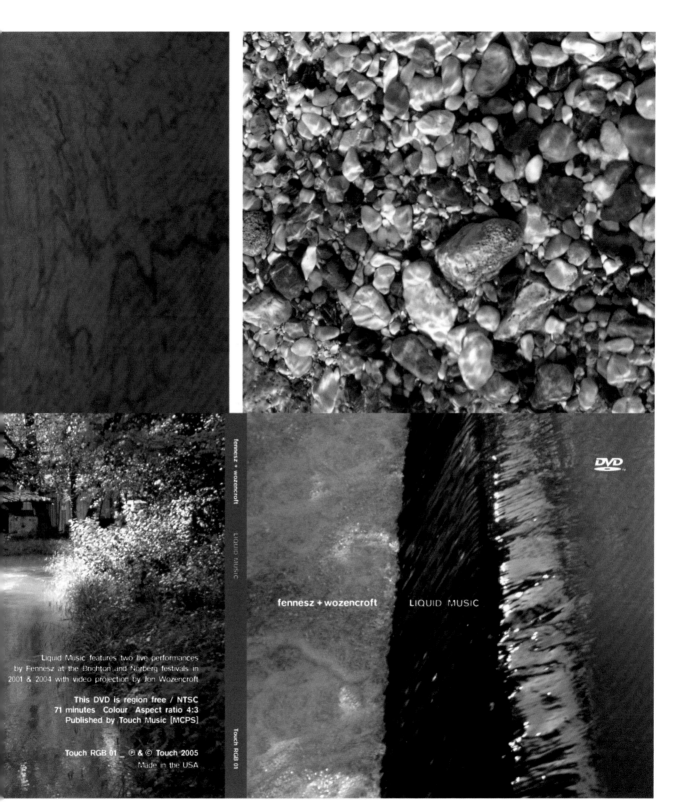

fennesz + wozencroft

LIQUID MUSIC

Liquid Music features two live performances
by Fennesz at the Brighton and Norberg festivals in
2001 & 2004 with video projection by Jon Wozencroft

**This DVD is region free / NTSC**
**71 minutes   Colour   Aspect ratio 4:3**
**Published by Touch Music [MCPS]**

**Touch RGB 01 _ ℗ & © Touch 2005**
Made in the USA

Touch RGB 01

DVD

fennesz + wozencroft     LIQUID MUSIC

◨ ●

116

Jon Wozencroft /
Touch

Designer / Editor /
Label Originator

London,
UK

05 /

A: KK Null,
   Chris Watson &
   Z'EV
T: Number One
F: CD
L: Touch
D: Jon Wozencroft
P: Jon Wozencroft
Y: 2005

06 /

A: Jóhann Jóhannsson
T: Englabörn
F: CD
L: Touch
D: Jon Wozencroft
P: Jon Wozencroft
Y: 2002

07 /

A: Fennesz
T: Live in Japan
F: LP
L: Autofact Records
D: Jon Wozencroft
Y: 2007

08 /

A: Autodigest
T: A Compressed
   History of
   Everything Ever
   Recorded Vol.2
F: CD
L: Ash International/
   Cronica
D: Jon Wozencroft
P: Heitor Alvelos
Y: 2005

09 /

A: Organum & Z'EV
T: Tinnitus VU
F: CD
L: Touch
D: Jon Wozencroft
P: Jon Wozencroft
Y: 2004

kk.null
chris watson
z'ev

number one

05 /

06 /

Jon Wozencroft /
Touch

Designer / Editor /
Label Originator

London,
UK

117

° Live in Japan _ ライヴ・イン・ジャパン

# fennesz

Published by Touch Music (MCPS)

© 2005, AshaTaT, Touch ℗ Touch
Composed and played by Christian Fennesz
Originally released on CD by Headz, Japan

07 /

AUTODIGEST
A COMPRESSED HISTORY
OF EVERYTHING
EVER RECORDED, VOL. 2:
UBIQUITOUS ETERNAL LIVE
ASH INTERNATIONAL 6.1 +
CRÓNICA 016~2004

ORGANUM | Z'EV          TINNITUS VU

08 /                         09 /

Jon Wozencroft /
Touch

Designer / Editor /
Label Originator

London,
UK

10 /
A: BJ Nilsen
T: Fade to White
F: CD
L: Touch
D: Jon Wozencroft
P: Jon Wozencroft
Y: 2004

11 /
A: Fennesz Sakamoto
T: Cendre
F: CD
L: Touch
D: Jon Wozencroft
P: Jon Wozencroft
Y: 2007

12 / 13 /
A: Biosphere
T: Substrata 2
F: CD
L: Touch
D: Jon Wozencroft
P: Jon Wozencroft/
   Haitor Alvelos
Y: 2001

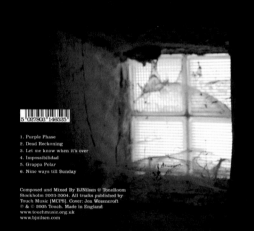

1. Purple Phase
2. Dead Reckoning
3. Let me know when it's over
4. Impossibilidad
5. Grappa Polar
6. Nine ways till Sunday

Composed and Mixed By BJNilsen @ ToneRoom
Stockholm 2003-2004. All tracks published by
Touch Music [MCPS]. Cover: Jon Wozencroft
℗ & © 2005 Touch. Made in England
www.touchmusic.org.uk
www.bjnilsen.com

BJ Nilsen  Fade to white

10 /

Jon Wozencroft /
Touch

Designer / Editor /
Label Originator

London,
UK

119

11 /

12 /

13 /

■● 

120

Jon Wozencroft /
Touch

Designer / Editor /
Label Originator

London,
UK

14 /
A: Various
T: Spire -
   Organ Works Past,
   Present & Future
F: CD
L: Touch
D: Jon Wozencroft
P: Jon Wozencroft
Y: 2003

15 /
A: KK Null
T: Fertile
F: CD
L: Touch
D: Jon Wozencroft
P: Jon Wozencroft
Y: 2007

14 /

15 /

■□○
121

Jon Wozencroft /
Touch

Designer / Editor /
Label Originator

London,
UK

16 /
A: Jacob Kirkegaard
T: Eldfjall
F: CD
L: Touch
D: Jon Wozencroft
P: Jon Wozencroft
Y: 2005

17 /
A: Geir Jenssen
T: Cho Oyu 8201m:
   Field Recordings
   from Tibet
F: CD
L: Ash International
D: Jon Wozencroft
Y: 2006

Jacob Kirkegaard ‡ Eldfjall

16 /

2886
Serie 20d
A B
C D
Edition Nov 2000

Geir Jenssen
**Cho Oyu 8201m**

*Field Recordings from Tibet*

**Day 3**

*We are sitting in a café in Kathmandu discussing high altitude medicine. For or against.
Most members have already started to use Diamox, a medicine used to reduce the symptoms
of edema (an excess storage of water by the body that leads to localized swelling or puffiness)
and altitude sickness. It is also used to treat a number of disorders, including the control of
epileptic seizures in those who suffer epilepsy.*

*Unwanted side effects while taking Diamox include drowsiness, fatigue, or a dizzy lightheaded
feeling. Other common side effects include shortness of breath. In some cases, individuals may
suffer depression, pains in the area of the kidneys, and bloody or black tarry stools.*

*I have already decided not to use Diamox.*

Ash International # Ash 7.1
MADE IN ENGLAND

5 027803 047129

17 /

Michaela Schwentner /
Mosz

Film-maker /
Label Owner

Vienna,
Austria

122

# Michaela Schwentner / Mosz

**Name:**
Michaela Schwentner

**Occupation:**
Film-maker and
Label Owner

**Label:**
Mosz

**Location:**
Vienna, Austria

**Website:**
www.mosz.org

**Biography:**
Michaela Schwentner and
Stefan Nemeth have been
working together for
about 13 years doing
small film projects and
visual installations
for concerts and clubs.
In 2003 they decided to
work together on another
level and founded the
record label Mosz. Their
first release, a 2 CD set
by Kapital Band 1, came
out in January 2004.
They have been produc-
ing and releasing music
since then. They now
have 14 releases, with
more in the pipeline.

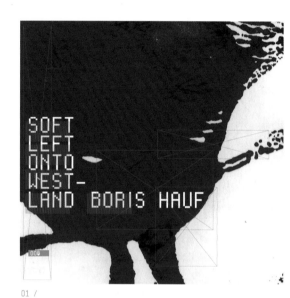

01 /

**Where does the name Mosz come from?**
Mosz has no special meaning. It was a result of brainstorming a name that couldn't be easily put in a special context. I wanted a 4-letter word and a 1-syllable word with an M and an O in it, so it was also a visual decision.

**Mosz is run by you and Stefan Nemeth, can you talk about how you run the label – do you both have separate duties?**
Yes, we have separate duties. I do all media work, press, general organization, event organization like label presentation, concerts, etc. Stefan is in charge of administration, shipping and financial concerns. Apart from these duties, each of us supervises particular favourite releases.

**Who designs your sleeves and how is that process managed?**
The sleeve design is a cooperative act between the graphic designers and the artists. We have a regular graphic design team – re-p (Nik Thoenen and Maia Gusberti, both from Switzerland but living and working in Austria since 1998). Mostly the musicians bring some sketches, photos, pictures, sometimes even paintings (like Boris Hauf – mosz008), which are worked on by re-p, according to our and the artists' conceptions. So in fact, everyone is part of the creative process. There was one exception – Szely (mosz003). The artwork was done by Austrian artist Christoph Hinterhuber. Usually we want re-p to do the final artwork because we think they understand Mosz's conception of

the music we want to release. The idea is to have a photographic cover in the end – the material artists provide is mostly photographic (like mosz001, mosz002, mosz005, mosz007, mosz009, mosz010), sometimes it's drawn (like mosz004), sometimes it's a painting (like mosz008). For mosz012 a 3D computer-generated image was used. Right from the start Stefan and I decided to use jewel cases. A certain kind of packaging is also a factor that has an effect on the design. You cannot do the same design with digipaks and jewel cases – at least not in my opinion.

**How important is sleeve design to you?**
It's very important to us. It's the first contact you have with the product and it should tell you something about the music and the label. Because there are so many new releases, you have to define yourself by your visual appearance. It's like a business card; a reference to our work and our intentions. Our sleeve design is mostly photographic with graphic elements. We like minimal design but we want more than just graphic design for our releases. And minimal design does not automatically mean just typography. We use straight photographs in most cases.

**If you had major label budgets, would your sleeves change?**
As I said, we already made the decision to only use jewel-case packaging – this is already a compromise and a low-budget solution. On the other hand, it's a more neutral packaging than digipak or other

paper sleeves that have the touch of something 'special' already on the outside because the material is also different. The material is already an important element of the cover art. We use neutral inlay cards.

**Your covers are varied and different – Rettet die Wale is very different from For Waiting, For Chasing, for example. Is having a diverse 'look' important to you? Do you want your covers to reflect the music rather than project a label image?**
Reflecting the music and the label image are important. One important thing is that the content of the covers should look 'organic', not too 'technoid'. The music we release is also organic, it's not just electronica. The idea is to reflect the feeling the music evokes on a visual level. I think there's something like a thread running through our releases – the label print and the logo (our label logo varies). The principle is the same with each release: we want to create a kind of openness, the hint or a trace of a potential development, not a strict and fixed minimalistic graphic structure, like the labels 'scape or Ritornell. You can recognize these labels by their look and design. I think they are good examples of very clear label images. Beyond that, our CDs are standard monochrome label print using a characteristic colour with a specific variation of the logo. Diversity is important, of course. But this thread I mentioned before should be recognizable.

**What about MP3s and the digital downloading of music – does it mean the end of cover art?**
Not really. It's already possible to download MP3 files plus covers that can be printed and put into a jewel case. This could be a new challenge – why not? When I was young I taped a lot of music because I couldn't afford to buy all the records I wanted. This was in the late 1970s and early 1980s when it was quite fashionable to make special, individual covers for tapes. This could happen again, though I'm afraid the MP3s will end up on iPods linked with just a name and no images, or perhaps just thumbnails. I belong to the vinyl generation. For me it was a compromise to release CDs. But the production of vinyl has become rather expensive and consumers are used to buying and using CDs that are also cheaper. I always prefer the haptic factor of any medium. It wouldn't be enough for me just to have an MP3 file with a downloadable cover. I use MP3 downloads for previewing, before going to the record store. But we have to deal with other people, with another generation, which is not familiar with vinyl. On the other hand we want to preserve these media. It might be possible to offer MP3s plus digital covers to download and to produce a small edition of vinyl as well. This would satisfy both the label and the customers.

124

Michaela Schwentner /
Mosz

Film-maker /
Label Owner

Vienna,
Austria

01 /
A: Boris Hauf
T: Soft Left onto
   Westland
F: CD
L: Mosz
D: re-p
   (Maia Gusberti &
   Nik Thoenen)
Y: 2005

02 /
T: Mosz Logo
D: Nik Thoenen
Y: 2003

03 /
A: Peter Rehberg
T: Fremdkoerper
F: CD
L: Mosz
D: re-p
   (Maia Gusberti &
   Nik Thoenen)
P: Chris Haring
Y: 2005

04 /
A: Metalycée
T: Another White Album
F: CD
L: Mosz
D: re-p
   (Maia Gusberti &
   Nik Thoenen)
P: Pascal Petignat
Y: 2004

05 /
A: Fuckhead
T: Lebensfrische
F: DVD
L: Mosz
D: re-p
   (Maia Gusberti &
   Nik Thoenen)
I: Joreg
Y: 2007

MOSZ LOGOFONT

— EX

— APP

| 60 | 61 | 62 | 63 | 64 | 65 | 66 | 67 | 68 | 69 | 70 | 71 | 72 | 73 | 74 | 75 | 76 | 77 | 78 | 79 |
|----|----|----|----|----|----|----|----|----|----|----|----|----|----|----|----|----|----|----|----|
|    |    |    |    |    | mosz |  |  |  |  |  |  |  |  |  |  |  | mosz |  | mosz |
| 80 | 81 | 82 | 83 | 84 | 85 | 86 | 87 | 88 | 89 | 90 | 91 | 92 | 93 | 94 | 95 | 96 | 97 | 98 | 99 |
|    |    |    | mosz |  |  |  |  |  |  | mosz |  |  |  |  |  |  | mosz |  |  |

mosz

02 /

Fremdkoerper

03 /

125

Michaela Schwentner /
Mosz

Film-maker /
Label Owner

Vienna,
Austria

04 /

05 /

Michaela Schwentner /     Film-maker /                                          Vienna,
Mosz                      Label Owner                                           Austria

06 /
A: Pan American
T: For Waiting, for
   Chasing
F: CD
L: Mosz
D: re-p
   (Maia Gusberti &
   Nik Thoenen)
P: Mark Nelson
Y: 2006

07 /
A: Martin Siewert
T: No Need to be
   Lonesome
F: CD
L: Mosz
D: re-p
   (Maia Gusberti &
   Nik Thoenen)
P: Pascal Petignat
Y: 2004

mosz 010

FOR WAITING, FOR CHASING

Pan•American

06 /

002

**Martin Siewert**
No Need to Be Lonesome

07 /

08 /
A: Kapital Band 1
T: 2xCD
F: CD
L: Mosz
D: re-p
   (Maia Gusberti &
   Nik Thoenen)
P: Stefanie Berger
Y: 2004

09 /
A: Lokai
T: 7 Million
F: CD
L: Mosz
D: re-p
   (Maia Gusberti &
   Nik Thoenen)
P: Gudrun Likar
Y: 2005

08 /

09 /

128

Ralph Steinbrüchel /
Synchron

Graphic Designer /
Label Owner

Zurich,
Switzerland

# Ralph Steinbrüchel / Synchron

**Name:**
Ralph Steinbrüchel

**Occupation:**
Graphic Designer and
Label Owner

**Label:**
Synchron

**Location:**
Zurich, Switzerland

**Website:**
www.synchron.ch

**Biography:**
Ralph Steinbrüchel was
born in 1969 and studied
Communication Design at
Central Saint Martins
College of Art & Design
in London, where he
acquired a Masters of
Arts and Design with
distinction. He now
lives and works as a
musician and graphic
designer in Zurich,
Switzerland. Music
releases under the
name Steinbrüchel can
be found on labelssuch
as 12k, LINE, ROOM40,
nonvisualobjects and
others.

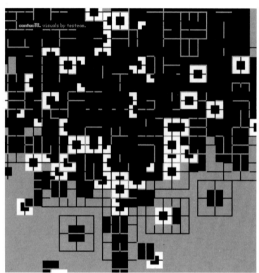

01 /

Ralph Steinbrüchel /
Synchron

Graphic Designer /
Label Owner

Zurich,
Switzerland

## How would you describe your design work?

Obviously it could most easily be defined as minimal. But in my opinion there is more to it as I am very interested in concepts and structures. Mainly I aim to achieve an atmosphere or texture, similar to what I like to create in music. In design it is very important for me that everything has a reason and does not function as decorative elements. Most of my graphic design is conceptual, following certain rules I have established, and has a defined reason for its look and aesthetic.

## Can you talk about the parallels between the music you make and the graphic design you produce?

The graphic design work is far more conceptual than my music work, which is mainly based on emotions. That is probably the biggest difference in the working method of these two disciplines. The graphic-design work has a more rational and systemic approach because of the fact that it has to be successful in visualizing information or content, even if it's on a very abstract level. In music all these rules do not apply for me. Obviously on the surface there are similarities in aesthetics and choice of form and structure, which are based on my personal taste and on interests I have. So there exists strong connections, but the approach and the working methods are completely different and not necessarily connected, even though the completed work sometimes appears to be similar and perhaps

related. Of course when designing covers for music, especially my own, there is a strong relation, but the graphic design process always comes after the musical part has been defined and completed. Often the design of packaging for music releases has some conceptual or visualized explanation and is connected to the process of creating the sound-based content.

## How do you manage to juggle your two roles: working as a designer and running a label?

The most honest and straightforward answer to this question is: I don't! I'm employed full-time as a graphic designer in a commercially oriented company based in Zurich, Switzerland, and I work on my own graphic design and music in my free time after work, alongside my responsibility as a father and supporting a family. In my life there is a constant lack of time and energy for creating my own work and I would love to be able to do so much more. The graphic design I create during my daytime job is not necessarily far away from my own work in terms of aesthetics and approach, but it is far more commercial and therefore also follows different rules and reasons. But doing this was, and still is, a very important decision for me (which I continuously evaluate). I do not want to be forced to 'have to' earn money for living and supporting a family with my own personal creations in graphic design and music. Instead my job as a commercial graphic designer gives me the freedom to be able to create my own work without outside pressure.

## You offer MP3 tracks on your website. Where do you stand on this – will we bother with record covers in the future?

I will! I will never get the same satisfaction from downloading a track or an album compared to owning an object of design and music (even if the media format changes in the future). There are so many important aspects in the packaging of music – paper, material, colour, printing process, etc. – that cannot be transmitted digitally. And it has a lot to do with the look and feel of the object itself. Of course, when everything is printed on standard, cheap, glossy paper and slotted into a regular jewel case, then I seldom get overly excited, but I just do not get any satisfaction out of looking at a cover of an album displayed on iTunes or bleep. However, I see more potential in displaying graphic design when downloading music, and in my opinion this has not been successfully touched on; for instance, using animations or including other animated graphic elements. I do not have anything against the MP3 format or downloading music as long as it is legal, but the media and packaging, if there is any, have to be chosen carefully and for a reason. For me, MP3 is just another medium for music storage, and the MP3 tracks on my website are either tracks already released and not in print any more, or they are documenting live performances.

## What influences shape your work – musical, visual and cultural?

My everyday life. I have a deep interest in listening to and creating music. I like other art forms – architecture, graphic design, photography, visual arts, painting. A lot of the things I like and which interest me also influence my own creations in some way. For example, even small things like listening to my son breathing in his sleep influenced me to record this sound and transform it into a track entitled Snooze (dedicated to my son), and therefore containing a deep emotional and personal relationship that does not necessarily have to be felt or heard by the dedicated listener. In graphic design I would say that I have the same influences, as I cannot really disconnect my thoughts and feelings for music from the way I think or feel about graphic design.

## What are your ambitions for Synchron?

Mainly I see it as a platform for my own work and the possibility of releasing music and objects exactly the way I want to, without outside influence and in whatever form I like. I am interested in releasing more, but then I would have to invest far more time than I have available. And I am realistic enough to know that I could not earn enough money to live on from the products I am interested in releasing on Synchron. ■●

01 /
A: Steinbrüchel
T: contacT8.09.02.00.
F: 7" Vinyl
L: Synchron
D: Ralph Steinbrüchel
Y: 2002

02 / 03 /
A: Various
T: Opaque (+re)
F: CD
L: ROOM40
D: Ralph Steinbrüchel
Y: 2005

Ralph Steinbrüchel /          Graphic Designer /          Zurich,
Synchron                      Label Owner                 Switzerland

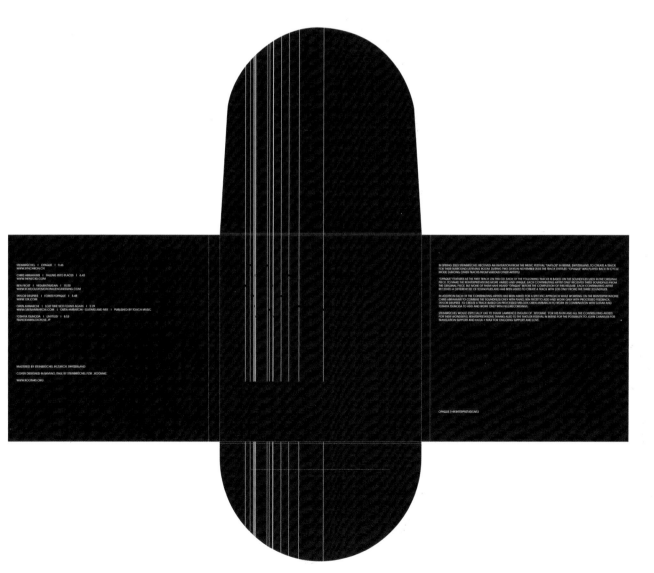

Ralph Steinbrüchel /
Synchron

Graphic Designer /
Label Owner

Zurich,
Switzerland

132

04 /
A: Steinbrüchel
T: 00sieben.19.01.00.
F: 7" Vinyl
L: Synchron
D: Ralph Steinbrüchel
Y: 2002

05 /
A: Steinbrüchel
T: End5.29.09.99.
F: 7" Vinyl
L: Synchron
D: Ralph Steinbrüchel
Y: 2002

06 /
A: Steinbrüchel
T: fLOPpy4.30.08.99.
F: 7" Vinyl
L: Synchron
D: Ralph Steinbrüchel
Y: 2002

04 /

05 /

133

Ralph Steinbrüchel /
Synchron

Graphic Designer /
Label Owner

Zurich,
Switzerland

06 /

07 /
A: Steinbrüchel
T: vERsiON2.28.06.99.
F: 7" Vinyl
L: Synchron
D: Ralph Steinbrüchel
Y: 2002

08 /
A: Steinbrüchel/Brusa
T: -00:dedaih
F: Mini CD-Rom
L: Synchron
D: Ralph Steinbrüchel
Y: 2004

09 /
A: Steinbrüchel
T: siXsiX6.20.10.99.
F: 7" Vinyl
L: Synchron
D: Ralph Steinbrüchel
Y: 2002

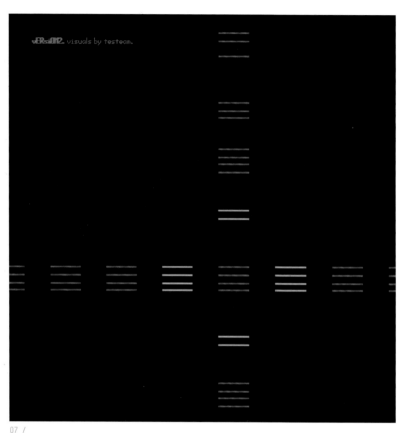

07 /                                                                                08 /

09 /

10 / 11 / 12 / 13 /
A: Various
T: Substrat -
   Innovation
   Durch Irritation
F: CD
L: Stattmusik
D: Ralph Steinbrüchel
Y: 2001

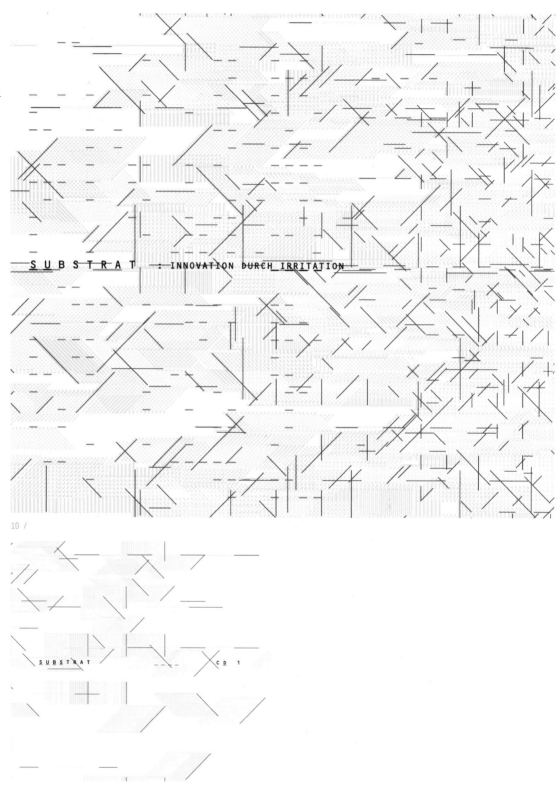

10 /

11 /

07.05.98 live: STYRO2000 _ 14.05.98 MINUS 8 (plus3gleich4) _ 28.05.98 MARK BROOM (uk). live: INTRICATE. CIO
_ 04.06.98 live: ZOR-EL & ALURA meet RHUBART 2 meet LULLABY _ 11.06.98 ANDREA PARKER. DEEJAY PUNK-ROC
18.06.98 live: R+R _ 25.06.98 live: ROGER ROTOR. KLONATOR. IVAN E. _ 17.09.98 live: a$$AUL+ n3U+RON _ 24.09.98
live: MANUEL STAGARS. CHRISTA WENGER _ 01.10.98 live: STEINBRUECHEL. M-DESSERT. GO LOOP. GMD THREE _ 08.10.98
live: SCHALLBETTER. BRUSA. TESTEAM _ 15.10.98 DUBSEARCH. BUREAU. MACKE. _ 22.10.98 live: SONICFOAM. live:
LE BUEBER. SVEN _ 29.10.98 live: STYRO2000 _ 05.11.98 live: NADER & MUELLFISCH. SACCO. _ 12.11.98 AR-MF.
PM. _ 19.11.98 live: HALLTOWN. PHILIPP ANZ _ 26.11.98 live: STAUBSAUGER. live: OMTREK. KLEX. MIDI _ 03.12.98
live: KLETTERMAX. FRAGMENT. STEFAN ALTENBURGER _ 10.12.98 ERIC BORGO. MIDI _ 17.12.98 TEK JAM. MARIJN.
23.12.98 im blauen saal _ 21.01.99 live: CLAUS/GP. live: DIMITRI. live: HOOVER. live: PACO PLUS. live:
PROTOTYPE BLAZE. STROMPROD. ALEX. ALEXIS. DEREK. LEX. _ 28.01.99 live: SEELENFINDER. STROMPROD. T.I.M.O.
M.L.STROMPROD. _ 04.02.99 live: MANUEL STAGARS. live: ROGER ROTOR. live: STEINBRUECHEL. GRAFIKSALOON. TESTEAM
_ 11.02.99 live: FUGO. BAD BAXTER. DIFFUSE _ 18.02.99 live: DOMIZIL. live: TELEFORM. SEKUNDAER _ 25.02.99
live: dAN plU. live: STEFANO BENINI. ROBERTO PISTOLESE. STEVE BASTARDO _ 04.03.99 live: HYBRID (d). DIVA D.
HALTER-GRATWOHL _ 11.03.99 STYRO2000 _ 25.03.99 KLONATOR. ROBATRONIC. NINA HOYGEN. TESTEAM _ 08.04.99 TIRDAD.
PAT. TESTEAM. ANNETTE. BRITTA. DANIEL. EVELYN. JOEL. MICHEL. MIKE. NICOLE _ 15.04.99 live: HALLTOWN. CHRISTIANE
HUMMEL. _ 21.04.99 im exil. live: KALEIDOPHONE. LIEBESLEBEN _ 22.04.99 live: KALEIDOPHONE. BUERO DESTRUCT.
HGB FIDELIUS. LODELFILZLER. VENUS. WELTSCHMERTZ _ 29.04.99 BASTIEN UND FREUNDE. GRAFIKSCHWADRON _ 06.05.99
live: FELIX WALDER & MANUELA KELLER & ANSELM CAMINADA & MARCO HEINIGER. SABINE HAGMANN & THOMAS ISLER
13.05.99 MARKUS P. KENNER. JUERG EGLI _ 20.05.99 live: SIMON GRAB. TOMAS KUDRNA _ 27.05.99 PROF. DR. FRANZ
LIEBL. GAME OVER: live: BITBOUTIQUE. live: DRECK REALA SCANIA _ 03.06.99 live: ARE DEE. SWO. MARIANNE LANDOLT
_ 10.06.99 live: SACHA WINKLER & SASCHA ROBERT. FABIAN _ 17.06.99 live: MANUEL STAGARS. CORNELIA BOEHLER.
KARIN ZERRI. CHRISTA WENGER _ 28.06.99 GAME OVER: live: PLASTIQUE DE REVE. COPY _ 01.07.99 live: WIDERSTAND.
KLONATOR. TESTEAM _ 08.07.99 voc: DELIA. CUT THE WEAZLE. DIVA D. DRIFT. EIKI. RESTLES _ 15.07.99 LITURGIE:
TESTEAM. ANDREA REISNER _ 22.07.99 GOLDSPRINT: T.I.G.G.E.R. _ 29.07.99 live: SAFY SNIPER (d). MAURICE (d).
05.08.99 live: G. MARKER. live: ROGER M _ 12.08.99 BARBITURAT. GRAFIKSALON. SCHALTKREIS. SUBSTRAT_PM. TESTEAM.
SAN KELLER _ 19.08.99 live: SCHALLBETTER. ROBATRONIC. SUBSTRAT_PM _ 26.08.99 live: SACHA WINKLER. live: GABI
DEUTSCH _ 02.09.99 BABYFACE. TRAMPOLIN _ 09.09.99 live: ELECTRONICAT (f). ROBA-STRATH. CECILE BABIOLE (f)
16.09.99 live: MAROX LYRIX. live: UNTERTON _ 23.09.99 live: STYRO2000 _ 30.09.99 live: STAUBSAUGER. live:
DENNE. FREUNDE. KLEX _ 07.10.99 DJ DIXON (d). LILLEVAEN (d). SEQUEL DJ TEAM. TONY
STONE _ 21.10.99 live: KLETTERMAX. live: ANATOL. BAD BAXTER. POCHATZ. STEFAN ALTENBURGER _ 29.10.99 live:
TELEFORM. live: MARCUS MAEDER _ 04.11.99 live: STEINBRUECHEL/BRUSA. NULLELF _ 11.11.99 PEACE: M FOR METASTAR
_ 18.11.99 LITURGIE: SACHA WINKLER. MIDI. METASTAR _ 25.11.99 PEACE: live: NOTO AKA CARSTEN NICOLAI (d)
02.12.99 live: BANG GOES. BILD WURF _ 08.12.99 MARIANNE. ANDREA. GABI. COMMANDER THAR _ 16.12.99 PEACE:
RUSSEL HASWELL (usa) _ 23.12.99 live: NICOLE DE LORENZI & MARTIN GUENTHARD live: PATRICK STUDER. STYRO2000
_ 06.01.00 GRANULAT: live: ANSELM CAMINADA. live: RAMON ORZA. live: ROGER ROTOR. live: STEINBRUECHEL. live:
SACHA WINKLER. ROBATRONIC. ANDREA REISNER. CHRISTIANE HUMMEL. GABI DEUTSCH. METASTAR. TESTEAM. THOMAS ISLER
13.01.00 SWO. GEISHA. CHALET. ALTHAUS _ 20.01.00 HI-SPEED. MEDOOZA. KLONATOR. METASTAR. JACQUELINE ZUEND & PHILIPP
ANZ _ 27.01.00 PATRICK STUDER. MARIO MARCHISELLA. DKNY. _ 03.02.00 KUEHLSCHIFF. live: SUPER. WIEDERHOLUNG.
RADIO WAR. BIOPOP. MICH. SONIC _ 10.02.00 live: SENKING-KANDIS (d). STROBOCOP. SNAUT _ 17.02.00 DJ MALIK.
DJ STERN EIS. G.MARKER. ISSA23 _ 24.02.00 HIGH_END_LOW: live: PEOPLE LIKE US (uk). live: INSTITUT FUER
FEINMOTORIK (d). live: VOICE CRACK. RALF SCHREIBER. MIDI _ 02.03.00 BIONIC DISCOUNT. METASTAR _ 09.03.00
live: NADER & ANDRE K. SONIK. SACCO _ 16.03.00 MISS KITTIN. MIDI _ 23.03.00 live: ROGER ROTOR live:
STEINBRUECHEL/BRUSA. TESTEAM _ 01.07.00 BARBITURAT. BANG GOES - STYRO2000 + HALLTOWN ET LES
BELLES VILLES + INSTANT + MARCUS MAEDER - TELEFORM + ROGER ROTOR + SUPER + DECOMPOSED SUBSONIC (d). MTS#19.
NULLELF. STEINBRUECHEL. MATHIAS SCHAFFHAEUSER (d). GABI DEUTSCH. MIDI _ 02.11.00 im blauen saal: live: TED
MILTON (uk) & LOOPSPOOL (d). METASTAR _ 06.12.00 live: ROGER ROTOR. METASTAR. CHRISTOPH GAECHTER _ 13.12.00
live: TURNER (d). MIRA. GABI DEUTSCH _ 20.12.00 live: ROGER ROTOR. live: STEINBRUECHEL. live: BATCHAS. BRUSA.
NULLELF. FRANZ GRATWOHL _ 03.01.01 live: MONOBLOCK-B. live: STAUBSAUGER. JOHN PLAYER. FRANK LUELLING _ 10.01.01
live: MARCO REPETTO. live: DRAMA MARTINI. live: PERSON. live: VITALTRANSFORMER. live: AKARUS MILBUS v. DUVALL
_ 17.01.01 BAD BAXTER. MONOTONI. MOLE. GABI DEUTSCH _ 24.01.01 live: UNISEX. TANIA FERRARI _ 27.01.01
SUBSTRATOS: live: KOTAI (d) + CANSON + COSILI + DAVIDE LEGITTIMO + RM74 + SEELENFINDER + SMS + STEINBRUECHEL/BRUSA.
MARCUS MAEDER. ROBATRONIC. SABAKA. MO (d). AMOK. CAROLINE FLUELER. FORT & NAH. GERMAINE E. HIGH KNEE. SASHA
HAETTENSCHWEILER. SKIM.COM. SUSANN SCHWEIZER. XESS+BABA. GABI DEUTSCH. MIDI. MARCO WALSER _ 31.01.01 live:
FRANCISCO LOPEZ (sp). live: JASON KAHN. METASTAR _ 07.02.01 live: STEINBRUECHEL/BRUSA. YVES NETZHAMMER
14.02.01 live: BOHREN & DER CLUB OF GORE (d). BEIGE. METASTAR _ 21.02.01 DIE_LOUNGE: live: NANOSPEED FEAT
SPACETANK (d). live: MAGNUM38 (d). DOMINICK BAIER (d). CAMP COGITO (d). RICHARD VITO (d). MEMBRAN SHIRT (d)
_ 28.02.01 live: RM74. live: TELEFORM & MARCUS MAEDER. live: MICROMUSIC-CREW. MODULAR-VISIOTROP. 0+1.t3l3 _
07.03.01 live: AKARUS MILBUS v. DUVALL. live: ONEBEAT. live: KAMAL B. live: HEINER. ANTON BETON. NOID _
14.03.01 live: SCHALLBETTER. ANDERSON. ROBATRONIC. JACKY Z. _ 21.03.01 live: SAN AGUSTIN (usa). live:
PRESOCRATICS (usa). JEFF HUNT (usa). STEINBRUECHEL _ 28.03.01 live: TRATOSPHAERE. GROOVELINER MANU. SNAUT _
04.04.01 live: BANG GOES & PRINZESSIN IN NOT. NOVILON. DIGITALES DB+ _ 11.04.01 live: T. RAUMSCHMIERE (d).
live: STEINBRUECHEL. BEELZEBUB. TOYBOY _ 18.04.01 live: SCHALLBETTER. METASTAR. ANOTZ _ 25.04.01 KALABRESE.
GEORGIOS MARGARITIS. SECURITY _ 02.05.01 live: BARBARA MORGENSTERN (d). BARBIEQ. NOKIA 3210. CHRISTIANE HUMMEL
_ 09.05.01 PAC/APC: live: GILLES AUBRY. PACMAN PACGIRL. FELDERMELDER _ 16.05.01 KLONATOR. MEDOOZA. RICHTKRAFT.COM
_ 23.05.01 live: KADET (usa). RUN. ROBATRONIC. ZUELLIG ON TESTRUN _ 30.05.01 live: HALLTOWN. TRIPPLE P. GABI
DEUTSCH _ 30.06.01 SUBSTRATOS: live: RECHENZENTRUM (d) + DIMITRI DE PERROT + ALURA + HI-SPEED + JASON KAHN
+ MANUEL STAGARS + MONOBLOCK-B + STAUBSAUGER. NANOSPEED (d). GOON. KALABRESE. MARCEL MEIER. BEIGE. HUNDEHERZ.
PAC. RELAX. SUSANN SCHWEIZER. MARTINA BOEHLER. GABI DEUTSCH & VANESSA BILLETER. MIDI. ELEKTRA STURMSCHNELL.
METASTAR ...

12 /

S U B S T R A T  19 - 20

›... Ziit vom Flower Power isch verbii, Woodstock isch Scheisse gsii!
Das sind Zueri Punks, die haerte Zueri Punks...‹ (Sperma, Zuerich, 1980)
The funky days are back again.

Willkommen in meiner Nachbarschaft. Ich wurde 1971 in Zuerich geboren. Mit 8
bekam ich mein erstes Kassettengeraet. 1980 hoerte ich Bestseller auf dem
Plattenteller. 1985 lernte ich, wie man einen Computer einschaltet. Mit 16 sah
ich meine erste Punk-Band, live in Zuerich. Ein Jahr spaeter erzaehlte mir
jemand von Chicago-House. 1990 waren wir draussen auf der Strasse und kaempften
fuer billigen Wohnraum. 1992 bin ich an der ersten Street Parade weg getanzt.

Ein Jahrzehnt spaeter wohne ich immer noch in derselben Stadt. Manche Dinge
haben sich veraendert, andere nicht. Was auch immer in den Nachrichten ueber
Zuerich erzaehlt wird: Vergesst es. Hoert lieber die Musik.

The punky days are back again.

Philipp Anz
31-08-2001

SUBSTRAT 98-01 _ 111 Veranstaltungen _ 111 verschiedene live-acts: 088 aus der Schweiz (v.a. Grossraum
Zuerich). 023 internationale _ 090 verschiedene djs: 078 aus der Schweiz (v.a. Grossraum Zuerich).
012 internationale _ 087 verschiedene Licht-/Bild-Gestaltende: 077 aus der Schweiz (v.a. Grossraum
Zuerich). 010 internationale _ 036 verschiedene Aktionen: Installation. Performance. Mode. Literatur.
017 Kooperationen: u.a. Blauer Saal. Buero Destruct. camp cogito. Domizil. Gottlieb Duttweiler Inst.
Migros-Museum. Museum fuer Gestaltung. PAC. Shedhalle. Velokurier-WM

DANKE 1 _ FU r.c.gaffuri (Mastering) _ PHILIPP ANZ (Text) _ POPKREDIT (Geld) _ STATTMUSIK (Label) _
STEINBRUECHEL (Cover)

DANKE 2 _ ALL _ ARNOLD MEYER _ BARBITURAT _ BETTINA _ BLAUER SAAL _ BRAUER60 _ CAMP COGITO _ COMMANDERBHAR
_ CORNEL WINDLIN _ DANI GASSER _ DANI LUETHI _ DOMIZIL _ DOTORE ROTORE _ EL GRECO _ EVELYN THAR _
GABI DEUTSCH _ GRAFIKSALON _ GRANULAT _ HR+RH MEIER-CLEMENS _ KARBON _ KATJA STIER _ KOMBIRAMA _
LIMMAT215 _ MARION MEIER _ MARTIN FRIGG _ METASTRAT _ MIDI _ MIGROS MUSEUM _ MUSEUM FUER GESTALTUNG _
NORDSEE _ PAC/ACP _ QUINTEN _ RALPH STEINBRUECHEL _ REIN WOLFS _ ROBATRONIC _ ROHSTOFFLAGER _ ROTE
FABRIK _ RUDOLF GFELLER _ SCHALTKREIS _ SHEDHALLE _ START-BARTEAM _ STRATOS _ TAIFUN _ THOMAS BRUSA
_ UG _ VALS _ WALTER HUEGLI _ und allen Produzentinnen und Gestalter der Substrat-Naechte!

Die Gaeste erhielten als Dankeschoen unzaehlige Gratis-Eintritte und immer wieder die Moeglichkeit,
zu interagieren. Dadurch wurden sie ebenso zu Mitproduzenten.

STATTMUSIK _ 2CD01 _ stattmusik@gmx.net
Distributed by Neuton. +49 69829744-0. fax -50. www.neuton.com

13 /

Ralph Steinbrüchel /
Synchron

Graphic Designer /
Label Owner

Zurich,
Switzerland

138

14 / 15 / 16 /

A: Institut fuer
   Feinmotorik
T: Akoasma
F: 7" Vinyl
L: Synchron
D: Ralph Steinbrüchel
Y: 2004

14 /                                    15 /

INSTITUT
FUER
FEINMOTORIK

A
AKOASMA

B
IN B

SYNCHRON ▦ sync04 – 2004

www.synchron.ch
www.institut-fuer-feinmotorik.de

16 /

# Rick Myers

**Name:**
Rick Myers

**Occupation:**
Graphic Designer

**Location:**
Manchester, UK

**Website:**
www.footprintsinthesnow.
co.uk

**Biography:**
Graphic designer and
artist Rick Myers was
born in Manchester in
1974. He was asked to
make his first sleeve by
the band Lamb in 1996.
The band had seen his
final show at Stockport
College and commissioned
him on the strength of
what they saw. Since
then, he has produced
around 100 artworks
for artists such as
John Cale, Doves and
Dinosaur Jr. His website
– Footprints in the
Snow – has presented
a steady stream of
objects and special
editions, his latest
being art subscriptions
by post. His acclaimed
7-year project, Funnel
Vision Portable Museum,
was shown at the 2004
Liverpool Biennial, and
then during British
Architecture Week in
Birmingham, 2005.

01 /

**Much of your work is typographic. Is this through choice, or do you tend to work with artists who aren't interested in having their pictures on their covers?**
There are two John Cale sleeves I've made where he is on the cover. Both were based around ideas of him in various roles, as a character within an idea that runs through the rest of the artwork. Things gravitate towards montages of some kind, with photographs, models and type, but it's down to the individual project really. I don't think there's a set way it should be approached, and I wouldn't want to become too comfortable with a particular style. I've tried to find a way to work on things so they can develop in their own way specific to the project.

**You work with some commercially successful bands – like Doves – and some much less well-known acts. Does your approach to designing a cover change if you are working on a project for a major label?**
So far I've tried to find interesting options combining relatively simple materials and processes, so, fundamentally, I suppose this could be my approach, along with more specific ideas or responses to things being presented or found in the music. It can be interesting and sometimes a difficult challenge to come up with something that can remain exciting to work on and that will also make some kind of sense to the large number of people involved, which is definitely a mode of creativity in its own right. I've always tried to push the work within the different

situations, making sure it's true to the project. Work made in one of those situations can directly influence and sometimes enable work in another.

**There are lots of examples of hand lettering in your sleeve work; can you talk about this?**
I didn't have a computer when I started making sleeves. And I was unable (and also not too interested) to make things look really precise. It's something that just looked very natural to me, and became a way of personalizing very mundane information, making it an integral part of the artwork.

**How do you get sleeve commissions? Do artists approach you, or does your work come through label connections?**
Initially, growing up in a creative environment, I was interested in making artwork, while other friends were making music, so it was quite a natural development to start with, and still is really. Things have also come through labels, or I'm approached by an artist, or I'll send an idea to someone.

**Are you one of these designers who grew up looking at sleeves?**
I suppose I was, as well as so many other things. I think Vaughan Oliver's sleeves were the most impressive I knew of then, and I really liked sleeves for Sonic Youth's EVOL and Sister, and some Fall LP covers. I think something from looking at sleeves crept in when I started making work, although there were many other kinds of influences, and many intangible ones, but

records and music were definitely part of an entry point to other things I'm interested in now, and still are.

**Where do you stand on the question of MP3 downloads?**
I'm sure there will always be a minority out there who really enjoy, and want to make, printed sleeves and objects. I think there's something in the scale and intimacy of actually holding and examining something that many people enjoy, but I don't think it's always relevant or necessary; any aspect of it is just enjoyment, and a luxury.

**I can see lots of subtle influences in your work – Surrealism, French avant-garde poster art from the early part of the 20th century – can you talk about your influences?**
They have changed over the years. Aged 8 or 9, I had a small Friedensreich Hundertwasser exhibition catalogue of his Regentag portfolio. Hundertwasser (1928–2000) was an Austrian painter and sculptor, and when I was first making sleeves the tiny details around his prints were definitely an influence on the way I arranged practical information, to try and make it look more complicated and intriguing. Posters for Japanese, Russian, European and some American independent and avant-garde films. More recently written/spoken words and sound. And music throughout. Initially so many influences came through skateboarding and the act of skateboarding itself. Also many individual artists and designers, and a

few found objects and printed matter. But I've tried not to refer to anything too directly. I've always tried to focus on the reason for the work existing and let that guide the way things look and feel. I think as the work has developed, and as I've developed, there are hopefully less direct aesthetic influences, although perhaps they are more visible to others. In addition to the underlying ideas, it's also become about the materials themselves, and approaches to the work. There's always been a feeling of working at a certain scale, to some level of detail, maybe even similar to the feeling of skateboarding, which has been my main influence.

**I don't see many 'current' influences in your work. Does contemporary design interest you?**
There are a number of individual pieces of contemporary design that appeal to me in different ways, and some are just really interesting for how bad or funny they are. I have developed a real problem with the marketing of the term 'contemporary' in some situations, especially in the development of cities now.

**Tell me about your website Footprints in the Snow?**
I started it in 1997. It's been a simple way of publishing work, an ongoing and changing catalogue. I have a huge backlog of material now. At some point, I'd like to commit it to print. ■●

01 /
A: Rec:
T: Rec: 20305
F: CD
L: Self release
D: Rick Myers
Y: 2006

02 /
A: John Cale
T: Turn the Lights On
F: CD
L: EMI
D: Rick Myers
Y: 2005

03 /
A: Patterns
T: Patterns
F: LP
L: PP
D: Rick Myers
Y: 2006

04 /
A: Lowgold
T: Welcome to Winners
F: CD
L: Sanctuary
D: Rick Myers
Y: 2004

02 /

PATTERNS

1.
2.
3.
4.
5.

03 /

04 /

05 /
A: Doves
T: Some Cities
F: CD
L: Heavenly/EMI
D: Rick Myers
Y: 2005

06 /
A: Doves
T: Black and White
   Town
F: 7"/Poster-sleeve
L: Heavenly/EMI
D: Rick Myers
Y: 2005

05 /

DOVES / BLACK AND WHITE TOWN

H ERE COMES THE ACTION
  HERE IT COMES AT LAST
  LORD GIVE ME A REACTION
  LORD GIVE ME A CHANCE

A. BLACK AND WHITE TOWN
B. 45

07 /
A: Rebelski
T: Stickers on Keys
F: CD
L: Twisted Nerve
D: Rick Myers
Y: 2004

08 /
T: Jakob Olausson
F: Poster
D: Rick Myers
Y: 2006

09 /
A: Rebelski
T: Play the School
   Piano
F: CD
L: Twisted Nerve
D: Rick Myers
Y: 2004

10 /
A: Voice of the Seven
   Woods
T: Solo Guitar
   Recordings
F: CD
L: Self release
D: Rick Myers
Y: 2006

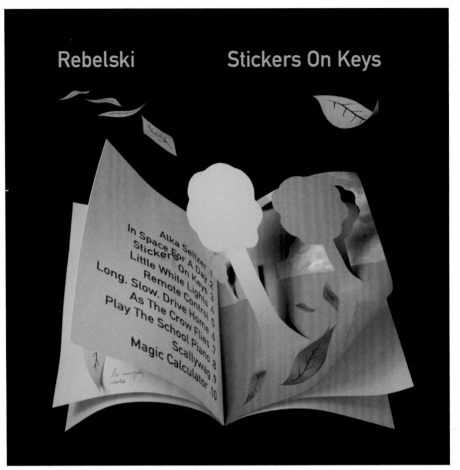

07 /

08 /

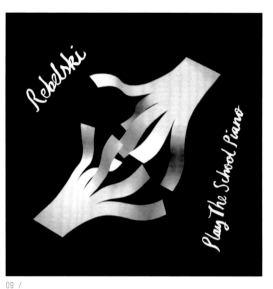

09 /

10 /

11 /
T: Rebelski
F: Poster
D: Rick Myers
Y: 2004

12 /
T: Jack Rose &
   Chris Corsano
P: Poster
D: Rick Myers
Y: 2006

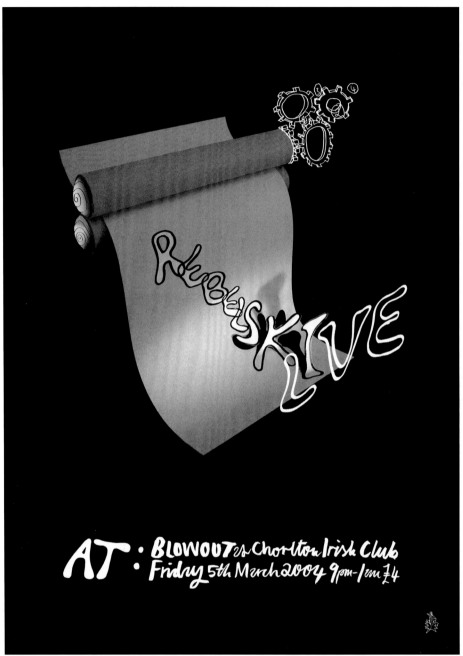

11 /

Nao Sugimoto /
Plop and Spekk

Designer /
Label Owner

Tokyo,
Japan

150

# Nao Sugimoto /
# Plop and Spekk

**Name:**
Nao Sugimoto

**Occupation:**
Designer, Musician and
Label Owner

**Labels:**
Plop and Spekk

**Location:**
Tokyo, Japan

**Website:**
www.spekk.net
www.naturebliss.jp

**Biography:**
Nao Sugimoto (aka
Mondii) runs the
creative office Nature
Bliss, and also works
as a freelance record
label A&R, designer and
translator. He grew
up in Chicago, USA,
learning piano from an
early age. Sugimoto
studied ethnic music
at university and played
guitar in several bands.
He also made solo music
on computers. After
working as a sound
designer for TV ads, he
accepted a job in a
record company and
started the Plop label
in 2001. He launched his
own independent label,
Spekk, in 2004, which
explores interpretations
of minimalism. Most of
the label's artworks
are designed by the duo
Mondii & Cheason.

01 /

151

Nao Sugimoto /
Plop and Spekk

Designer /
Label Owner

Tokyo,
Japan

**Can you tell me about Mondii & Cheason?**
NS: Mondii is my nickname and I use it when I make music and design. Cheason is my design partner, who is also a musician. She is one half of the electronic duo Fonica. Cheason designed all the early Plop and Spekk CDs and I was the art director for them. I eventually stole techniques from Cheason [laughs] and now I mainly design all the Plop and Spekk covers, but we are good friends giving advice to each other.

**Have you been professionally trained as a designer?**
C: No, but I used to work at a company where they made stickers with shapes and letters for advertisements, etc.

NS: Me neither. I started using design software when I worked at a record company making promotional goods for the stores. I was already doing art direction for the releases I was in charge of, so it was natural to start designing myself.

**How do you combine running a record label with being a musician and a designer?**
NS: It's very difficult in terms of time. I wish I could concentrate more on music and design, but that's one of the reasons why I started Nature Bliss. I also wanted a platform where I didn't have to separate music and design, as it's usually 'design company' or 'record company'. I hired 3 full-time staff members this year, and Nature Bliss is now developing as a company, so things should get easier for me. Hopefully!

**Can you tell me about Plop — are you no longer connected to the label?**
NS: No. I was running Plop as a division of a record company but I departed from that company, and now I run Plop on my own. From the Hausmeister release, Plop will restart with a new logo, catalogue number and barcodes. Also new sales staff and distribution, too. Anyway, I couldn't leave my precious children behind!

**Spekk covers are very distinctive — do you admire those labels that have a strong 'label identity' and is this something you try to do with Spekk?**
NS: Yes, we have a strong label concept and the covers are also important to tighten the image. Rather than trying to be 'distinctive', it's more important not to compromise, and to get closer to your ideals. With the Spekk covers, we had an idea to make a package like a book. I'd seen some vertical CD packages, but they tended not to have a spine. So we made many trials using clay, urethane, etc. to give the CD tray thickness, but they didn't look very beautiful. So we researched a way to make the tray with paper, and contacted many printers worldwide and finally found a company that could realize our idea. We got there by chance because we found a good paper tray from Sweden. That company only makes normal CD and DVD sizes, but they introduced us to a company in Japan that makes replicas of the trays in custom-made sizes.

**Do you allow the musicians to have input into their cover designs?**
C: I do listen to their opinions, but we always have the final say, as the musicians' profession is music not design.

NS: It's important to ensure that the artists are satisfied with their own covers, but this is always a difficult issue. I once conducted a survey when I had to make a 'popular' design, but responses differed depending on who I asked. But it's more about likes and dislikes than good or bad. We think that our covers represent our label, and I personally feel it's the most collaborative part of the process — the label making the designs and the artists making the sounds.

**Does your work have a Japanese accent, or is it 'international' in its outlook?**
C: We're not conscious of it, but maybe our Japanese essence somehow shows up. I don't know. But I hope that people abroad will appreciate our designs, so we hope it looks 'international' in terms of that!

**Do you foresee a time when music will be only available as digital downloads? Is the record cover a relic from the ancient past?**
NS: I hope not, as I love the covers as much as the music. An album is always a set with the cover in my memory. But vinyl jackets have become CD covers, and people are now familiar with covers on their computer screens, so eventually people might forget about the covers.

**I've been disappointed by attempts to mix visuals with digital downloads. Have you seen any interesting attempts to do this?**
NS: No, actually I've never tried digital downloads before.

**Which other labels do you admire for their cover art?**
C: Touch and Raster-Noton.

NS: ECM, Fonal Records and Non Visual Objects.

■●
152

Nao Sugimoto /
Plop and Spekk

Designer /
Label Owner

Tokyo,
Japan

01 /
A: FS Blumm & Friends
T: Sesamsamen
F: CD
L: Plop
D: Mondii & Cheason
I: Yumiko Matsui
Y: 2004

02 /
A: Various
T: Micro Blue
F: CD
L: Plop
D: Cheason
Y: 2002

03 /
A: Fonica
T: Ripple
F: CD
L: Plop
D: Cheason
Y: 2002

04 /
A: Lullatone
T: Little Songs About
   Raindrops
F: CD
L: Plop
D: Mondii & Cheason
Y: 2004

02 /

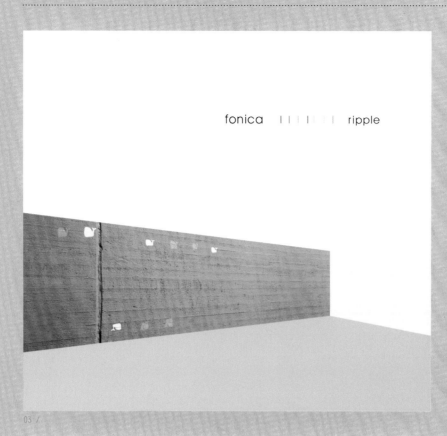

fonica | | | | | | ripple

03 /

little songs about raindrops by lullatone

04 /

154

Nao Sugimoto /
Plop and Spekk

Designer /
Label Owner

Tokyo,
Japan

05 /
A: Fenton
T: Pup
F: CD
L: Plop
D: Mondii
P: Dan Abrams
I: Dan Abrams
Y: 2005

06 /
A: Taylor Deupree &
   Christopher Willits
T: Mujo
F: CD
L: Plop
D: Cheason
P: Cheason
Y: 2004

05 /

06 /

07 /
A: Kazumasa Hashimoto
T: Yupi
F: CD
L: Plop
D: Cheason
P: Kazumasa Hashimoto
Y: 2003

08 /
A: Land Patterns
T: The World on
   Higher Downs
F: CD
L: Plop
D: Mondii
P: Mondii
Y: 2007

09 /
A: Gel:
T: Dolce
F: CD
L: Plop
D: Cheason
I: Cheason
Y: 2003

10 /
A: Hausmeister
T: Water-Wasser
F: CD
L: Plop
D: Mondii
I: Christian Przygodda
Y: 2007

07 /

08 /-

09 /

10 /

11 /
A: Enzo & Further
T: Boca Raton
F: CD
L: Spekk
D: Mondii
P: Mondii
Y: 2005

12 /
A: Level
T: Cycla
F: CD
L: Spekk
D: Mondii
P: Maura Wallace
Y: 2005

13 /
A: John Hudak
T: Room With Sky
F: CD
L: Spekk
D: Cheason
Y: 2004

14 /
A: William Basinski &
   Richard Chartier
T: Untitled
F: CD
L: Spekk
D: Cheason
I: Richard Chartier
Y: 2004

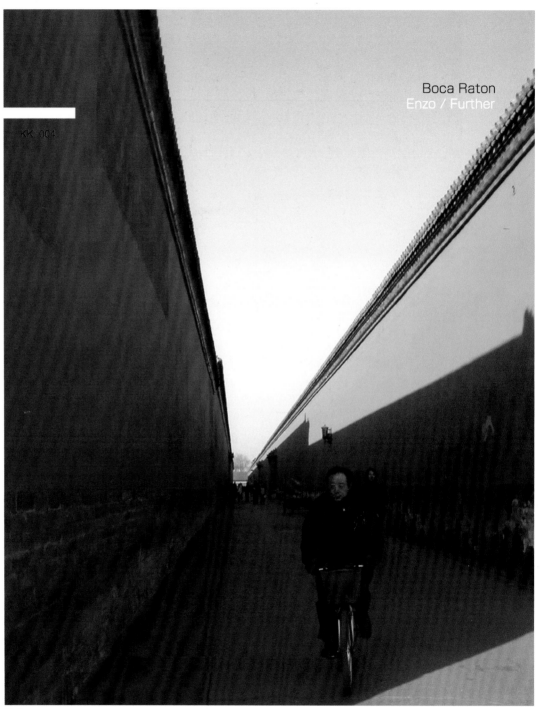

KK 004

Boca Raton
Enzo / Further

11 /

CYCLA / LEVEL

KK: 007

01: Samuil 02: Coimm 03: Design 04: Resonn 05: Aier Basc 06: Formen 07: Ferra

12 /

John Hudak
Room with sky

KK: 003

William Basinski + Richard Chartier

KK: 002

13 /                                    14 /

Nao Sugimoto /
Plop and Spekk

Designer /
Label Owner

Tokyo,
Japan

15 /
A: Taylor Deupree
T: January
F: CD
L: Spekk
D: Cheason
P: Cheason
Y: 2004

Taylor Deupree
January

KK: 001

16 /
A: Ken Ikeda
T: Mist on the Window
F: CD
L: Spekk
D: Mondii
P: Mori Koda
Y: 2007

KK: 010

Mist on the window
Ken Ikeda

Lawrence English /
ROOM40

Label Owner /
Sound Artist

Brisbane,
Australia

160

# Lawrence English / ROOM40

**Name:**
Lawrence English

**Occupation:**
Label Owner and
Sound Artist

**Label:**
ROOM40

**Location:**
Brisbane, Australia

**Website:**
www.room40.org

**Biography:**
Lawrence English is a
media artist, composer
and critic based in
Brisbane, Australia.
Working across a broad
range of investigations,
his work is eclectic
and characterized by the
long-term exploration
of various themes
including audio/visual
environments, found
sound/vision, subtle
transformation of public
space and sonic artworks
that exist at the very
edge of perception. His
label ROOM40 has produced
numerous editions over
the past 7 years and
continues to document
a wide range of
international sound
practitioners who
explore disparate
audio materials. ROOM40
launched its sister
label Someone Good
in early 2007.

01 /

161

Lawrence English /
ROOM40

Label Owner /
Sound Artist

Brisbane,
Australia

**Why the name ROOM40?**
Actually the name draws some inspiration from the 'room' used by the allies during World War II, where various codes were broken. I guess in some ways, I saw the label's musical output replicating a puzzle or code – a varied array of sounds and textures that were reflective of a particular aesthetic. It's been interesting too as the label has grown and developed people come to me and say, 'You should listen to this, it's a real ROOM40 record.' But when you actually listen across the catalogue of materials we've issued there's not necessarily a sonic aesthetic. Rather I think about it more like a concept or idea that guides the aesthetic qualities of the label.

**Do you run the label on your own?**
While for the most part the label has been a one-man operation, I am greatly assisted by two individuals: John Chantler, who is based in the UK, and Rebecca English, based here in Brisbane. Both of these guys are increasingly central to the ROOM40 family and work on aspects of the label like the website, MySpace and digital aggregation.

**As well as running the label you are also a sound artist – can you talk about your own musical activities?**
Over the past decade I've been involved in a variety of art, music and sound projects. There's a discrete line between each of the streams of the sonic work and I think it could be summarized by my explorations into field recordings, minimal electronics, work

with guitar and other instruments and production for other groups and artists such as Tenniscoats, Tujiko Noriko, The Rational Academy, etc. I'm very interested in sound, so for me, the move from working with a post-folk group from Japan to recording underwater environments is natural. The conditions might vary wildly, but the experience of sound remains constant and I see connections between all these different sound spaces and textures, both organic and synthetic.

**What is the experimental music scene like in Australia?**
Like any island country, I believe Australia has developed a unique voice and there are countless musicians and sound artists here examining sound in fascinating ways. Artists like Philip Samartzis, for instance, have created such a personal language with concrete sound. Equally, prepared players like Erik Griswold and Dave Brown have effectively produced an entire language for their given instruments. I'm ceaselessly excited by the sounds being produced and the willingness of musicians here to reach out to something unfamiliar – it's a wonderful quality to have in any experimental community.

**Most of your covers are like origami. They have a handmade quality. Can you talk about this?**
At the end of the day, I do see each and every one of our releases as an edition. If we're pressing 40 CD-Rs or 10,000 CDs for The Wire magazine, each disc is an opportunity to consider the

relationships of shape and form, and in the process create something that connects with people.

**Your packaging graphics are minimalist - is this a reflection of the ROOM40 musical ethos?**
In some ways, yes. I do think even our most dense works have a strong consideration and contemplation of sound in space – exploring the opportunities to bring an awareness of this idea to the listener. The ideas of presence and absence and our understandings of sound between and during those two states. Added to that, I've always loved the monochromatic nature of some visual artists (and sound artists for that matter) and I find that there's a lot to be gained from limitations. Often the old adage of 'less is more' really rings true and I'd like to think that's the case with the editions' artwork and design.

**The minuscule front cover typography on ROOM40 sleeves would give a major-label marketing executive a heart attack. Do you ever think about traditional marketing techniques? Do you think you'd sell more copies if you had Janek Schaefer's picture on the front cover with his name in 36pt text?**
Ha! Actually I think there's a great opportunity for a sound artist (with a healthy sense of humour) to produce one of those classic photograph-style album covers à la Michael Jackson's Bad or maybe Phil Collins' Face Value – with big typefaces and all! Seriously though, marketing is a word that for many might as well mean 'being overt'. I find that something

like unique design or care of the materials used in producing a CD edition can really draw you into that label/ person's ideas and you also get a real sense of the enthusiasm they feel for the work they're doing. I'd like to think that in this age of so much opportunity, there's a chance to travel the less familiar road and see what that journey turns up. So far it's been a great wander.

**How important is a label 'look' to you? Do you want people to pick up one of your CDs and know instantly that it comes from ROOM40?**
Ideally, yeah – and that hopefully is developed through the monochromatic art, standard typefaces and the various series of die cuts, etc. we've grown. In the same way I'd hope someone might buy a ROOM40 record because it has been issued by the label. I hope they have the same attachment to the various artwork styles we have – whether it be the 'three-fold' die-cut series or the 'fandisc' editions series, or any of our other variations for that matter.

**You seem to use a number of different sleeve designers. How do you approach commissioning?**
There have been a number of designers over the years. I worked closely with Rinzen on the first 5 releases from the label. Initially what drew me to working with them, and particularly [Rinzen member] Steve Alexander, was the fact that not only was he really visionary with his designs, but he was a real fan of the music, and I think that played

162

Lawrence English /
ROOM40

Label Owner /
Sound Artist

Brisbane,
Australia

a role in defining the characteristics of those early releases. Equally, designers like Richard Chartier, who also happens to be an excellent sound artist, has that same meditative quality to his design work. His die cut for the On Isolation edition, for instance, really captures certain themes of that project so well. I suppose even for myself when I was working on the 'three-fold' die cut, I was conscious of setting up a canvas on which various artists and designers could play with the conventions of CD-edition design and I think we've seen that, which is a real joy.

**Describe a typical sleeve design process. How much involvement do the musicians have?**
I'm not sure there is a typical process. If I'm working on the design, then for the most part I do speak at length with the artists about the themes and qualities I hear in the sound, and I talk about the potentials of reflecting on those within the design. If an artist is working on the design, then generally this takes a little time to make sure they get the standard parts correct. Monochrome poses a real challenge for some artists it seems, but thus far I think everyone involved in the label has been very satisfied with their editions. In fact I know of one artist who approached the label specifically so they could work with the 'three-fold' die cut!

**Where do you stand on the whole download question? Does it mean the end of sleeves and sleeve art?**
Only for labels that don't bother to invest any time, creativity or energy in producing their editions. It's so easy to produce these little works of art, and yet here we are again and again offered these second-rate standard lifeless designs housed in jewel cases. As for downloads, it's what's happening so I think the best thing to do is work with it, and already it's given us some great opportunities to issue projects from artists that could never work on a CD format – like three-hour long prepared piano pieces to be played in repetition, the digital format caters for that so well! I think it's another way for musicians, artists and labels to think about sound and the way it might be presented to audiences. At the end of the day, it's just a new horizon for us to examine and respond to.

**Is there a valid argument to say that music is actually better without visuals?**
I think that some sound can be very powerful with the visual senses turned off – I can speak personally about a number of concerts I've experienced in pitch-black settings. That said, for a CD, the experience of buying and, for the most part, listening to it is mediated by the environment of the home or street (not a concert hall), so it's a very different proposition, and hopefully the art complements that setting.

Whenever I talk to young graphic designers I still encounter a strong interest in sleeve art. Why do you think this is?
Let's face it, the artifact is always going to have a place in our collective hearts. Sure, we can read an e-book, but the tactility of holding a book creates some deeper resonance, I think. Equally there's a quality to sleeve art that expands the music in some sense. I have to say for the most part that I'm really disappointed with most CD jewel-case publications these days, they are lazy, poorly designed and lacking any real qualities that make you want to own the artifact. So it's hardly surprising people are downloading the music when the housing that contains it offers nothing more than increased clutter for your shelves. I think a responsibility lies with labels and artists to reach for something unique or at least interesting when working with these formats.

**Which labels do you think take on this responsibility?**
I think there's a variety of labels whose work I've respected for a range of reasons. On some of the Raster-Noton discs, for instance, the die cuts are so spectacular. Likewise the standard format from Spekk is a work of art – so unique and complementary to the sounds released by the label. Then labels like Improvised Music from Japan have cultivated a format that has delivered some very elegant matt-finish designs. I've always enjoyed the chic minimalism of Line and also

the use of the large-scale CD format from Sub Rosa's Audiosphere series. Of course, then there is Touch, who have developed a strong visual identity. And The Helen Scarsdale Agency – here's a label working with a conventional format in the most amazing ways. The owner, Jim Haynes, spends inordinate amount of time working on the design and printing of each release and they're always so special and feel very personal to me. It is as if he has hand made each CD himself – and in some cases that is what he's done. ■●

Lawrence English /
ROOM40

Label Owner /
Sound Artist

Brisbane,
Australia

163

01 /
A: Various
T: [Five]
F: CD
L: ROOM40
D: Rinzen
Y: 2006

02 / 03 /
A: Lloyd Barrett
T: Mise en Scene
F: CD
L: ROOM40
D: Andrew Thomson &
   Lloyd Barrett
Y: 2006

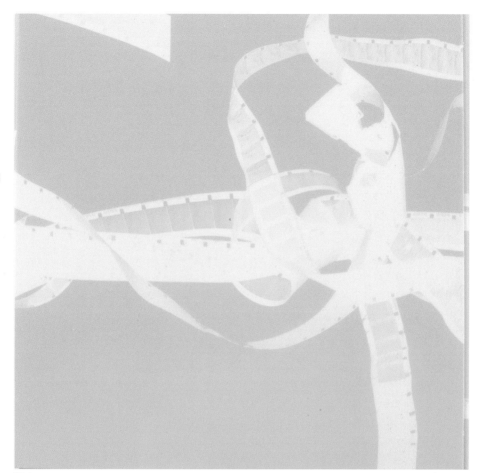

02 /

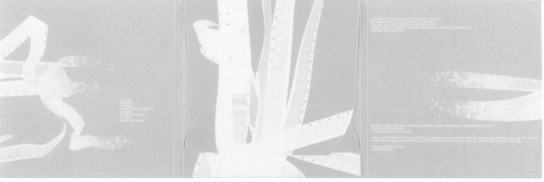

03 /

164

Lawrence English /
ROOM40

Label Owner /
Sound Artist

Brisbane,
Australia

04 /
A: Oren Ambarchi &
   Robbie Avenaim
T: Clockwork
F: CD
L: ROOM40
D: Lawrence English &
   Tim Nilsen
Y: 2005

05 /
A: Philip Samartzis &
   Lawrence English
T: One Plus One
F: CD
L: ROOM40
D: Lawrence English
Y: 2006

06 /
A: Philip Samartzis &
   Kozo Inada
T: H[]
F: CD
L: ROOM40
D: Lawrence English
Y: 2006

07 /
A: Text of Light
T: Rotterdam.1
F: CD
L: ROOM40
D: Lawrence English
Y: 2006

08 /
A: Richard Chartier        04 /
T: Current
F: CD
L: ROOM40
D: Richard Chartier
Y: 2006

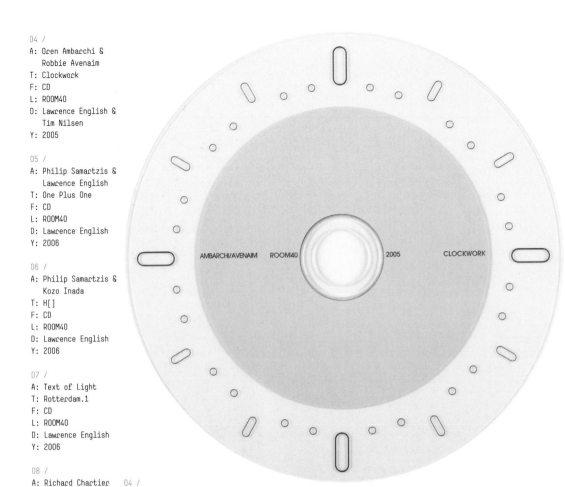

AMBARCHI/AVENAIM    ROOM40    2005    CLOCKWORK

165

Lawrence English /
ROOM40

Label Owner /
Sound Artist

Brisbane,
Australia

05 /

06 /

07 /

08 /

Lawrence English /
ROOM40

Label Owner /
Sound Artist

Brisbane,
Australia

09 /
A: Rod Cooper
T: Friction
F: CD
L: ROOM40
D: Lawrence English
Y: 2004

10 /
A: Chris Abrahams
T: Thrown
F: CD
L: ROOM40
D: Lawrence English
P: Tim Williams
Y: 2005

11 /
A: Zane Trow
T: For Those Who Hear
   Actual Voices
F: CD
L: ROOM40
D: Lawrence English
Y: 2004

12 /
A: Janek Schaefer
T: In the Last Hour
F: CD
L: ROOM40
D: Janek Schaefer
Y: 2006

13 /
A: M Rösner
T: Alluvial
F: CD
L: ROOM40
D: Matt Rösner
Y: 2005

14 /
A: Reinhold Friedl &
   Michael Vorfeld
T: Pech
F: CD
L: ROOM40
D: Lawrence English
P: Michael Vorfeld
Y: 2006

09 /

10 /

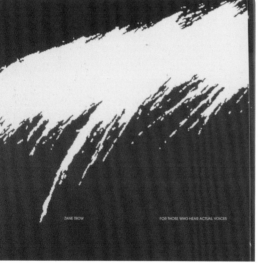

11 /

12 /

Lawrence English /
ROOM40

Label Owner /
Sound Artist

Brisbane,
Australia

13 /

14 /

# Rune Mortensen

**Name:**
Rune Mortensen

**Occupation:**
Graphic Designer

**Location:**
Oslo, Norway

**Website:**
www.runemortensen.no

**Biography:**
Rune Mortensen was born and raised in Flekkefjord, a small town in the south of Norway. After high school he moved to Oslo and started his education to become an art director. After graduating he spent two years working for Norwegian pioneer designer Egil Haraldsen, doing mainly book sleeves and film posters. He next worked in advertising at DDB Oslo. He started designing sleeves and posters for friends and slowly built up a network of contacts. After two years at DDB he left to concentrate on his own work. In 2000 he started his own studio focusing on the music and publishing industry.

01 /

**How would you describe your work?**
Working for small, independent record labels gives me a lot of freedom compared to my experience in the commercial industry. I can pretty much do whatever I want, and there are more or less no boundaries. I am free to do different styles depending on the music genre, and I try not to see myself as an artist with a certain signature to my work. I enjoy finding out new ways of visualizing the music.

**I detect similarities between your work and other Norwegian designers like Kim Hiorthøy. Do you consider your work to be Norwegian?**
I am sure you can find similarities in some of my sleeves, but that's just because I am a huge fan of Kim's sleeves and the fact that we both do sleeves for the same record label. But I don't think I have a Norwegian look. I think my sleeves are more influenced by the music genre they represent, rather than being Norwegian.

**There seems to be a lot of striking music coming out of Norway. What's it like being a record sleeve designer in Norway?**
I love it! I feel fortunate to be able to work with such talented people who give me the opportunities and artistic freedom to make my sleeves. The music scene that I concentrate my work around is small, but it also happens to represent some of my favourite music. The idea of giving the listeners a total package of both music and design is very important for many of the artists I work

with. I know that this is not the same in the more commercialized part of the industry, and it makes me even more glad to be working with the smaller and experimental music scene.

**Smalltown Superjazzz releases interesting music and gives work to adventurous designers. Can you tell me about your relationship with the label?**
Joakim Haugland, the label manager, is a childhood friend of mine. We grew up together and the label was created during high school. We had a lot of things going on together, mostly because nothing really happened in Flekkefjord. In addition to the label we also arranged concerts and we had our own small film club at the cinema. My job was mainly to make posters and fanzines for all the things that we had going on. When we moved to Oslo in the mid 90s the label grew bigger and got more attention both in Norway as well as abroad. It was now a natural progression for Joakim to add other designers to the label. We had always admired Kim Hiorthøy's work, and when Joakim released Kim's debut album, Kim also started making sleeves for other artists. Lately, foreign designers have been working with the label. Californian Geoff McFetridge made the sleeve for The Whitest Boy Alive, and Yamantaka Eye (formerly Yamatsuka Eye) from Boredoms has made the sleeve for the latest Smalltown Supersound release, Sunburned Hand Of The Man's album Fire Escape.

**Where do you stand on the question of digital downloads – does it mean the end of record sleeves?**
I hope not! There's nothing more satisfying than the smell of a new release printed on uncoated paper! But on the other hand digital download is here to stay. I believe that in 20 years time the most common way to manufacture and sell music will be via the Internet. But I still believe that the music will need the design and the identity that the sleeve provides, no matter what media it's delivered by.

**How much contact do you have with the musicians you design sleeves for?**
This varies. As I mentioned before, I am often free to do whatever I want. But sometimes the musicians or the record label have specific ideas about how they want their sleeves to look. Depending on the ideas being good or bad, I often find it necessary to work out some sketches from my point of view, and then try to turn it into a constructive discussion about which way the project should go. Sometimes I have to make compromises that I wish I didn't have to, but that's all part of the game.

**How important is it to like the music you design covers for? Could you design a cover for a band you didn't like?**
To make a living out of designing record sleeves in Norway, you can't be as selective as you might like. I make sleeves for all sorts of genres, from black metal to folk music, from jazz to electronica. So it goes without saying that

I don't like all the music that I do sleeves for. But for me, this is not a problem. I have a lot of freedom working for a music scene that is very close to my heart, so I feel confident with having an artistic side and then a not-so-artistic side. I don't feel like this compromises my work much, it just gives me the financial freedom to do the more experimental sleeves.

**Which Norwegian sleeve designers do you like?**
I admire what Yokoland and Grandpeople have accomplished in the last couple of years. They are young and ambitious and they have both managed to draw attention to themselves with their fresh, playful and humoristic style.

**Which international sleeve designers do you admire?**
Some sleeves are hard to forget: The Velvet Underground (design by Andy Warhol); Yoko Ono - Season of Glass (photograph by Yoko Ono); New Order - True Faith (design by Peter Saville); Sonic Youth - Goo (drawing by Raymond Pettibon); Pixies - Surfer Rosa (design by Vaughan Oliver); Dinosaur Jr - Green Mind (photograph by Joseph Szabo); Stereolab - ABC Music (design by Julian House); Aphex Twin - Windowlicker (design by The Designers Republic); Anthony and the Johnsons - I am a Bird Now (photograph by Peter Hujar). ■●

01 /
A: The Thing
T: Action Jazz
F: CD
L: Smalltown
   Superjazzz
D: Rune Mortensen
Y: 2006

02 / 03 /
A: Popface
T: Teardropper
F: CD
L: CCAP
D: Rune Mortensen
Y: 2006

02 /

03 /

04 / 05 /
A: Erlend Skomsvoll
T: Variasjoner
F: CD
L: Grappa
   Musikkforlag AS
D: Rune Mortensen
Y: 2006

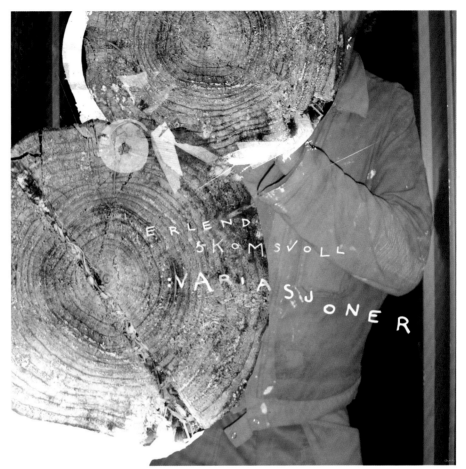

04 /

05 /

06 /

A: Cato Salsa
   Experience &
   The Thing with
   Joe McPhee
T: Two Bands and
   a Legend
F: CD
L: Smalltown
   Superjazzz
D: Rune Mortensen
P: Pål Nordseth
Y: 2007

06 /

07 / 08 / 09 /
A: Mats Gustafsson &
   Paal Nilssen-Love
T: Splatter
F: CD
L: Smalltown
   Superjazzz
D: Rune Mortensen
Y: 2007

07 /

08 /

09 /

10 / 11
A: Paal Nilssen-Love
   & Ken Vandermark
T: Seven
F: CD
L: Smalltown
   Superjazzz
D: Rune Mortensen
Y: 2006

10 /

# KEN VANDERMARK
# PAAL NILSSEN-LOVE
## SEVEN

1. First Hit, Second Fall (26:36)
2. Open Too Close (14:03)
3. Universal Funeral (3:19)

Ken Vandermark, tenor and baritone saxophone, Bb clarinet
Paal Nilssen-Love, drums and percussion

All compositions by Vandermark (ASCAP) and Nilssen-Love
(TONO/NCB). Recorded live at Blå on April the 1st,
mixed on December the 13th 2005 by Thomas Hukkelberg
at desibel.no. Live sound by Stig Gunnar Ringen. Produced
by Ken Vandermark and Paal Nilssen-Love. Co-produced by
Joakim Haugland. Photos and design by Rune Mortensen.
This recording is dedicated to Bjørnar Andresen.

www.smalltownsuperjazzz.com

SMALLTOWN SUPERJAZZZ

SMJZ

6 00116 84192 | NCB | STSJ119CD

℗© SMALLTOWNSUPERJAZZZ 2006

11 /

# Steve Byram

**Name:**
Steve Byram

**Occupation:**
Graphic Designer

**Location:**
New York, USA

**Website:**
www.screwgunrecords.com

**Biography:**
Born in 1952 in Oakland, California, Byram grew up in the 'artistic muck' that made up the late 1960s San Francisco Bay Area. He attended the Academy of Art in San Francisco in the mid 1970s, leaving California in 1979 for New York City, where he has resided since. Starting out as a junior designer for a small design firm that did work for Polygram Records, he has also been unemployed, a 'hanger-on' at Stiff Records America, an art director at RCA Records, an art director at CBS Records, an art director at Sony Music and a principal designer for the JMT, Winter & Winter and Screwgun labels.

01 /

**Much of your work is a sort of illustration/graphic-design hybrid. How do you describe yourself?**

I usually call myself a graphic designer since that is the step where it's all finally composed. However, I believe that graphic design includes anything one can throw into it. This would include illustration, design, painting, sculpture, photography, writing or anything else you can use to communicate with.

**Can you talk about your relationship with the Screwgun label?**

Ah, Screwgun. It's the label of the great sax player Tim Berne and it releases the music he makes in several different band configurations, and on occasion the music of his collaborators. Tim and I met in the mid 1980s when I was an art director for CBS Records. He'd just been signed to Columbia Records (part of CBS), and he'd seen a drawing of mine that appeared on a classical record. From that he decided that we had the same sensibility and requested that I do his cover. That was an amazing bit of deduction on his part. He was right, as it turns out, and we've worked together ever since. Columbia dropped him after 2 records, and he went on to record for the JMT label (later to become Winter & Winter). I met Stefan Winter, the owner of JMT, when Tim was doing the first Columbia recording. He ended up using the first cover I did that Columbia rejected on a JMT release. After that, I became the art director for JMT. So with the support of both Tim and Stefan, I fooled around doing all the things

they wouldn't let me do at CBS. When JMT was shut down by Polygram in the mid 1990s, Tim decided to start his own label, and invited me along for the ride. I've known Tim for more than 20 years, and we've built up a lot of trust between us. Tim has always given me a completely free hand. I've watched him evolve as a composer and a musician, and I've also seen my understanding of that music evolve and deepen, and as a result both I and my art have evolved. It's been an excellent long-term design lab — a very rich experience for me. He's the perfect client everyone hopes to have.

**This relationship makes you part of a noble tradition in sleeve design, where designers working with supportive labels are able to create a distinctive house style. Is this something you try to do with Screwgun?**

I don't think it was ever something I thought much about. The look is because I did it all and I have a pronounced signature that the label didn't try to sand smooth. I think that's true for the other labels as well: pronounced signatures, unedited.

**How does your approach differ when working with other labels? I'm thinking of your work for Winter & Winter, for example.**

I think the approach differs with each record, depending on its content. The music is different on Winter & Winter, so the design changes, and the W&W packaging format makes a difference, too. I'm slightly edited at W&W, so that affects the

outcome somewhat, but my process is my process no matter where I go. For the most part though, if I know I won't be messed with much, that knowledge makes me feel freer (which is essential for good work).

**Much of your work is in the progressive jazz sector. Can you see yourself working in other areas, and would you take on a purely commercial sleeve design project?**

I see it as a logical progression from the type of stuff I listened to as a teenager growing up in the San Francisco Bay Area during the late 1960s. Like the music from that era, art goes hand in hand with it, and seeing all that then is what inspired me to want to be what I became. Sure, I've done plenty of commercial sleeves, rent to pay... mouths to feed. Some I'll sign my name to, others not. At this point in my life I'd rather do projects that I find interesting and meaningful; however, those are two rare commodities in the music business nowadays, and often don't pay very well.

**Do you do any non-music projects?**

Gee, not that much — a book or a bookcover now and then, the occasional logo. I guess enough music stuff comes in still that I get distracted from going outside, even though I know that a design career in music alone is a fool's paradise at this point in time. It also seems that people outside music tend to see my work as 'too fine art' to be useful to them. But that may just be my own paranoia, or an excuse

on my part that allows me to avoid going out there.

**What is your view on the role of the musician in the sleeve design process?**

The musician should understand the process enough to realize that picking a designer to do your package is like picking a sideman. You can choose someone who is compatible with what you're trying to do, and you let them contribute to it, or you can get a hired hand to execute your vision. I prefer the former but have had some worthwhile experiences of the latter. Where you get into a mess is when they think they're doing the former but are really doing the latter.

**Can you talk about your attitude to collaboration with photographers, illustrators, etc?**

It's kinda like the way I see the role of the musician. I try to make the right choice and then let them have the pleasure of running with it. I also try to avoid having a real clear picture of how things will turn out: I like being surprised. I love to sit around and have philosophical discussions about the project, and I like to give vague parameters about the project. I also like to work with the same people a lot. You know, trust and evolution. All things get richer and more complicated with age. ■●

01 /
A: Guy Klucevsek &
   Alan Bern
T: Notefalls
F: CD
L: Winter & Winter
D: Stephen Byram
Y: 2007

02 / 03 /
A: Big Satan (Berne,
   Rainey, Ducret)
T: Souls.savedhear
F: CD
L: Thirsty Ear
   Recordings Inc.
D: Steve Byram
P: Robert Lewis
Y: 2004

02 /

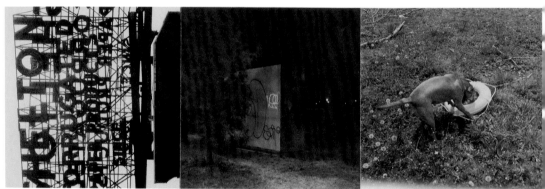

03 /

.......................................................................

04 / 05 /
A: Craig Taborn
T: Junk Magic
F: CD
L: Thirsty Ear
   Recordings Inc.
D: Steve Byram
Y: 2004

06 /
A: Drew Gress
T: 7 Black Butterflies
F: CD
L: Premonition Records
D: Steve Byram
P: Nancy Sacks
Y: 2005

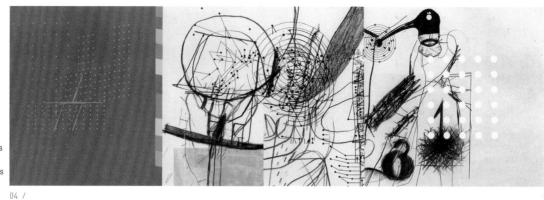

04 /

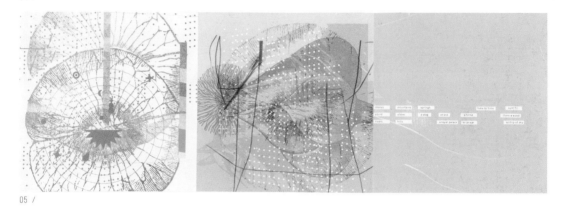

05 /

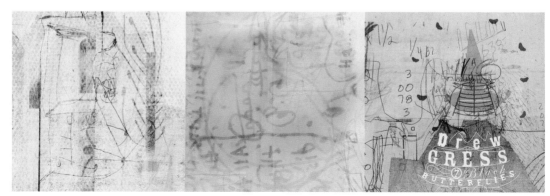

06 /

07 / 08 /
A: Hardcell
T: Feign
F: CD
L: Screwgun Records
D: Steve Byram
P: Robert Lewis
Y: 2005

09 /
A: Brave Old World
T: Dus Gezang fin Geto
   Lodzh/Song of the
   Lodz Ghetto
F: CD
L: Winter & Winter
D: Steve Byram
Y: 2005

tim suggests no type here

recorded with surpris.
.bathroom attendant:

07 /

hardcell −berne+taborn+rainey (                    feign)

08 /

mastering: splattercell/tom assistant: o.t. turbold intern: kevin lenhart .lunch by splattercell
this such a pleasure ....and of course the lovely b .artydesignstephenbyramallsmokelessholyshit

bhouse *in* rhinebeck may 12, 13 .engineer: hector castillo .ear management and
tom, craig, dt, hector, byram, lewis, looking glass and the clubhouse for making

all pictures robert lewis robertlewisphotography.com .web by jason tors .all tunes berne/ party music bmi
except pan/ex by taborn .screwgun is run by me for you so don't burn this for your friends

10 / 11 /
A: Christopher O'Riley
T: Hold Me to This:
   Christopher O'Riley
   Plays Radiohead
F: CD
L: World Village
D: Steve Byram
P: Wendy Lynch
Y: 2005

10 /

11 /

12 / 13 /
A: Paraphrase
T: Pre-Emptive Denial
F: CD
L: Screwgun Records
D: Steve Byram
Y: 2005

14 / 15 /
A: Big Satan
T: Live in Cognito
F: CD
L: Screwgun Records
D: Steve Byram
P: Jason Tors
Y: 2006

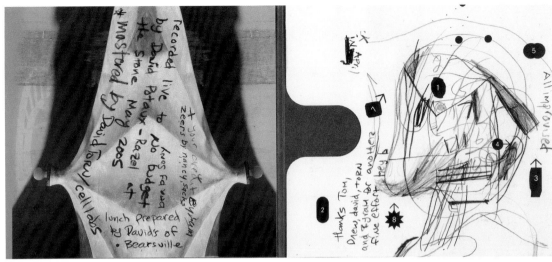

12 /

13 /

14 /

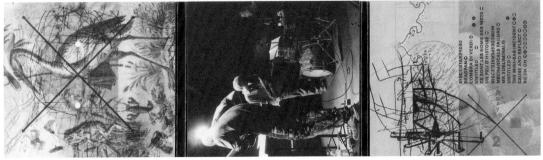

15 /

16 / 17 /
A: Uri Caine
T: Uri Caine Ensemble
   Plays Mozart
F: CD
L: Winter & Winter
D: Steve Byram
Y: 2006

16 /

17 /

18 / 19 / 20 /
A: Tim Berne and
   the Copenhagen Art
   Ensemble with Herb
   Robertson and
   Marc Ducret
T: Open Coma
F: CD
L: Screwgun Records
D: Steve Byram
P: Robert Lewis
I: James Sheehan,
   Dan Mandel,
   Rance Brown
Y: 2001

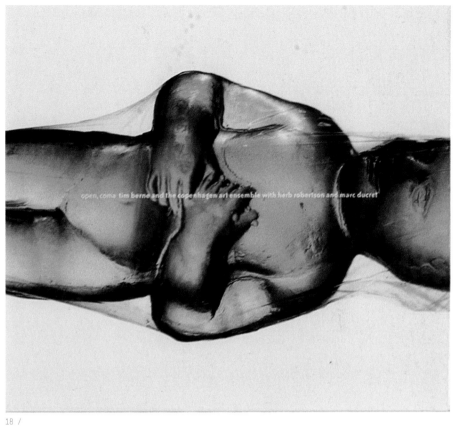

18 /

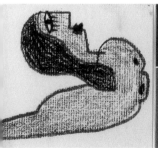

/

20 /

21 / 22 /
A: Ryuichi Sakamoto
T: Moto.tronic
F: DVD/CD
L: Sony Classical
D: Steve Byram
P: Kazunari Tajima
I: Jonathon Rosen
Y: 2003

21 /

Steve Byram          Graphic Designer                          New York,
                                                               USA

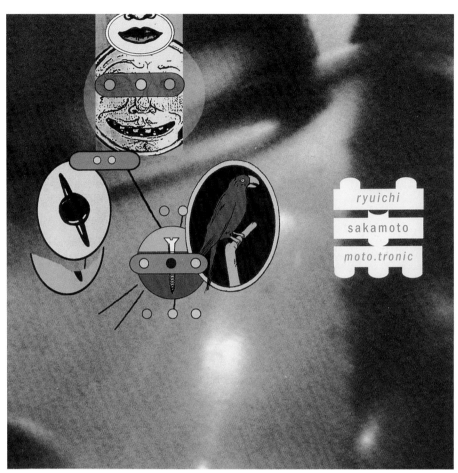

ryuichi
sakamoto
moto.tronic

22 /

23 / 24 / 25 /
A: Christopher O'Riley
T: Home to Oblivion:
   An Elliott Smith
   Tribute
F: CD
L: World Village
D: Stephen Byram
P: Wendy Lynch
Y: 2006

23 /

24 /

Steve Byram          Graphic Designer                                          New York,
                                                                               USA

25  /

190

Taylor Deupree /
12k

Graphic Designer /
Label Owner

New York,
USA

# Taylor Deupree / 12k

**Name:**
Taylor Deupree

**Occupation:**
Sound Artist, Graphic
Designer, Photographer
and Label Owner

**Label:**
12k

**Location:**
New York, USA

**Website:**
www.12k.com
www.taylordeupree.com

**Biography:**
Taylor Deupree is the
founder of the label
12k, which focuses
on minimalism and
contemporary musical
forms. He has released
over 80 CDs by a roster
of international sound
artists, and has
developed 12k into one
of the most respected
experimental electronic
labels. With sound
artist Richard Chartier,
Deupree formed LINE,
which documents work by
composers exploring
the aesthetics of
contemporary sound
installation work. Since
1993 Deupree has made
recordings for labels
worldwide, and curated
the ground-breaking
Microscopic Sound
compilation. His solo
works have explored a
fusion of digital sound
manipulation with
organic and melodic
textures that draw
on his interest in
architecture, interior
design and photography.

01 /

Taylor Deupree /
12k

Graphic Designer /
Label Owner

New York,
USA

191

**Are you formally trained in design?**
No. I studied photography at New York University and was introduced to computer imaging around 1990. The department had set up a digital imaging course and we learned how to paint and manipulate our photos on Amiga computers. Being involved in electronic music I had my own Macintosh in my studio and was already doing catalogues and cassette covers for the tape label that I had started in the late 1980s. Running this tiny label on no budget and producing cassettes, flyers, catalogues, etc. forced me to learn how to design by myself. Obviously the photographic training helped in a compositional sense, and I've always been a very visual person. Upon graduating from NYU with my photography degree, I landed (miraculously) the job as an art director at an NYC record label, without any knowledge of what a match print or PMS book was. Needless to say, I learned quickly. I love design and have been freelancing in NYC now for 14 years.

**You combine the role of designer, musician and label owner with great aplomb; how do you manage to juggle these different roles?**
The surprising thing about juggling all of these careers, alongside family, home ownership and the rest of life, is that I don't find it difficult. I do think about it a lot and believe that it boils down to a few things. First of all, passion. I am deeply passionate about my music and art. I live it and breathe it.

I think about it all day, every day, constantly researching studio technology, dreaming up new projects, creating sounds, photographing. The photographer in me is constantly looking and observing, and the musician in me is constantly listening to the world around me. So I have a need to simply 'get it done', so I make it happen and greatly enjoy doing it all. It's also quite important that I'm self-sufficient so when it comes to running the labels I can do everything myself. I also keep things very simple. Artist relations, contracts, etc. Simplifying the business flow means more time for creativity and less overhead costs. I think it's quite common knowledge that the more people involved in a project the more complicated, slow and mired it becomes. This is one area where my philosophy of minimalism, which runs through my whole life, affects everyday lifestyle. I keep it simple. It's essential for me to succeed in what I do. Sadly, I think my sleep also suffers! I'm the type of person who'd much rather be doing something creative than sleeping. So, unfortunately, in order to get everything done, sleep is one of the first things to go. But, really, you'd be surprised how much you can accomplish by staying focused, keeping things simple and loving what you do.

**You do some commercial design work; how does this differ from the work you do for your own label?**
It differs drastically, in the same way I'm sure it does for most designers. As a commercial designer you're not always hired so much for your own style, but simply because you can get something done well and on time. Unfortunately, even when I am hired for my style, the client will often change things to the point where it is no longer me. But these are pretty common realities for most commercial designers. It's just part of the job. Deadlines, budgets and client vision usually take precedence. For me, the two most common complaints I get from clients are 'the type is too small' or 'there's too much white space'.

**We are constantly being told that in the age of the digital download, music packaging is a thing of the past. Where do you stand on this?**
I definitely see that packaging is becoming less and less important for a lot of people, especially commercial music and larger labels. As a designer and label owner I have mixed emotions that really cloud a straightforward answer. I strongly believe that with 12k I produce not only music, but objects as well. And the physical object is important to the label. It helps create an aesthetic and I believe it sends out the message that I care about what I do. I think most of 12k's listeners are very aware of the design and I hope that it's one of the reasons they are interested in the label. Of course, design also has the ability to bring

in new listeners who may appreciate the visual aesthetic as they see it sitting on the shelf of a record store. When I was a teenager in the 1980s I used to visit my local alternative record store and buy albums by bands I had never heard of, based on sleeve design. The interesting thing is, I was usually right in my choices; the design often said a lot about what kind of music it was. It's funny now, because if I look back to those records that I bought based only on sleeve design, it was stuff mostly done by Neville Brody or Peter Saville, before I knew who they were, people who I now consider my design heroes.

**Will you miss liner notes and credits when everything is a download?**
In the music industry, amongst artists and producers, there is a lot of importance put on liner notes. Finding out who produced an album, or who played what instrument, or who the mastering engineer was, is really vital and sought-after information. When you download an album from iTunes you get nothing. You have no idea what or who went into the production of that music. It's pretty sad. I think the loss of information is as bad as the loss of an object and the visual aesthetic. On the other hand, I buy lots of music online as downloads and really enjoy it. So despite being very interested and concerned about packaging I am a big consumer of non-packaged music as well. When it comes down to it, it's the music that is the most important thing. But losing a package

192

Taylor Deupree /
12k

Graphic Designer /
Label Owner

New York,
USA

somehow makes the whole experience seem less complete, at least with the sort of music that demands a bit of thought or creative listening.

## What influences shape your work?

I'm influenced by a lot of architecture and art. Minimalism and modern design. Architects like Tadao Ando and John Pawson, and artists such as James Turrell, Harry Bertoia, Donald Judd. Peter Saville is my design hero. Photography by Hiroshi Sugimoto, Michael Kenna. All of this stuff influences my whole creative life. I'm also influenced a lot by my surroundings, by nature, by weather. In fact, most of the projects I do are based on a central theme or concept. Sometimes vague, sometimes specific – perhaps a photograph, or the lines of a piece of architecture.

## You are on record as saying that you rarely consider your work complete. This seems to be a feature of digital culture in general – we remix endlessly – but is it a good thing?

No, I don't think it is a good thing. It's too easy to get overwhelmed, to get lost, and that's why I impose restrictions and deadlines on myself. With music, especially, I am able to create and manipulate any sound to degrees unimaginable only 4 or 5 years ago. Audio is now as elastic (or more so) than digital imagery. One can tweak and edit and re-edit, over and over again, so it's a matter of self-discipline to tell yourself: 'this is my goal, this is my concept' and to know when you have reached it. It's really sort of a feeling, a sense of

almost euphoric feeling, when you have achieved the mix or the layout that you set out to create. I believe that the more tools we have available to us, the more important the role of editing becomes. To know when to use what tool and to know when to stop. Simplification has become more important than ever, and because of this my position as a minimalist is as valid as it's ever been. Minimalism can be applied not only to composition but to process as well.

Taylor Deupree /
12k

Graphic Designer /
Label Owner

New York,
USA

193

01 /

A: Gutevolk
T: Twinkle
F: CD
L: Happy
D: Taylor Deupree
P: Miho Kakuta &
   Taylor Deupree
Y: 2004

02 /

A: Antti Rannisto
T: Ääniesineitä
F: CD
L: 12k
D: Taylor Deupree
P: Taylor Deupree
Y: 2005

03 /

A: Seaworthy
T: Map in Hand
F: CD
L: 12k
D: Taylor Deupree
P: Taylor Deupree
Y: 2006

02 /

03 /

04 /
A: Taylor Deupree &
   Christopher Willits
T: Live in Japan
F: CD
L: 12k
D: Taylor Deupree
P: Taylor Deupree
Y: 2005

05 /
A: Minamo
T: Shining
F: CD
L: 12k
D: Taylor Deupree
P: Taylor Deupree
Y: 2005

Taylor Deupree /
12k

Graphic Designer /
Label Owner

New York,
USA

MINAMO SHINING

00:47:18

05 /

Taylor Deupree /
12k

Graphic Designer /
Label Owner

New York,
USA

196

06 /
A: Taylor Deupree
T: Stil. (Reissue)
F: CD
L: 12k
D: Taylor Deupree
P: Taylor Deupree
Y: 2006

07 /
A: Taylor Deupree
T: 1 am
F: CD
L: 12k
D: Taylor Deupree
Y: 2006

08 /
A: Fourcolor
T: Letter of Sounds
F: CD
L: 12k
D: Taylor Deupree
I: Keiichi Sugimoto
Y: 2006

09 /
A: Motion
T: Every Action
F: CD
L: 12k
D: Taylor Deupree
Y: 2004

06 /

07 /

Taylor Deupree /
12k

Graphic Designer /
Label Owner

New York,
USA

| | | |
|---|---|---|
| 01 | 82 | 06:34 |
| 02 | ROWBOAT (with Piana) | 04:57 |
| 03 | SEASON | 04:04 |
| 04 | FOUNTAIN | 04:47 |
| 05 | FLYAWAY | 06:36 |
| 06 | VIGNETTE | 06:23 |
| 07 | LEAVES | 14:19 |
| 08 | FRAME | 04:20 |

08 /

09 /

10 /
A: Moskitoo
T: Drape
F: CD
L: 12k
D: Taylor Deupree
I: Sanae Yamasaki
Y: 2007

11 /
A: Bretschneider &
   Steinbrüchel
T: Status
F: CD
L: 12k
D: Taylor Deupree
Y: 2005

12 /
A: Shuttle358
T: Chessa
F: CD
L: 12k
D: Taylor Deupree
Y: 2004

13 /
A: Frank Bretschneider
T: Looping I-VI
   (and other
   assorted love
   songs)
F: CD
L: 12k
D: Taylor Deupree
Y: 2004

14 /
A: Various
T: Blueprints
F: CD
L: 12k
D: Taylor Deupree
Y: 2006

15 / 16 /
A: Piana
T: Ephemeral
F: CD
L: Happy
D: Taylor Deupree
Y: 2005

10 /

11 /                        12 /

13 /                        14 /

199

Taylor Deupree /
12k

Graphic Designer /
Label Owner

New York,
USA

all tracks written, arranged and mixed, produced by piana
except for track 8: cello arranged by seigen tokuzawa

cello: seigen tokuzawa (2, 5, 8)
violin: gen saito (2) sayaka kuwabara (3)
guitar: yuichiro iwashita (1, 3)
piano, organ, guitar + voice: piana

special thanks to:

Taylor Deupree, Keiichi Sugimoto, Cubic Music, Risa Uzushiri,
Yuichiro Iwasita, Seigen Tokuzawa, Toshihiko Masuyoshi, Takahiro Mochida,
Yasuyo Toi, Sayaka Kuwabara, Hisayoshi Hayashi, Shinnosuke Takizawa,
Katsuhiko Maeda, Junji Kubo, Kaname Ito, Kensuke Arakawa,
Andreas Tilliander, Hiromi Sasaki, Anson Wu, Mickey Pan,
Friends and Family

www.12k.com/happy/piana

Piana ephemeral

| | | |
|---|---|---|
| 1. | なくしたもの | something is lost |
| 2. | 初夏 | early in summer |
| 3. | 僕のとなりで | beside me |
| 4. | 風色 | color of breeze |
| 5. | 小さな女の子の詩 | little girl poems |
| 6. | 空想の響 | muse |
| 7. | 母性愛 | mother's love |
| 8. | 月とチェロ | moon and cello |
| 9. | はじまり | beginning |

(P) + (C) 2005 Happy, distributed by 12k.
www.happy.12k.com

HAP003

200

Jan Lankisch /
Tomlab

A&R /
Art Director

Cologne,
Germany

# Jan Lankisch / Tomlab

**Name:**
Jan Lankisch

**Occupation:**
A&R and Art Director

**Label:**
Tomlab

**Location:**
Cologne, Germany

**Website:**
www.tomlab.com

**Biography:**
Jan Lankisch was born
in 1978, and first
started working in art
and graphic design when
he was 16 years old, as
an intern at a local
magazine. He then went
to work for a multi-
media agency where he
extended his education by
working on projects for
clients such as Nokia.
He studied design in
Cologne for 4 years, but
left without completing
his degree. In 2001,
he started working
for Tomlab, which was
then run solely by
the label's founder,
Tom Steinle. In the
beginning Lankisch did
several posters, working
as a freelancer, but a
year later he did the
label's first four
covers. By that time
there were more individual
designers involved, and
his role grew to include
both producing his own
in-house art and design
and also working closely
with other graphic
designers and artists.

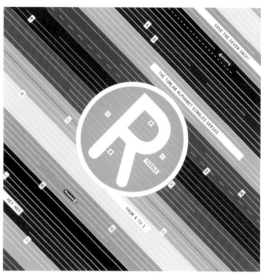

01 /

**How did Tomlab start?**
The label started in the fall of 1997. Tom Steinle started making music under the name VISOR with a couple of friends, and their music became Tomlab's first release. It was a CD-R release only. It started getting attention so he decided to make a small pressing of that one. That was the beginning.

**Where did the name come from?**
Tom's friend Jörg Follert (who later released music under the name Wechsel Garland) was also in VISOR and suggested calling the label 'Tom'. After 5 releases, Tom wasn't sure that this was a good way to continue the label, so he added the word 'lab'. That's when the real Tomlab was born.

**The German radical music scene is very strong, and I'm always struck by how much inventiveness there is in the cover art – why do you think this is?**
That's quite a hard question. I think European design is generally very strong.

**Is there a Tomlab look?**
Maybe in the beginning there was one. The label was mostly focused on electronic music then, and the covers were mostly illustrated. No photographs or anything like that. I am very happy that there is not a specific look anymore. We think that every artist should get their own unique look. There is no belief in a communal or uniform design aesthetic. The only identity comes from our love and devotion to the music we release.

**How do you include the thoughts and wishes of the bands and musicians in the design process?**
I'm very happy if the artist's vision of how the final product should look is so strong that I just have to lay out his or her ideas. So, in general, the artist decides how it turns out. In other situations I try to get their ideas and form something of my own, but still in close contact with the artist. I wouldn't do it on my own if I thought someone else could do it better. For example, the last Deerhoof album artwork happened because I introduced the band to David Shrigley. Both were 100% into working with each other on that project. So this is maybe the most wonderful thing that happens – to see that you are the connection to something you think works perfectly together. I wish this happened all the time!

**What aspects of the design process do you enjoy and what aspects do you dislike?**
In general I always feel like I have more ideas that I can reproduce. Some ideas develop into something in the end, others I carry around for ages as I feel they don't fit into an actual project. Sometimes I wish I could even reproduce the ones that are left in my head, but usually timing issues leave those as 'mind sketches'. Also, it's difficult to battle for something where you are absolutely convinced it would fit better, but the artist thinks differently about it. But I'm happy that these situations mostly turn into a longer discussion rather than an argument. I don't feel happy arguing about design ever. That's so selfish. I believe that if you feel you have a better idea, you can usually find a way to convince people. So, every project has both the artist and me in it. Likes and dislikes are part of every process. But the result is rarely ever a compromise.

**Which label's cover art do you admire?**
I think there are many, many great labels out there, using interesting designs on their releases. But if you only gave me a second to answer, there is maybe just one I would name: Teenbeat. Mark Robinson, who works on every release, is not only the most productive man I've ever come across, he also always come up with a 100% original design for every one of his releases. He has definitely got a signature style, and has created a whole new world of awesome stuff over the past 22 years. He was the most significant person for me back when I was a teenager. I was daydreaming all the time looking at the covers he did. I absolutely love this man.

**Is there a way of 'packaging' audio downloads so that they come with the digital equivalent of a cover?**
I've never been a fan of Macromedia Flash, but I think that is what most of the labels do these days to avoid offering a boring PDF. Even though I love the Internet, I believe so much in physical artwork that I would not really mind some extra packaging that I could keep somewhere in the depths of my hard disk. I think the new iTunes feature of having the covers like a library is quite nice. But I prefer to buy all the albums on vinyl and then get the MP3s right after to listen to all the time. So, when I love the cover, I grab the vinyl and stare.

**What will the record label of the future be like – will Tomlab still be commissioning covers in 10 years time?**
I hope so! I think I would stop working for the label immediately if it was only Flash-booklets or flashy, glowing PDF-Booklets. It's not that I want to sound old-fashioned, but I'm addicted to paper and the smell of printed artwork when it comes back fresh from the printer. Getting something nice done on beautiful paper is one of my main reasons for doing what I do. ■●

Jan Lankisch /        A&R /                                              Cologne,
Tomlab               Art Director                                         Germany

01 /
A: Various
T: The Tomlab Alphabet
   Singles Series
F: 7" Vinyl
L: Tomlab
D: Jan Lankisch
Y: 2004-2008

02 /
A: Deerhoof
T: Friend Opportunity
F: CD
L: Tomlab
D: David Shrigley
Y: 2007

03 /
A: Casiotone for the
   Painfully Alone
T: Etiquette
F: CD
L: Tomlab
D: Heidi Anderson
Y: 2006

04 /
A: Casiotone for the
   Painfully Alone
T: Bobby Malone
   Moves Home
F: CD
L: Tomlab
D: Anthony Lukens
Y: 2006

05 / 06 /
A: Deerhoof
T: The Perfect Me
   (Limited Edition)
F: 7" Vinyl
L: Tomlab
D: David Shrigley,
   Jan Lankisch
Y: 2007

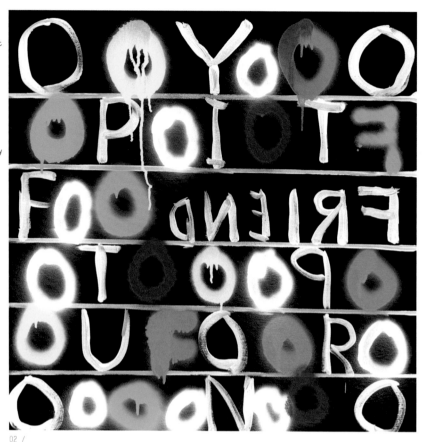

02 /

03 /

Jan Lankisch /
Tomlab

A&R /
Art Director

Cologne,
Germany

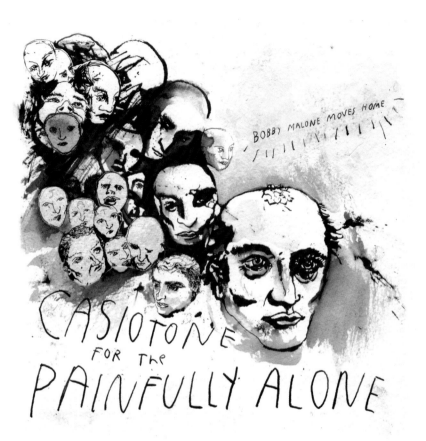

04 /

05 /

06 /

■O ●

204

Jan Lankisch /
Tomlab

A&R /
Art Director

Cologne,
Germany

07 /
A: Hey Willpower
T: PDA
F: CD
L: Tomlab
D: Amanda Kirkhuff
Y: 2006

08 /
A: Dog Day
T: Night Group
F: CD
L: Tomlab
D: Seth Smith
Y: 2007

09 /
A: Final Fantasy
T: Many Lives
F: CD
L: Tomlab
D: Lydia Klenck
Y: 2006

07 /

08 /

205

Jan Lankisch /
Tomlab

A&R /
Art Director

Cologne,
Germany

09 /

Jan Lankisch /
Tomlab

A&R /
Art Director

Cologne,
Germany

10 /
A: Les Georges
   Leningrad
T: Sur Les Traces
   de Black Eskimo
F: CD
L: Tomlab
D: Dominique Pétrin
Y: 2005

10 /

207

Jan Lankisch /
Tomlab

A&R /
Art Director

Cologne,
Germany

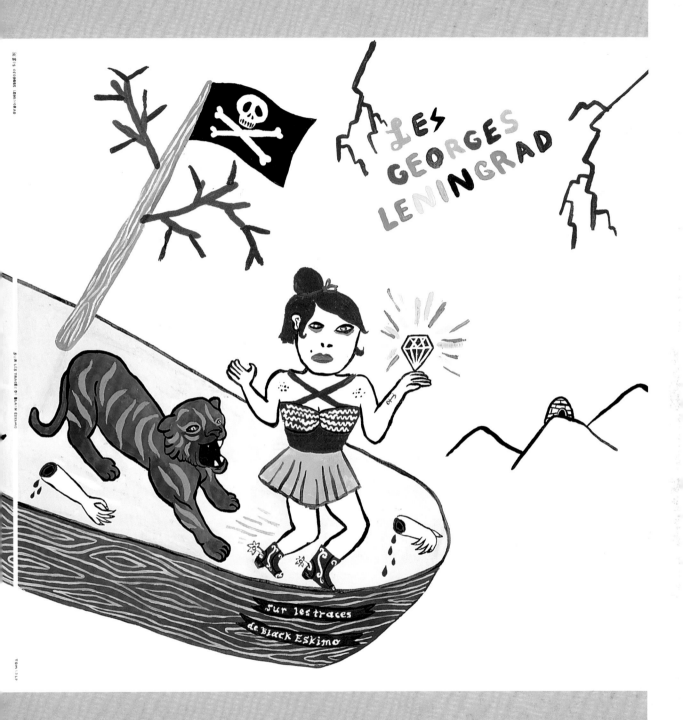

208

Mattias Nilsson /
Kning Disk

Label Owner

Gothenburg,
Sweden

# Mattias Nilsson /
# Kning Disk

**Name:**
Mattias Nilsson

**Occupation:**
Label Owner

**Label:**
Kning Disk

**Location:**
Gothenburg, Sweden

**Website:**
www.kningdisk.com

**Biography:**
Mattias Nilsson started
Kning Disk in 2005.
Although not a designer
and artist by trade,
he had done 'a lot of
different things in the
outer regions of art for
many years'. Kning Disk
was born of a desire
to 'combine sound-art,
music, art, design and
similar, doing most
of the productions
by hand in limited
editions; choosing the
best printers, the
best paper, different
formats, and combining
art and music and design
on a more or less equal
level in all products'.
Since starting Kning,
he has added two more
labels: SOUND + ART and
Gallery Editions.

01 /

**Where does the name Kning Disk come from?**
'Disk' means 'record' in Esperanto and Kning is a word that does not exist. It tastes good if you put it in your mouth, and it sounds good if you listen to it; so Kning Disk it is.

**What is the philosophy behind Kning Disk and the other labels you have, SOUND + ART and Gallery Editions?**
The aim for Kning Disk is to respect and raise the art of records. In a time when we are frequently downloading our music, we hope that Kning Disk can be the polar opposite, where craft, art and uniqueness are acclaimed. SOUND + ART and the Gallery Edition Series are two examples of the Kning Disk philosophy. In the SOUND + ART Series we connect a piece of art with a sound work to create a dialogue between the two. Gallery Edition Series is a limited-edition collection where the record is released in only 8 copies and it is exclusively distributed at a specific venue or exhibition.

**How important is cover art to this philosophy?**
I would say it is the whole foundation of Kning Disk. I make every cover by hand — from the graphic art, to printing, cutting, creasing, mounting, gluing and packaging. I feel a close affinity to a figure like William Morris, who wanted to raise craftsmanship to an art form.

**Yes, I can see the connection. Your sleeves seem to have a uniform typographic approach, and there is a high degree of black and white covers.**
I am fascinated by old woodcuts, lithography and Gutenberg aesthetics: simple, timeless and beautiful images, presenting themselves in a sober way. I work with old-fashioned techniques: screen-printing, foil- and blind-blocking (of both lettering and illustrations) and also lithographic and traditional offset. I do not want my design to compete with the musical content, but I want it to feel like a subtle consequence of some kind of purity and plainness. The typography is very important. I mostly work with roman text typefaces — typography that could be found in a medieval text and used until the mid 18th century. I collect black-and-white illustrations from this period.

**Do you set out to cultivate a Kning 'label look'?**
I would say that the Kning Disk series has a certain recognizable look. The individual releases could, in theory, look different from product to product, but since there is just one illustrator (me) there is obviously a certain resemblance here also — a Kning Disk look emerges. But apart from the look itself I hope, and consider it very important, that you will be able to feel the care behind the package when you hold it in your hands. I want it to be a unique and tactile sensation.

**Lots of your covers use illustration — what does illustration give you that photography doesn't?**
I've always felt a strong sensation and pleasure in looking at old illustrations. I've spent a lot of time improving myself in libraries and antiquarian bookshops around Europe.

**Do you ever use other sleeve designers?**
I make all the cover designs myself.

**What formats do you use?**
CD; CD-R 3" and 5"; vinyl 7", 10" and 12"; lathe-cut 8" and 9".

**How do you accommodate the preferences of the musicians you work with?**
It varies from case to case. I listen and create, and then I show the artist my suggestion. If there are any cases where interests differ (these are rare), I work on a new idea. Often I ask the artist for emotionally charged words describing the music, and on the basis of those I create something that I feel is both suitable for the musical content as well as having a clear Kning Disk profile.

**Where do you stand on the question of MP3 downloads?**
I do not see this as a threat. I think there is space both for fast and flexible downloads, and for the handmade package, which is unique and tells a good story.

**So you don't think digital downloading means the end of physical packaging for music?**
No, I think that in the future, if people are interested in music, they will have vinyl players in their homes. MP3 can never be a substitute for the need to experience music with our senses. I am not too sure about the CD's traditional jewel case in the long term, but I'm absolutely positive about vinyl and well-made CD packages persisting. Who knows, maybe we will see a demand for other 'slow' materials, for example lathe-cut discs. We have released (and are going to release) artists like Wolf Eyes, Kim Hiorthøy and Jim O'Rourke in this format. It is plastic, engraved by hand in real time by Peter King in New Zealand. That is craft in its essence! ■●

01 /
A: Joakim Pirinen &
   Mikael Strömberg
T: Afrika
F: CD
L: Kning Disk
D: Mattias Nilsson
I: Joakim Pirinen
Y: 2005

02 /
A: Dror Feiler
T: Zvug
F: CD
L: Kning Disk
D: Mattias Nilsson
Y: 2005

03 /
A: Dead Letters Spell
   Out Dead Words
T: Sally Hill EP
F: CD
L: Kning Disk
D: Mattias Nilsson
Y: 2005

04 /
A: BJ Nilsen
T: Silverliner
F: CD
L: Kning Disk
D: Mattias Nilsson
P: Andreas Nilsson
Y: 2005

05 /
A: Anla Courtis
T: Seattle Flow
F: CD
L: Kning Disk
D: Mattias Nilsson
P: Andreas Nilsson
Y: 2005

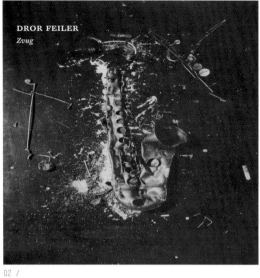

DROR FEILER
*Zvug*

DEAD LETTERS SPELL OUT
DEAD WORDS

*Sally Hill* EP

02 /

03 /

BJNilsen
*Silverliner*

ANLA COURTIS
*Seattle Flow*

04 /

05 /

Mattias Nilsson /          Label Owner                              Gothenburg,
Kning Disk                                                         Sweden

06 /
A: Tsukimono
T: Time Canvas
F: CD
L: Kning Disk
D: Mattias Nilsson
Y: 2007

07 /
A: Alvars Orkester
T: Pocket Transmitter
F: CD
L: Kning Disk
D: Mattias Nilsson
Y: 2006

08 /
A: Åke Hodell
T: Invokation
   (till Öyvind)
F: CD
L: Kning Disk
D: Mattias Nilsson
P: Åke Hodell
Y: 2005

09 /
A: Niclas Löfgren
T: Kontiko-con-tei-a
F: CD
L: Kning Disk
D: Mattias Nilsson
I: Niclas Löfgren
Y: 2005

06 /

**ALVARS ORKESTER**
*Pocket Transmitter*

07 /

**ÅKE HODELL**
*Invokation (till Öyvind)*

08 /

**NICLAS LÖFGREN**
*kontiko-con-tei-a*

09 /

■● 

212

Mattias Nilsson /
Kning Disk

Label Owner

Gothenburg,
Sweden

10 /
A: Leif Elggren
T: We are all Angels
   Born to Become
F: CD
L: Kning Disk
D: Mattias Nilsson
I: Leif Elggren
Y: 2006

11 /
A: Mats Gustafsson
T: Slide Away
F: CD
L: Kning Disk
D: Mats Gustafsson
P: Olof Madsen
Y: 2005

12 /
A: PO Ultvedt
T: Oavsett Smaken så
   Kostar Det
F: CD
L: Kning Disk
D: Mattias Nilsson
I: PO Ultvedt
Y: 2005

13 /
A: Ingar Zach
T: In
F: CD
L: Kning Disk
D: Mattias Nilsson
Y: 2006

**LEIF ELGGREN**
*We are all angels born to become*

10 /

**MATS GUSTAFSSON**
*Slide Away*

11 /

**P.O. ULTVEDT**
*Oavsett smaken
så kostar det*

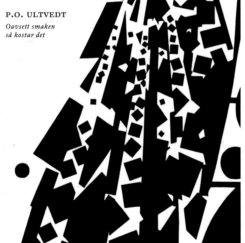

12 /

INGAR ZACH
*In*

KNING DISK

13 /

14 /
A: Wolf Eyes
T: Black Wing Over
   the Sand
F: CD
L: Kning Disk
D: Mattias Nilsson
I: Fredrik Söderberg
Y: 2007

15 /
A: Lasse Marhaug
T: Old Friends
F: CD
L: Kning Disk
D: Mattias Nilsson
Y: 2005

16 /
A: Pär Thörn
T: Just nu Händer
   det Ingenting -
   en Textmaskin
F: CD
L: Kning Disk
D: Mattias Nilsson
Y: 2006

17 /
A: Wolf Eyes
T: Untitled
F: CD
L: Kning Disk
D: Mattias Nilsson
Y: 2005

14 /

**LASSE MARHAUG**
*Old Friends*

15 /

**PÄR THÖRN**
*Just nu händer det ingenting*
*- en textmaskin*

16 /

**WOLF EYES**

17 /

18 /
A: Mike Magill
T: The Confluence of
   the Geat and the
   Raritan
F: CD
L: Kning Disk
D: Mattias Nilsson
Y: 2007

19 /
A: The Idealist
T: Half Men, Half Knings
F: CD
L: Kning Disk
D: Mattias Nilsson
Y: 2005

20 /
A: Perlonex by the
   Idealist
T: Untitled
F: CD
L: Kning Disk
D: Mattias Nilsson
I: Per-Isak Snälls
Y: 2005

21 /
A: Anders Dahl
T: Habitat
F: CD
L: Kning Disk
D: Mattias Nilsson
Y: 2006

**MIKE MAGILL**
*The confluence of the
Geat and the Raritan*

18 /

**THE İDEALIST**
*Half Men, Half Knings*

19 /

**PERLONEX BY
THE IDEALIST**

20 /

Anders Dahl                            *Habitat*

21 /

22 /
A: Maja Ratkje &
   Lotta Melin
T: Illegal Parking
F: 12" Vinyl
L: Kning Disk
D: Mattias Nilsson
Y: 2006

23 /
A: Playdo
T: For the First Time
F: CD
L: Kning Disk
D: Mattias Nilsson
Y: 2005

Maja Ratkje/Lotta Melin
*Illegal Parking*

22 /

**PLAYDO**
*For the First Time*

23 /

24 /
A: Giuseppe Ielasi &
   Nicola Ratti
T: Bellows
F: CD
L: Kning Disk
D: Mattias Nilsson
Y: 2007

25 /
A: Tom Bugs
T: Defekt
F: CD
L: Kning Disk
D: Mattias Nilsson
Y: 2005

26 /
A: Jasper Tx
T: So Now We're Ghosts
   No More
F: CD
L: Kning Disk
D: Mattias Nilsson
I: Dag Rosenqvist
Y: 2006

27 /
A: Nathan Thompson
T: Electrocuted
F: CD
L: Kning Disk
D: Mattias Nilsson
Y: 2006

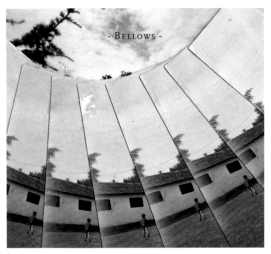

24 /

25 /

**JASPER TX**
*So now we're ghosts no more*

**NATHAN THOMPSON**
*Electrocuted*

26 /

27 /

28 /
A: Henrik Rylander
T: Public Loudspeakers:
   Information &
   Disinformation
F: Book & CD
L: Kning Disk
D: Mattias Nilsson
Y: 2007

29 /
A: James Blackshaw
T: Waking into Sleep
   Göteborg, 27.05.06
F: CD
L: Kning Disk
D: Mattias Nilsson
P: Dan Fröberg &
   Cecilia Bergman
Y: 2006

30 /
A: Birchville Cat
   Motel
T: Stellar Collapse
F: CD
L: Kning Disk
D: Mattias Nilsson
Y: 2005

**PUBLIC
LOUDSPEAKERS**

**INFORMATION &
DISINFORMATION**

HENRIK RYLANDER

29 /

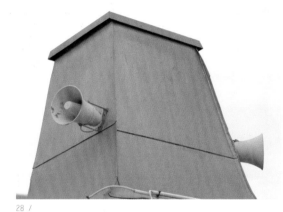

28 /

**BIRCHVILLE CAT MOTEL**
*Stellar Collapse*

30 /

31 /
A: LARM
T: From Mouth Cavity
   to Laptop
F: CD
L: Kning Disk
D: Mattias Nilsson
Y: 2007

32 /
A: Harris Newman
T: Dark Was the Night
F: CD
L: Kning Disk
D: Mattias Nilsson
P: Dan Fröberg &
   Cecilia Bergman
Y: 2006

33 /
A: Jerry Johansson
T: And a String
   Quartet
F: CD
L: Kning Disk
D: Mattias Nilsson
P: Dan Fröberg &
   Cecilia Bergman
Y: 2006

34 /
A: Steffen Basho-
   Junghans
T: In the Morning
   Twilight
F: CD
L: Kning Disk
D: Mattias Nilsson
P: Dan Fröberg &
   Cecilia Bergman
Y: 2006

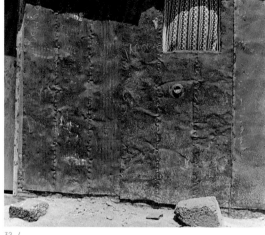

31 /

32 /

33 /

34 /

35 /
A: Folke Rabe &
   Jan Bark
T: ARGH!
F: CD
L: Kning Disk
D: Mattias Nilsson
Y: 2006

36 /
A: Martin Küchen &
   Erik Carlsson
T: Beirut
F: CD
L: Kning Disk
D: Mattias Nilsson
Y: 2007

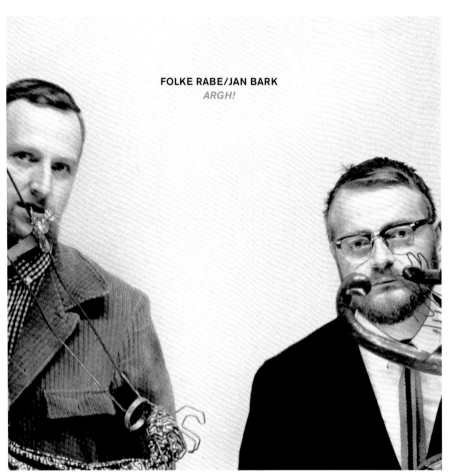

**FOLKE RABE/JAN BARK**
*ARGH!*

35 /

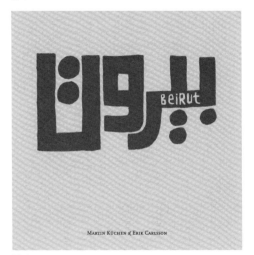

36 /

37 /
A: David Stackenäs
T: BOW
F: CD
L: Kning Disk
D: Mattias Nilsson
Y: 2006

38 /
A: Per Svensson
T: Beehive XI
F: CD
L: Kning Disk
D: Mattias Nilsson
Y: 2005

39 /
A: Jesper Norda
T: Tear Gravity
F: CD
L: Kning Disk
D: Mattias Nilsson
Y: 2006

40 /
A: Henrik Rylander
T: Found Sound
   Generator
   with Feedback
   Treatment
F: CD
L: Kning Disk
D: Mattias Nilsson
Y: 2005

37 /

38 /

39 /

40 /

221

Mattias Nilsson /
Kning Disk

Label Owner

Gothenburg,
Sweden

41 /
A: Sheriff
T: Sail, Sail,
   Sail Away!
F: CD
L: Kning Disk
D: Mattias Nilsson
P: Aron Jonason
Y: 2006

42 /
A: Erik De Vahl
T: The World Where
   No One Needs
   to Swim
F: CD
L: Kning Disk
D: Mattias Nilsson
I: Lisa Engström
Y: 2005

**SHERIFF**
*Sail, sail, sail away!*

41 /

42 /

222

Marc Richter /
Dekorder

Label Owner /
Sound Artist

Hamburg,
Germany

# Marc Richter / Dekorder

**Name:**
Marc Richter

**Occupation:**
Label Owner and
Sound Artist

**Label:**
Dekorder

**Location:**
Hamburg, Germany

**Website:**
www.dekorder.com

**Biography:**
Since the late 1980s,
when he was still in
high school, Marc
Richter has hosted radio
shows, written articles
and provided photography
for fanzines and has
been involved in various
record labels. After
moving to Hamburg, he
started the Dekorder
label in 2003. Around
the same time his
musical project Black
To Comm slowly emerged
and he began to design
record sleeves, post-
cards, ads and websites
for the label and for
his own music.

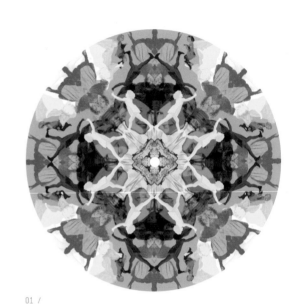

01 /

Marc Richter /
Dekorder

Label Owner /
Sound Artist

Hamburg,
Germany

223

**You have described Dekorder's releases as a new type of folk art?**
When I speak of folk art (and I use the term loosely), I'm trying to distinguish myself and the label from the academically trained art world. I'm a self-taught musician and designer and so are many artists on the label. Hence some of us have a healthy 'primitive' and 'naïve' attitude towards the creative process and don't even care if it is actually called art. Of course all that doesn't necessarily mean we're amateurs, but we try to find our own methods and ways around standard processes, leading us hopefully to more personal and individual conclusions. That said, I'm in no way working against the academic art world; just searching for different paths yet sometimes coming to similar conclusions. Additionally, the handcraft aspect of folk art attracts me. Although I spend a lot of time in front of my laptop I think it's certainly inspiring to work hands-on as often as possible, even though I wouldn't say I'm very talented in this area. I can't draw or paint and I'm not capable of playing any instrument in a traditional sense, but I still do these things anyway and use the results in my music and designs.

**Can you talk about the international and intercultural aspects of your label? How do you account for such open-mindedness?**
I have been involved in several musical genres and most of them seem allergic to any outside influences, and in my view this is obviously a dead end. There's so much music and art in every corner of the atlas, and dozens of different attitudes towards the perception of culture and what it could be. It would be stupid to ignore these and not to learn from them. It literally opens new ways of thinking.

**Would you say Dekorder has an implicit political or utopian vision?**
Implicit yes, explicit no. And I wouldn't even use the words 'political' or 'utopian'. But the label, our music and our artworks exist in a real world with real human beings and are not hermetically secluded from anything that happens in this world. The label reacts and responds to human experience and does not neglect what is happening outside the music world.

**Your music and its accompanying artworks weave together a multitude of styles and influences. How do you manage to do this without succumbing to cultural appropriation or merely emulating other people's work?**
It's actually quite difficult not to fall into that trap. The so-called information age (aka the Internet) makes it easy to just collect any amount of information and simply emulate it (modern technology is helpful, too). And the outcome might even be in some way 'different' and 'unique', but it will be missing the personal subjective approach, the human touch. It will be rendered interchangeable. So I try to learn from the multitude of sources, find their essence and how it blends with my life.

**You seem to acknowledge the symbiotic relationship between music and images, as evidenced in your first 10" release, where you produced sounds by using a filter that transformed pictures into sounds, and on your contribution to the MP3 label tu m'p3, where you created soundtracks to webcam pictures. Do you draw lines between the music and its cover or do you allow them to develop hand in hand?**
A symbiotic relationship is obviously there, isn't it? When working on a record I often have the sleeve design finished before the music is actually there. That's one reason why I prefer physical releases over downloads. I grew up with vinyl and the cover artwork was an important part of the whole picture. It could add to the mystery or completely destroy it. Music always comes as a whole package to my brain, and the artwork and track titles are some of my clues to the mind of the artist. Even a painting is only half as interesting without its given title. A MySpace page is not a substitute for that. On my first record I actually used the raw data files of particular pictures to produce sound. In the end it is only digital data but I do believe there can be some sort of telepathic undercurrents in the choice of material one uses. So I'm usually very careful when selecting raw material for my music. On that 10" I used the sound of data of pictures of a mother and combined it with sound files of her daughter, who is supposed to be the black sheep of the family. Sounds pretentious but it

blended perfectly. Regarding the soundtrack to the webcam picture, the music and photo are not interconnected at all though. They're both beautifully void snapshots of sound and colour without any philosophical significance, but in my view, this is what connects them.

**Most of your label's covers were designed by you or the musicians themselves. Would you ever consider working with other artists?**
I would probably consider doing so in certain cases but generally I prefer internal processes. Usually the musicians do the artworks themselves or bring in a friend. In all other cases we have done the artworks ourselves. Sometimes it would be easier to send some money to an artist I admire and ask for an artwork, but I think it's more challenging (and, in the end, more beneficial to everyone involved) to do it ourselves. And usually the money isn't available anyway. I'm very interested in musicians with a clear visual far-sightedness to their works, which is one reason why I embraced the new Finnish Underground (Kuupuu, Uton, Tomutonttu) so warm-heartedly as soon as I discovered it.

**How do you see the role of cover art evolving as music becomes increasingly digital?**
Cover art seems to have been replaced by small JPEGs, websites, MySpace and YouTube pages, and I'm not happy about it. Even albums themselves seem to be disappearing and people's record collections are becoming an incoherent aggregation of tracks on their hard

224

Marc Richter /
Dekorder

Label Owner /
Sound Artist

Hamburg,
Germany

disc. But people have a choice, and no one is really forcing them to go this way. So there's not much I can do about it except continue to work on a different route. I don't think a complex story can be told in one single track most of the time. And more people seem to be working with film and DVD formats to present their music, which can be a fertile combination, but very often isn't. In this case I think both media are too strong to co-exist and the visual aspect often drowns out the sound. Personally I chose the opposite way and returned to releasing vinyl-only albums instead of digital media in many cases. And it works.

**You were involved in other record labels, radio shows and concerts before starting your own label. How would you compare the challenges that you're facing now as the owner of an independent label?**
The challenge is doing all the work myself (which at the same time is the benefit of doing it). The restrictions are usually of a financial nature but can be reversed into a (positive) challenge as well. For the most part, it has created more freedom of artistic expression for myself and the musicians involved; fewer barriers, less bureaucracy, more creativity, less money, more work, less time, more fun!

**What do you think about the present state of the experimental music and design scene in Germany?**
I can't really comment on any design scene since I'm not well informed about it. In general I think most of

the designs I'm seeing are too formulaic and too much alike, whether they're from Germany or somewhere else. There are several amazing German painters deeply involved in music such as Daniel Richter (who runs the Buback label), Albert Oehlen (who runs the Leiterwagen label and is a member of The Red Krayola), Jonathan Meese (who releases music under various guises on his New Amerika label), and younger artists such as Andreas Diefenbach (who ran a record shop in Hamburg and is doing one of the next Dekorder sleeves). Bonds between the visual and aural arts seem to be very strong indeed. The experimental music scene in Germany is re-inventing itself every decade: Krautrock changed rock music forever in the 1970s (Faust, Harmonia, Can, Neu, Cluster); Neue Deutsche Welle ended the English language regime in the early 1980s with German Dada lyrics and crude electronics; and finally Minimal Techno influenced thousands of bedroom producers around the world in the 1990s. I'm not sure what the current decade will stand for. Possibly a multitude of styles and personas co-existing side by side but it's easier to pinpoint that in retrospect.

**Can you name some sleeve designers or labels that you find inspiring?**
In general I like artworks that don't just look like a design for a product because music is not a commercial product. I like cheap handmade CD-R designs although these are becoming way too formulaic as well with all the similar spray-painted collage artwork

around. Jan Anderzén is an adept master of these techniques. At the same time I like spectacular sleeves such as Hipgnosis' work for Led Zeppelin, Syd Barrett and Pink Floyd. Vintage Musique Concrète LPs always seem to have gorgeous sleeves as well. And I love the cliché Black Metal misty-forest-with-ornate-band-logos stuff. Most of the time it seems dangerous to me when labels use in-house designers for all sleeves or even serial artworks (except when it actually is a series of related recordings). Every record is different and needs a different look. My favourite label when it comes to design is Drag City from Chicago. Perhaps not an obvious choice, but they have released dozens of great albums (The Red Krayola, Royal Trux, Gastr de Sol and many others) with amazing artwork that acknowledges the strong distinctions from artist to artist and record to record. Admittedly, they have put out some very bad-looking stuff as well, but that's the risk when you're trying to produce genuine material for each album. ■●

Interview by Angelina Li

225

Marc Richter /
Dekorder

Label Owner /
Sound Artist

Hamburg,
Germany

01 /
A: Black to Comm
T: Levitation/
   Astoria
F: Lathe Cut Picture
   Disc
L: Self release
D: Marc Richter &
   Renate Nikolaus
Y: 2006

02 /
T: Black to Comm
F: Postcard
D: Marc Richter
Y: 2006

03 /
A: Black to Comm
T: Rückwärts Backwards
F: CD
L: Dekorder
D: Marc Richter &
   Renate Nikolaus
Y: 2006

02 /

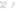

03 /

■● 
226
Marc Richter /
Dekorder

Label Owner /
Sound Artist

Hamburg,
Germany

04 /
A: Guido Möbius
T: Dishoek
F: CD
L: Dekorder
D: Marc Richter &
   Renate Nikolaus
Y: 2005

05 /
A: Un Caddie Renversé
   dans l'Herbe
T: Like a Packed
   Cupboard but
   Quite...
F: CD
L: Dekorder
D: Marc Richter
Y: 2004

06 /
A: Black to
   Comm/Aosuke
T: s/t
F: Split-LP
L: Dekorder
D: Marc Richter
Y: 2007

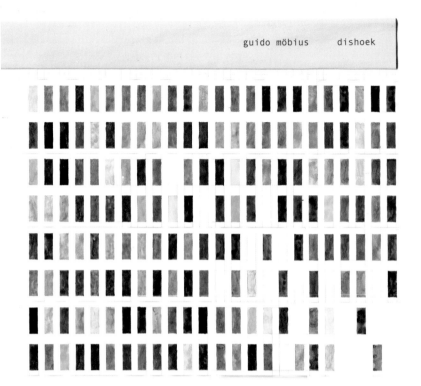

guido möbius    dishoek

04 /

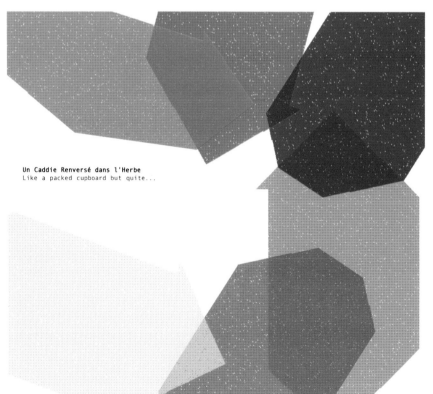

**Un Caddie Renversé dans l'Herbe**
Like a packed cupboard but quite...

05 /

Marc Richter /
Dekorder

Label Owner /
Sound Artist

Hamburg,
Germany

06 /

228

Marc Richter /
Dekorder

Label Owner /
Sound Artist

Hamburg,
Germany

07 /
T: Dekorder 003-006
F: Postcard
D: Marc Richter
Y: 2003

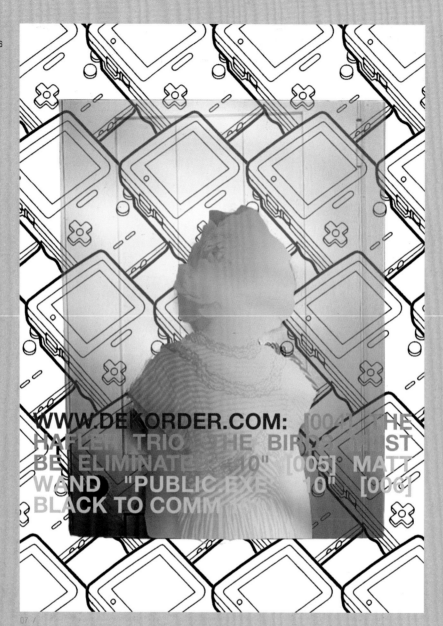

07 /

Marc Richter /
Dekorder

Label Owner /
Sound Artist

Hamburg,
Germany

08 /
A: Kuupuu
T: Unilintu
F: LP
L: Dekorder
D: Jonna Karanka
Y: 2007

09 /
A: Antonia Leukers
T: Hasenlove
F: LP Picture Disc
L: Dekorder
D: Renate Nikolaus
Y: 2007

08 /

09 /

230

Marc Richter /
Dekorder

Label Owner /
Sound Artist

Hamburg,
Germany

10 /

A: John Hegre
T: Colors Don't Clash
F: CD
L: Dekorder
D: Yasutoshi Yoshida
Y: 2006

11 /

A: Uton
T: Alitaju Ylimina
F: LP
L: Dekorder
D: Christelle Gualdi
Y: 2007

10 /

11 /

■□● 231

Marc Richter /
Dekorder

Label Owner /
Sound Artist

Hamburg,
Germany

12 /
A: Uton
T: Alitaju Ylimina
F: LP
L: Dekorder
D: Jani Hirvonen
Y: 2007

13 /
A: Un Caddie Renversé
   dans l'Herbe
T: Now There's a Weird
   Taste in my Mouth
F: 3" CD
L: Dekorder
D: Marc Richter &
   Renate Nikolaus
Y: 2003

14 /
A: Un Caddie Renversé
   dans l'Herbe
T: Atlas saltA
   [Map Lies, Border
   Lies...]
F: 3" CD
L: Dekorder
D: Marc Richter &
   Renate Nikolaus
Y: 2005

15 /
A: Kuupuu
T: Yökehrä
F: LP
L: Dekorder
D: Jonna Karanka
Y: 2006

12 /

13 /

14 /

15 /

232

Kim Hiorthøy /
Rune Grammofon

Designer

Berlin,
Germany

# Kim Hiorthøy / Rune Grammofon

**Name:**
Kim Hiorthøy

**Occupation:**
Designer

**Label:**
Rune Grammofon

**Location:**
Berlin, Germany

**Website:**
www.runegrammofon.com

**Biography:**
Kim Hiorthøy was born
in Trondheim, Norway
in 1973. After study-
ing fine art gradually
'skidded' into a career
as a freelance graphic
designer. In 1998 Rune
Kristoffersen set up
an independent record
label, Rune Grammofon,
and took Hiorthøy on
as in-house (although
physically out-of-house)
designer. So far the
label has put out over
60 records and continues
to thrive. Hiorthøy has
published books and
released a number of CDs
and LPs.

01 /

**First, a question that will embarrass you. Rune Mortensen and Grandpeople, both of whom I've interviewed for this book, cite you as a major influence. Magnus from Grandpeople said you have been a 'great inspiration for young people in Norway for many years now'. How do you feel about becoming the father figure of the Norwegian design scene?**
They have been just as much of an inspiration for me over the years as well. I vividly remember the first time I saw Grandpeople's work. It was just a tiny flyer, but it made me try and figure out who 'Grandpeople' were. I don't feel very much like a father figure.

**Well, father figure or not, you design record sleeves for other labels, but I'd like to concentrate on your work for the Rune Grammofon label. In a recent interview you've talked about the difficulty of retaining 'immediacy' while maintaining RG's look. Can you talk about this?**
It's trying to balance keeping a kind of recognizable style while at the same time making something new.

**You have established certain recurring themes and conventions in Rune Grammofon sleeves – are you now itching to throw them out?**
I feelfree to throw out recurring themes now, and do so more and more often. That also makes it easier to sometimes go back to them. It's a balance. I try to be open about it.

**Can you describe how the Rune Grammofon design process works?**
Mostly it's me sitting down and designing the cover and then I send it to Rune for approval. He usually stays in touch with the artists and passes it on to them. Sometimes they send me ideas or we enter into a dialogue, but most often not. Some sleeves I agonize over for weeks and weeks and deliver them long after they're due; some sleeves come along quite fast. I don't sketch but I do a lot of finished work that I end up abandoning.

**You use a variety of graphic and illustrational motifs for Rune Grammofon sleeves – how do you come to a decision about this?**
This may sound arrogant, but mostly it's just what I think fits the record, or a combination of that and what I'm inspired by at the time. It's sometimes dictated by a feeling that it should be different from the previous cover. This is a pretty vague design strategy (if you can even call it that) and I don't know that I can really justify it.

**You have established Rune Grammofon as a highly distinctive label with its own striking visual identity. Does this ever pose problems with some of the artists who record for the label – do they ever want to rebel against your 'look' and have their names in 36pt Palatino with a drop shadow?**
Very rarely. I think most of the artists who release music on Rune Grammofon choose to do so because they like the label and want to be part of it. I have a feeling some of the

younger people on the label think I'm a selfish bastard who won't listen to them. And in a way maybe it's wrong that they don't get to make their own sleeves or that it's not more of a collaboration. Rune and I made some decisions when we started and we've just stuck to them. Perhaps it should change.

**Rune Kristoffersen, who runs the label, is keen to establish his label's Norwegian credentials. You live in Berlin and you work internationally. Do you have to 'find' your Norwegian soul when you work with Rune Grammofon?**
Embarrassingly, I only just realized that the first words that appear on the label's website are: 'Rune Grammofon is a record label dedicated to releasing work by the most adventurous and creative Norwegian artists and composers.' I've never thought of it as a particularly Norwegian thing. I don't believe so much in a Norwegian 'soul', I suppose. I like to think that the Rune Grammofon sleeves aren't from particularly anywhere, but maybe I'm in denial.

**Like an increasing number of designers today, you also make music. Does designing covers for your own records differ from doing them for others?**
I try not to be self-conscious, which I guess is just another way of being self-conscious. I asked Grandpeople to do a sleeve once, but then afterwards I said I wanted it to be a collaboration, and then I couldn't keep my hands off it. Which I suppose makes me a hypocrite, as well as an ego-maniac.

**I've spoken to people who work for big labels about your work. They tell me how much they like your work, but they seem to pull back from actually commissioning you. Why do you think this is? Are you too dangerous to work with?**
I don't see why I would be considered 'dangerous', but perhaps the work doesn't look like it's done by someone who it would be easy to reason with? Or maybe people think if they commission me they'll just get work that, even if they like it, is not really what they're looking for. Personally, I'd rather commission someone to do something I haven't yet seen (either in their work or in anyone else's) but which I think they could do, rather than have someone repeat something they've already done. I don't know if it's true about me, but for anyone it's dangerous to become a 'branded' graphic designer, even if it's just in a small way. It makes you broke.

**Now the question I'm asking everyone – where do you stand on digital downloads?**
The older I get the more I believe in anarchy and the less I believe in ownership. If you want to control something you should set it free.
◼●

01 /
A: Nils Økland
T: Bris
F: CD
L: Rune Grammofon
D: Kim Hiorthøy
Y: 2004

02 / 03 /
A: Phonophani
T: Untitled
F: CD
L: Rune Grammofon
D: Kim Hiorthøy
Y: 2006

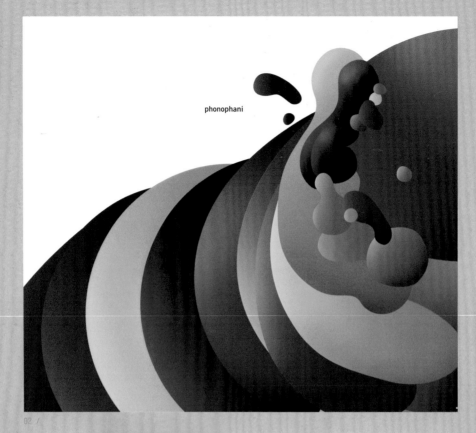

phonophani

02 /

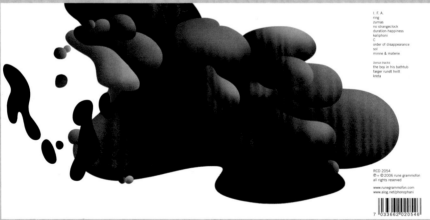

I. F. A.
ring
zurnas
no strangeclock
duration-happiness
kaliphoni
C.
order of disappearance
sol
minne & materie

bonus tracks
the boy in his bathtub
farger rundt hvitt
kreta

RCD 2054
℗ + © 2006 rune grammofon
all rights reserved

www.runegrammofon.com
www.alog.net/phonophani

7 033662 020546

03 /

04 /
A: Food
T: Last Supper
F: CD
L: Rune Grammofon
D: Kim Hiorthøy
Y: 2004

05 /
A: Monolight
T: Free Music
F: CD
L: Rune Grammofon
D: Kim Hiorthøy
Y: 2002

06 /
A: Alog
T: Miniatures
F: CD
L: Rune Grammofon
D: Kim Hiorthøy
Y: 2005

04 /

05 /

06 /

07 /
A: Scorch Trio
T: Luggumt
F: CD
L: Rune Grammofon
D: Kim Hiorthøy
Y: 2004

08 /
A: MoHa!
T: Norwegianism
F: CD
L: Rune Grammofon
D: Kim Hiorthøy
Y: 2007

09 /
A: Maja Ratkje
T: Voice
F: CD
L: Rune Grammofon
D: Kim Hiorthøy
Y: 2002

07 /

08 /

237
Kim Hiorthøy /
Rune Grammofon
Designer
Berlin,
Germany

09 /

■●

238

Kim Hiorthøy /
Rune Grammofon

Designer

Berlin,
Germany

10 /
A: MoHa!
T: Raus Aus Stavanger
F: CD
L: Rune Grammofon
D: Kim Hiorthøy
Y: 2006

A2 / B1 /

anders ha
morten j.

RCD 2049
℗ + © 20
all rights

www.rune
www.n-co

7  033

recorded in athletic sound, halden, august 8 and 9, 2005
engineered by kai andersen, mixed by kai andersen and moha!
produced by moha!
mastering by audun strype at strype audio

executive producer rune kristoffersen

sleeve by kim hiorthøy

239

Kim Hiorthøy /
Rune Grammofon

Designer

Berlin,
Germany

/ A4 / B5

der3

moha!
raus aus stavanger

ff, noxagt, ultralyd, andrew d, jaga,
ve, frode g, johs wb, ingebrigt, john h,
st and the n-collective

collective

utøvende kunstnere

11 / 12 /
A: Shining
T: Grindstone
F: CD
L: Rune Grammofon
D: Kim Hiorthøy
Y: 2007

13 / 14 /
A: Opsvik & Jennings
T: Commuter Anthems
F: CD
L: Rune Grammofon
D: Kim Hiorthøy
Y: 2007

11 /

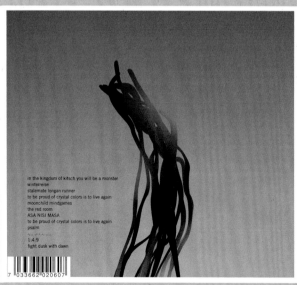

12 /

opsvik & jennings
commuter anthems

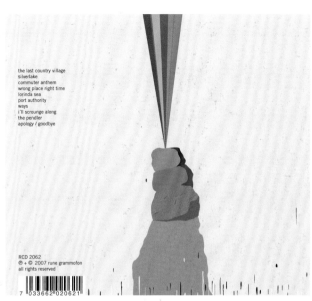

the last country village
silverlake
commuter anthem
wrong place right time
lorinda sea
port authority
ways
i'll scrounge along
the pendler
apology / goodbye

RCD 2062
℗ + © 2007 rune grammofon
all rights reserved

13 /

14 /

# Mathias Pol & Nicolas Motte / Check Morris

**Names:**
Mathias Pol and
Nicolas Motte

**Occupations:**
Designers

**Studio:**
Check Morris

**Location:**
Paris, France

**Website:**
www.checkmorris.com

**Biography:**
Mathias Pol and Nicolas
Motte met at the same
graphic design school in
Paris. They were both
'kicked out a few weeks
before our final exam',
an event that was to
start their professional
collaboration. Their
studio took off in 2003,
when they were commis-
sioned to do a poster
for the cult movie
Wanda. This was their
cue to become their own
boss and focus solely
on Check Morris. Today
they work for a variety
of labels — majors and
independents — both in
France and in the UK.
They have described
themselves as working
with 'four hands on
an image. One has an
abstract vision of
composition and image.
The other has a more
intellectual approach
to it.'

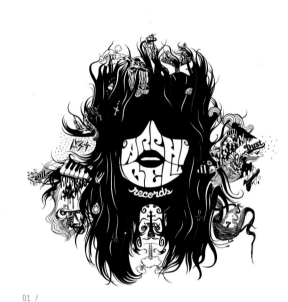

01 /

**You have an unusual name. Where does it come from?**
We wanted a name that was like the meeting of an umbrella and a sewing machine on a dissecting table. We wanted it to be an absurd and tacky name, something stupid that someone might grasp the sense of when there isn't one in the first place.

**Your work seems to be a fusion of illustration and graphic design. How would you describe it?**
We try to give life to our work by any means of expression. It really depends on the story we tell and the universe we build. Sometimes we only use drawings, sometimes we're mixing everything in a sort of 'total combination'. We have a certain taste for redrawing things. If we like a font or something, we'll never use it as it is. We will always give a new life to any item we use by redrawing it, or changing it. Combining one image with another often creates a new meaning, another dimension. The different techniques we use help to make these oppositions, which in turn create our personal universe.

**What are your influences?**
They are extremely numerous and varied but not necessarily visible in our work. They come mainly from pop culture and, like all 'Frogs', we border on the line between snobbery and bourgeoisie. Seriously, we brew everything we love in all art domains to produce a sort of 'personal booze'.

**You seem to work as a genuine partnership. On your website you say that you both work on the same job. Can you talk about this?**
Working together is a fragile alchemy. Mutual trust and admiration are vital, but sometimes one is forced to convince and seduce the other. And sometimes it can be a violent seduction. By confronting each other's work, we obtain a very different result from that which we would achieve if we worked independently. It really becomes a way of emancipation for us. It pushes us further.

**What percentage of your work is music related?**
After doing a few sleeves for friends like Chok Rock and Scratch Massive, we were spotted by Lily Allen and ended up doing her artwork, which helped put us in the spotlight with other labels. Since then, the music industry has been our main source of income. We still continue working on advertising, illustration and movie poster projects, along with the odd video.

**What sort of labels are you working for?**
Both major and independent ones. Our first job in the music industry was a sleeve for Warp. Then other independent French labels such as Chateau Rouge and Archibell records. After that, EMI UK, a major, hired us. Recently we took on the art direction of Dialect Recordings, and continue to work with English independent labels such as Southern Fried Records. In parallel, majors are still ready to work with us, so we're on 'both sides'.

**Can you describe a typical design project?**
People usually ask us to do something that looks like another job we have already done. We always try to do something new, which is better, and then, usually, they are happy.

**Tell me more about the Lily Allen album cover. The record has been a commercial success - was it different from other jobs you've worked on?**
Lily Allen knew our work and wanted us to do all the artwork for her straightaway. As with all big contracts, it ended up being a competition with other designers, which we were lucky to win. They were interested in a mixture of photography and illustration, something we had only tried our hands at on a few occasions before. As everyone seemed to think the record was going to be a big success we were expecting a lot of pressure from the label. But it was stimulating to see the amount of freedom that a major was willing to give us. In the end, this job was no different from any other, it just meant a lot more visibility for us (even if we forgot to put our name on the album cover!).

**What do you think of the current French design scene?**
We are not really conscious of a French scene, rather of a few individuals working in their separate corners. We love and admire some of them, but there's not a special French style. In fact, you may be more able to judge if there's one or not...

I'm a big fan of French graphic design, and I get cross with my French friends who say things are better in the UK. I'm not so sure about that. Can you name some other record sleeve designers that you admire?
We love so many of them. Here's a non-exhaustive list of 10 classic record sleeves that changed our lives for different reasons: Unknown Pleasures-Joy Division; Wish You Were Here-Pink Floyd; Revolver-The Beatles; 200 Motels-Frank Zappa; Autobahn-Kraftwerk; Goo-Sonic Youth; Let it Bleed-The Rolling Stones; Hazy Shade of Criminal-Public Enemy; Bitches Brew-Miles Davis; Hi, How Are You?-Daniel Johnston.

**There are some great covers in that list. What about the MP3 revolution - will record covers still exist in 5 years time?**
For us, MP3s are nothing. We're vinyl junkies. When audio tapes and CDs were introduced, people were making exactly the same kind of remarks. Although the market is no longer as strong, we hope that vinyl will never die. It has bigger images! ◼●

Mathias Pol & Nicolas Motte /          Designers                              Paris,
Check Morris                                                                  France

01 /
T: Generic cover for
   Archibell Records
F: 12" EP
D: Check Morris
Y: 2006

02 /
A: Riton VS Lindstrom
T: Monsteer
F: 12" EP
L: Battle Recordings
D: Check Morris
Y: 2007

03 /
A: Chin Chin
T: Chin Chin
F: 12" EP
L: Dialect Recordings
D: Check Morris
Y: 2007

04 /
A: Chin Chin
T: Toot D'Amore
F: CD
L: Dialect Recordings
D: Check Morris
Y: 2007

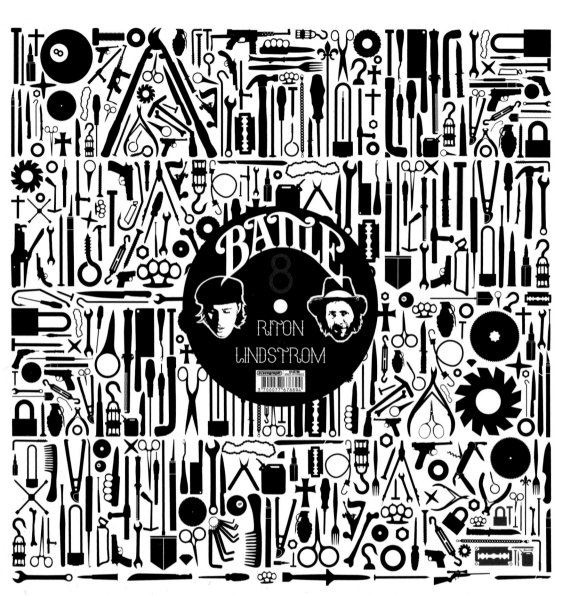

01. MIAMI
02. APPETITE
03. YOU CAN'T HOLD HER
04. CURTIS
05. HEY HEY
06. WHERE IS MY TIME
07. DONTCHUSEE
08. OHIO
09. MR SEXY BOY
10. TOOT D'AMORE
11. COTILLON
12. LE PETIT MORT
13. STEP BY STEP

A-SIDE // 33 RPM
A1. TOOT D'AMORE
PRINS THOMAS BOGUS BONUS
A2. TOOT D'AMORE
ORIGINAL MIX

B-SIDE // 33RPM
B1. TOOT D'AMORE
PRINS THOMAS DISKOMIKS
B2. TOOT D'AMORE
PRINS THOMAS BONUS BEAT

TOOT D'AMORE composed by CHIN CHIN and James Kelly
Published by Money Makes Me Dance (ASCAP).
Remixed by PRINS THOMAS.
Taken from the forthcoming CHIN CHIN album 'DIALC2002.
Out in the EU on DIALECT RECORDINGS in march 2007.

CHIN CHIN is:
Wilder Zoby Keys: Vox.
Jeremy Wilms: Bass, Git, Keys, Vox.
Yuriki Sekiguchi: Drums, Percussion, Git, Synth, Vox.

Additional musicians:
Yusuke Yamamoto: Vibes, Percussion
Colin Stetson: Baritone, Saxophone
Dave Smith: Trombone
Jeff Pierce: Trumpet, Flugelhorn
Tatu Hirono: Guitar
Jesse Bielenberg: Vox
Stuart Bogie: Tenor Saxophone

Horn arrangements by Yuriki Sekiguchi, Jeremy Wilms, and Jeff Pierce.
Recorded and mixed by Yuriki Sekiguchi and Jeremy Wilms.
For It's the Sound (www.itsthesound.net).

info@dialectrecordings.com / tel: 0033 142 33 87 59
www.dialectrecordings.com / www.chinchin.tv
www.myspace.com/chinchinnyc
DIALC2.RP01
All rights of the manufacturer and of the owner of the recorded
work reserved. Unauthorised copying, reproduction, hiring, lending,
public performance and broadcasting prohibited.
℗&© 2006 DIALECT RECORDINGS under exclusive license
for the EU from CHIN CHIN LLC. Made in the EU.
Distribution DISCOGRAPH / www.discograph.com
Artwork: CHECK MORRIS.

"TOOT D'AMORE"
original version &
PRINS THOMAS
REMIXES

05 /
A: Quizz Feat. El
   Nigno
T: The Monster is
   in Town
F: 12" EP
L: Dialect Recordings
D: Check Morris
Y: 2006

06 / 07 /
A: Chok Rock
T: Big City Loser
F: 12" EP
L: Warp Records
D: Check Morris
Y: 2005

06 /

07 /

08 /
A: Lily Allen
T: Alright, Still...
F: CD
L: Regal
D: Check Morris
Y: 2006

09 /
A: Lily Allen
T: Alfie
F: CD Single
L: Regal
D: Check Morris
Y: 2007

10 /
A: Lily Allen
T: Littlest Things
F: CD Single
L: Regal
D: Check Morris
Y: 2006

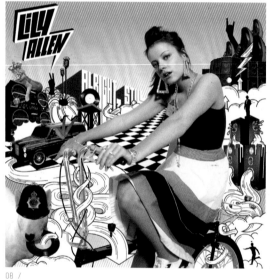

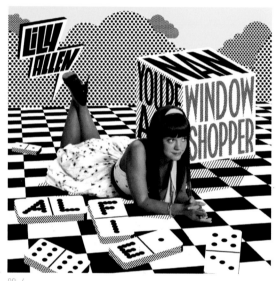

08 /                                         09 /

10 /

11 /
A: Naked
T: Scratch Massive
F: CD
L: Chateau Rouge
   Records
D: Check Morris
Y: 2005

12 /
A: The Black Ghosts
T: Anyway You Choose
   to Give It
F: 12" Vinyl
L: Southern Fried
   Records
D: Check Morris
Y: 2007

11 /

12 /

13 /
A: The Black Ghosts
T: Some Way
   Through This
F: 12" Vinyl
L: Southern Fried
   Records
D: Check Morris
Y: 2007

14 /
A: The Black Ghosts
T: The Black Ghosts
F: CD
L: Southern Fried
   Records
D: Check Morris
Y: 2007

13 /

Mathias Pol & Nicolas Motte /       Designers                                              Paris,
Check Morris                                                                               France

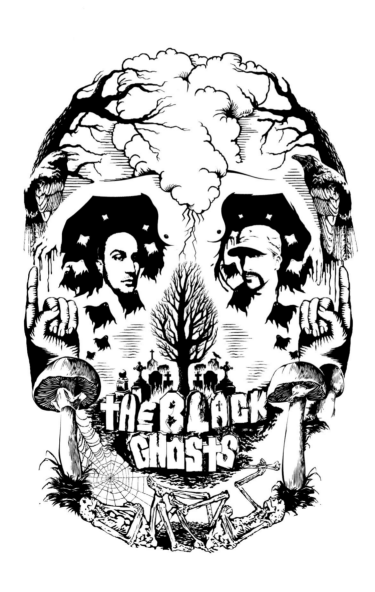

# Allon Kaye / Entr'acte

**Name:**
Allon Kaye

**Occupation:**
Book Designer

**Label:**
Entr'acte

**Location:**
London, UK

**Website:**
www.entracte.co.uk

**Biography:**
Allon Kaye was born in London in 1974, but was brought up in Israel. An interest in publishing and a profound fascination with typography has led him to work predominantly as a book designer since 2000. He is untrained ('or, rather, unschooled') as a designer. Entr'acte began in 1999 when he developed a 'mild interest in starting a label'. A friend asked him if he would like to release his CD, which he did later that year. Entr'acte was then dormant as a record label until 2004 when it was resurrected to publish the work of a few of Kaye's close friends. It currently releases music from all over the world.

01 /

**Do you design all the label's output?**
Yes.

**Are you ever tempted to invite other designers to work on releases – or does that defeat the object of having your own label?**
No. I'm not against it, but I also know that it's unlikely that anyone else will 'get it'. Entr'acte is a very personal project in that sense. There are a few exceptions though. My friend Martin Holtkamp (www.ma-ho.com) photographed every Entr'acte release and established the look of the label at that point. I also used Eric Olson's work (www.processtypefoundry.com) in a recent project, Esther Venrooy's Shift Coordinate Points, and the result is as much his as it is mine. The album's sleeve is a connect-the-dots code inspired by an excerpt from William Burroughs' Nova Express. The intention is for each sleeve to be drawn on by its owner in order to decipher the code. The lettering is based on FIG Script by Eric Olson, chosen for its continuous form, with easily segmented connecting points, but also for its reference to early modern computer coding, a theme that is relevant to the record.

**What's the difference between book design and sleeve design?**
I have a similar approach to both – I like my books to be simple, tactile and with as few images as possible.

**How would you describe Entr'acte's design philosophy?**
There isn't a design philosophy, per se (except high production standards) – the work is a product of its time. It appears in a certain way today, but that may well change tomorrow.

**Sealed bags containing discs seem to be a recurring theme in Entr'acte releases. What is the purpose of this?**
Agitation!

**So everything you sell comes in a sealed bag?**
Yes, anything sold via the website or through outlets is sold in sealed bags.

**Well, I got quite agitated at the thought of having to destroy the sealed bags – I wanted to keep them pristine. Are you sure this isn't one of those dastardly record-industry tricks to persuade 'punters' to buy two copies – one to keep and one to mutilate by opening?**
Ha! I haven't sold multiple copies to anyone yet. I'm not interested in the preservation of the sleeves – they are delivery vessels, as such, not precious art/design objects.

**There's a raw industrial aesthetic at work in your packaging; can you talk about this?**
These materials (mostly various types of military-grade PVC) are versatile and surprisingly cheap – thus perfect for my purposes and circumstances.

**Your website doesn't have any pictures of your sleeves. Why?**
I favour informative, text-based sites. And imagination!

**How much involvement do the musicians and sound artists have in Entr'acte packaging?**
Very little. I do discuss ideas with some, and even collaborate with others, but it's quite an autocratic set-up on the whole.

**Labels with a strong and consistent look sometimes run the risk of having the packaging eclipse the music. Do you worry about this?**
It happens occasionally, but I don't worry about it. I'm confident that the music Entr'acte releases is far more interesting than its packaging.

**What are your influences?**
I'm easily influenced, but not by anything in particular. I'm currently interested in food packaging, for example, so you see that in Entr'acte at the moment.

**Are you concerned with green issues in your packaging?**
I suspect that some of my materials are not easily recyclable. Since the bulk of Entr'acte's packaging is designed to be disposable, I strive to at least re-use it where possible.

**So much of your packaging relies on materiality. Where does Entr'acte stand on the MP3 question?**
If I thought a release is best suited to that format, then that's how I'd publish it. I think MP3 is a viable music format, and as such I'd consider it as I would vinyl or CD. It's a question of relevance.
■●

# SEA / SEAGULL
# PRESENTED BY DJ ORDEAL

I have been creating strange and unusual sound collages for about eight years now. Since childhood, I have been keen on music and playing it on old-style formats like the cassette (and using records as frisbees, but that was a long time ago and another story). My first tape player had an unfortunate tendency to eat the cassettes, but invoked a later interest in making music that has been dissected or destroyed and taken to a crazier, wilder world.

A good friend, Jase, introduced me to all manner of interesting music and sound — people playing show tunes with car horns, rattling bones or cutlery, making white noise, or just noise. I like the idea that just about anything and everything could be made into some form of music. Jase is responsible for my enthusiastic interest to make records.

I played my very first sound experiment to another good friend, Kristy. She suggested the pseudonym DJ Ordeal.

I think she found a very accurate and good description, and it made me laugh!

Over time, I have played around with lots of different music styles. At first, I was looking for what I considered to be the 'good bits' in bad records. Increasingly, however, I have focused on finding 'good records', then digging deep into their grooves and dissecting the tiniest samples. Putting sounds on tape and mixing and playing around with that format has remained. It is about putting sounds into different settings/ contexts and having fun to see what happens in the process.

The enclosed record sparked from hearing a great singer, seemingly everywhere — out of open windows, cars in the street, in shops… I stitched together several vocal riffs and found that at high speed the singer became a seagull. A rather crazy and wild bird this one. Then I worked with a simple maths formula and got the track.

Next
brea
alo
sea
pus
resp
And
beca
tap

Ship
DJ

Thank you Alasdair, Allon, Anna, Deb & Ger, Eamonn & Maria, Galina, Jase, Jim, Jo & Charlie, Mark, and Tatiana. DJ Ordeal can be contacted at ic36@brighton.ac.uk
This record is dedicated to the memory of the Sparticus Stargazer (1913–2006).
First edition of 200 copies. Published by Entr'acte, 2006
entracte.co.uk

**E39**

02 /

n old tape of sea
ed the two recordings
orchestral and real
tugged and pulled and
different elements by
t I felt at the time.
crazy in this process
ense, hour-upon-hour,
.

2006

# MOUTHS
# 1V2E

# HAPTIC
# DANJON SCALE

Mouths is a project by Jon Mueller and Jim Schoenecker using percussion, analogue synthesizer, shortwave radio, and human voice. Their focus is on combining elements to create a chorus of sorts, culminating in all 'mouths' emitting their voices together without negating one another. The combination of human voice within analogue electronic tones creates a demanding exercise of sustainability against the 'perfection' of machines. Once achieved, the effect is a satisfying, dense manifestation of texture and harmony which is as physical as it is otherworldly. This recording features the addition of Werner Moebius, who also joined Jon and Jim on the CD Amalgam, released under their own names.
  Recorded live in concert, this version of 1V2E reveals a more robust and direct approach which Mouths would continue to pursue in future performances.

Haptic was formed in the spring of 2005. A Chicago-based trio, it consists of Steven Hess (Pan American/Dropp Ensemble/On/Fessenden), Joseph Mills (Jonathan Chen/Dropp Ensemble), and Adam Sonderberg (Civil War/Dropp Ensemble).
  Initially conceived as a vehicle for live collaboration, Haptic has since incorporated a different, rotating fourth member for each performance. The unique contributions of this member create a new and challenging situation for the rest of the group to operate within, and send the music in unpredictable directions — from subtly shifting delicate textures and timbres to bursts of aggressive, rhythmic noise.
  Unlike live presentations, the group usually records as a trio, employing a myriad of percussion, digital and analogue devices (samples, oscillators, and decommissioned military equipment, for example), as well as hurdy gurdy, tuning forks, and various bowed objects.

For th[...]
compos[...]
constr[...]
sonor[...]
recor[...]
with [...]
from [...]
17 Ju[...]
clari[...]
appea[...]

1V2E was recorded live in Milwaukee on 18 February 2006 by C. Rosenau. Mixed by C. Rosenau and edited by Jim Schoenecker. Personnel: Jon Mueller (percussion/cassettes/vocals); Jim Schoenecker (analogue synthesizer/shortwave radio/vocals); Werner Moebius (computer/devices). Mouths can be contacted at info@jonmueller.net
Danjon Scale was performed by Steven Hess, Joseph Mills, and Adam Sonderberg. Recorded, assembled, and mixed by Adam Sonderberg between May and July 2006 in Chicago. Mastered by Nathan Moomaw.
© 2006 Hess/Mills/Sonderberg. Haptic can be contacted via adam@longboxrecordings.com
First edition of 200 copies. Published by Entr'acte, 2006
entracte.co.uk

**E37**

second published
emphasis was on
unfurling of
Danjon Scale was
oup's rehearsal space
recordings extracted
en in Chicago on
Jason Stein on bass
r. Stein does not
ion used herein.

# SUDDEN INFANT/CARLOS GIFFONI
# OSLO OSCILLATION ORGY

Carlos Giffoni says: 'I first met Joke Lanz four or five years ago in New York, during his US tour. I was immediately blown away by his work, by its ferocity and precision. I had been experimenting in similar areas in my solo performances and in recordings with the Old Bombs trio, and had heard of Joke through his involvement in Schimpfluch-Gruppe, but nothing could prepare me for the cut-up insanity of Sudden Infant's performance.

This current collaboration has its origins in a joint performance in a shady pub in London, though in between then and the time this record was made our styles had diverged — Sudden Infant still ferocious and precise but with a whole new refreshing approach to physical sound — me still looking for the perfect frequency to make the audience come in their pants.

Combine these approaches and you get a true Oscillating Orgy.'

Based in Berlin and London, Joke Lanz toils ceaselessly to create new sounds. Drawing on experimental and free music traditions, he crafts an abrupt musique concrète, a bewildering edifice of no-fi electronics, turntables, and unexpected and disorientating sound sources — the house that Joke built is not a safe structure, but instead is littered with fragments and shards of noise.

Since 1986 he has appeared under a variety of guises, including Schimpfluch-Gruppe, Schnäbi Gaggi Pissi Gaggi, WAL, Catholic Boys in Heavy Leather, The Eye of Arghhh, Jesuslandform, Psychic Rally, Tourette, Opposite Opponents, Vostok 1, Vehikel & Gefäss, Shitfun, Furtivfinger, Linako's Lovely Loops, Jaywalker, and the ubiquitous Sudden Infant.

Carlos Giffoni is a Venezuelan artist based in New York. His compositions — described as 'psychedelic electronics for the new ear of death and destruction

hope m
analog
manipu
instru
himsel
artist
Jim O'
and at
South
the cu
music
a memb
Monotr

All sounds by Joke Lanz and Carlos Giffoni. Recorded 2005/6 in London and New York. Mastered and cut by Rashad Becker at D&M, Berlin. Thanks to Christopher Dell. suddeninfant.com carlosgiffoni.com
First edition of 200 copies. Published by Entr'acte, 2007
entracte.co.uk

E40

se feedback systems,
1 synthesis, modular
ewired electronic
forms regularly by
aboration with other
rston Moore, Kid 606,
ow, and Smegma, in NYC
stivals in the US,
pe and Japan. He is
annual experimental
n Brooklyn. He is also
/noise/rock trio

E21

Raionbashi
Chloral Works I&II

Published by Entr'acte, 2005
entracte.co.uk

Packaged on 19 April 2007
for Adrian Shaughnessy

E38

Helena Gough
with what remains

Published by Entr'acte, 2007
entracte.co.uk

Packaged on 15 April 2007
for Adrian Shaughnessy

E

06 /

Helena Gough
with what remains

sift condensed milk liq silt unsung afterimage yolk

All sounds recorded by Helena Gough. Taken apart,
put together, composed and produced at home, Birmingham.
Mastered by Rashad Becker at D&M, Berlin.

For my family, Gas, Hannah, Lee, Donna, John,
Katy, P.A. and Tom CJ. With thanks to Allon.

First edition of 300 copies.
Published by Entr'acte, 2007
entracte.co.uk

E38

Helena Gough
with what remains

E38

07 /                                08 /

Simon Whetham Ascension_Suspension During a trip to the Portes du Soleil region of France, I recorded the sounds made by cable cars. All but ignored by the majority of passengers transported to the higher reaches of the mountains, through these sounds make the experience quite unique. Being trapped in the gondola seat for the duration of the journey was a factor I wanted to explore; waiting to be delivered to the summit, another. The conveyor transmits sounds - through the air, the wheels and cogs, the motors, the huge upright supports that stand on the mountainside, the seats, and the gondola itself - all reaching and affecting the passenger. As you take in the view of far-off peaks and the ground, some distance below your feet, the drones and rhythms lull you into a trance-like state. Time seems to stand still: suspended. Tension mounts as you reach the summit: now faced with the descent. The recordings were made in Les Gets, Morzine and Les Lindarets in July 2006, and have been only minimally processed. For Joan Elsie Shear, 1922-2006. Contact simonwhetham@hotmail.com or visit simonwhetham.co.uk Published by Entr'acte, 2006. entracte.co.uk

E41

264

Christof Migone /
Squint Fucker Press

Multidisciplinary Artist /
Label Owner

Montreal,
Canada

# Christof Migone / Squint Fucker Press

**Name:**
Christof Migone

**Occupation:**
Multidisciplinary Artist
and Label Owner

**Label:**
Squint Fucker Press

**Location:**
Montreal, Canada

**Website:**
www.squintfuckerpress.
com

**Biography:**
Christof Migone is
a multidisciplinary
artist and writer.
He co-edited the book
and CD Writing
Aloud: The Sonics of
Language, and his
other writings have been
extensively published.
He has released 6 solo
audio CDs on various
labels. He has curated
events in the sound and
radio arts and has
performed at festivals
and shows. His installations
have been exhibited
internationally. A
monograph of his work,
Christof Migone — Sound
Voice Perform, was
published in 2005.
The Galerie de l'UQAM
presented a retrospective
on his work accompanied
by a catalogue and a DVD
in 2006. He currently
lives in Montreal and
teaches at Concordia
University.

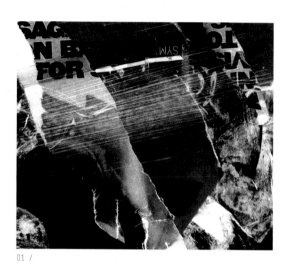

01 /

**What is the story behind Squint Fucker Press, which you co-founded with Alexandre St-Onge in 2001?**

Squint was born out of a certain dissatisfaction with being dependent on the release schedule of other labels. Not to mention being dependent on them to promote the CD once it was released. Those other labels, being rather small themselves, would sometimes not be able to fulfil their original promises, which is fine, it's not worth holding a grudge on that basis, but it was a large impetus in starting the label. Also, I had followed pretty closely the cassette/mail art underground in the 1980s in my role as a community radio broadcaster. Often, innovative packaging accompanied the innovative sounds.

**Can you recall some interesting examples?**

Touch, of course, and the Rising from the Red Sand series, as well the Trance Port releases out of LA. Crucial to the dissemination of this activity was a plethora of magazines such as ND, Op (then Option), Factsheet Five that reviewed cassettes. By the end of the 1980s I had released a couple of cassette compilations featuring local Montreal artists, as well as others I had crossed paths with, such as Negativland, Hakim Bey, Jack Wright, Knut Remond, Sue Ann Harkey, etc. The compilations included a lot of material initially presented on my program on CKUT-FM, Danger in Paradise. One cassette was spray-painted silver and wrapped in a wire (a strategy that returned with the first CD

released on Squint). And the second had a cover made of sandpaper.

**Very Fluxus.**

So all this prior activity and interest was formative in the eventual inception of the label. The original plan was to release as many CDs as there are letters in the alphabet. This does not preclude a change of plan but in 7 years we've only reached the letter I, so 10 releases in that time span is a pace that makes me think that perhaps Squint should change its name to Snail Fucker Press. Then again Squint functions with virtually no expectations, so the pace should not be attributed any undue importance.

**Where does the name come from?**

The name of the label came out of a letter I wrote to a friend in which I had to tell a secret and I feared that someone else might chance upon the letter. So I decided to write the paragraph-long secret in the most minuscule font size possible; as a result it looked like a blotch on an otherwise blank page. You had to use a magnifying lens to read it properly. My subterfuge didn't work, the secret got out.

**What is the experimental music scene like in Canada?**

That's a pretty broad question. I'm not sure I could even answer if you had asked me just about Montreal. But if I was to attempt to answer with regard to the latter, I would say that it is thriving; there is a lot of cross-breeding with other music scenes (improv, jazz, musique actuelle, electro-

acoustic, rock, noise), not to mention intersections with other disciplines such as dance, visual and media arts, theatre, etc. There are many small labels, supportive venues, good local radio, the whole seems lively and fluid.

**Much of your label's releases are conceptual and created purely from analogue sources, such as a CD with the sound of farts or people cracking their fingers. What draws you to naturalistic sound sources?**

You are referring to CDs of mine released on other labels. The farts one appeared as South Winds on Oral and the cracking appeared as Crackers on Locust. These sources are specifically somatic and they appear in my work because I'm interested in sounds that can be produced by anybody (any body). It is not a question of virtuosity; in fact, often it is about capturing sounds whose production one is not able to control. The label has released some CDs that could be said to have followed a conceptual methodology; I'm thinking specifically of Alexandre St-Onge's kasi naigo CD, where he took the soundtrack to Bergman's The Silence and used only the silences of the film. To be more precise, he excised all the words that can be found in a dictionary – thus, only utterances from imaginary languages were retained along with all the wordless passages. And on Cal Crawford's Sitting on Theories on the Frontier of Extension CD, he generated sounds by sitting on top of a bundle of blankets with a microphone rolled up in its

centre. This one-hour process was his starting point. He did further recordings by putting bodily pressure on various types of microphones: in water, clothing, skin, etc. Pressure was also created by heat, as in boiling water. Other CDs have also involved conceptual structures, but less overtly, or at least in my mind, these are two salient examples.

**Squint Fucker Press's covers usually are hard to decipher with no track titles, credits, or even the name of the artists. What is the purpose of this approach?**

Leaving the avenues of interpretation open is always welcome and can help in instances where the sounds cannot immediately be pinned down to a genre. In the case of some of the Squint releases the degree of illegibility in the textual information is matched by the degree of impenetrability of the sounds, i.e. sounds and structure that do not seem immediately knowable or even digestible. Some might argue that this strategy renders the work inaccessible; I would argue that ready access to a work is not always recommended, for it is known to cause atrophy of one's critical faculty.

**How much involvement do the musicians have in the design process?**

The artists are involved in the design process to the utmost degree, as each of them has conceived, designed and realized (and financed) their own release. They understand the parameters set out by Squint, which can be summarized by two directives:

266

Christof Migone /
Squint Fucker Press

Multidisciplinary Artist /
Label Owner

Montreal,
Canada

1) each CD must have 'an individual trace, gesture, intervention'; and 2) the type must suggest the need to squint, either literally or metaphorically. Once given these two constraints they are pretty much given carte blanche. It must be said that this method has worked because the artists involved so far have come from a pretty small circle. The fact that each artist finances their own release makes Squint pretty much a non-label, or at least an anomalous one. There hasn't been the possibility of structuring the label in any other way: lack of means has translated into the present state. In my mind having the artist involved in all the steps of the process is an advantage, perhaps even a necessity.

**Can you talk about the Cover Without a Record series? It 'sounds' like sense and non-sense. Are you suggesting a different state of encountering and inhabiting the world of music and sounds?**
The Cover Without a Record series is a homage of sorts to Christian Marclay's Record Without a Cover (1985). The series inverts the concept and therefore focuses on the physical attributes of the object itself (in this case, 'cover' was taken to mean CD cover, and more specifically the plastic jewel case). The series has quite a modest goal: to feature covers as sites themselves, no longer as physical supports for a sonic content to be found inside, but as an object which, even emptied of its musical content, might still be viewed in reference to sound or music. Or it

might be used in ways altogether removed from the sonic reference. There are examples of both in the Cover Without a Record series.

**As well as running the label, you're also a prolific artist performing at festivals and exhibitions around the world — can you talk about your own artistic activities?**
Well, I'm not sure how I would answer this question succinctly. My artistic activities are my primary occupation. I work around issues of endurance, portraiture, timelines, translation, rhythm. This list of preoccupations is not stable; it shifts over time. I began by doing radio in 1983. My political convictions made me realize pretty quickly that it wasn't enough to diffuse interesting sounds (from Crass to Rahsaan Roland Kirk, David Tudor to Television, Prince Far I to Kurt Schwitters), but that it was necessary to fuck with the prescribed parameters of radio (even local, community radio). My activities might have broadened across various media since, but that impetus to disturb pre-ordained parameters remains. Whether I'm successful at this is not the point, plus it's not up to me to determine; the idea is to continually stage the attempt, even if failure can be predicted.

**What are the personal, creative or cultural influences that shape your work?**
It depends on the project. A list would be endless. I am influenced by unanswerable questions, impossible scenarios, failures of all sorts, minutiae, absurdities and obsessions,

stutters and stammers... language is perhaps the recurring component, the inescapable one. From its socio-political parameters to its creative permutations, it's a structuring device that conjoins finitude with infinitude. If I were to name some concrete influences I would start with Alvin Lucier's I am Sitting in a Room for its elegant and poignant entwinement of language with time and space.

**Can you talk about your 17 CD jewel cases In Sink exhibition at Galerie de L'UQAM, which you mentioned might 'disgust some people'? I am intrigued by the subtitle — for Justin Timberlake...**
The subtitle just confirms the silly word game at work in the title, which fakes an adjoining between In Sink and 'N Sync (Justin Timberlake was a member of this pop music boy band). In Sink was initially my contribution to the Cover Without a Record series. ◼●

Interview by Angelina Li

01 /
A: Olivier Edgar
   Charles (aka Roger
   Tellier-Craig)
T: Et Ses Apparitions
F: CD
L: Squint Fucker Press
D: Roger Tellier-Craig
Y: 2005

02 / 03 /
A: Veda Hille &
   Christof Migone
T: Escape Songs
F: CD
L: Squint Fucker Press
D: Veda Hille &
   Christof Migone
Y: 2004

02 /

03 /

Christof Migone /
Squint Fucker Press

Multidisciplinary Artist /
Label Owner

Montreal,
Canada

04 /
A: Undo (Christof
   Migone &
   Alexandre St-Onge)
T: Un Sperme Qui Meurt
   de Froid en Agitant
   Faiblement sa
   Petite Queue dans
   les Draps d'un
   Gamin
F: CD
L: Squint Fucker Press
D: Christof Migone &
   Alexandre St-Onge
Y: 2000

05 / 06 /
A: Martin Tétreault
T: Fixé et Scellé/
   Fixed and Sealed
   [from the Cover
   Without a Record
   series]
F: Vinyl threads and
   crystal jewel box
L: Squint Fucker Press
D: Martin Tétreault
Y: 2003

04 /

05 /

06 /

07 / 08 / 09 /
A: Et sans [Roger
   Tellier-Craig &
   Alexander St-Onge]
T: Mi La le Mémoire
   est Chasse la
   Mille Voix Têtes
   de Tête dans de
   sa Ris Neige:
   le Monstre Absent
F: 3" mini CD
L: Squint Fucker Press
D: Roger Tellier-Craig
   & Alexander St-Onge
Y: 2004

07 /

08 /

09 / .

10 /
A: Christof Migone
T: In Sink [for Justin
   Timberlake] -
   from the Cover
   Without a Record
   series
F: 17 CD Jewel Cases,
   left in bathroom
   and kitchen sinks
   for variable
   durations (10, 20,
   30 days)
L: Squint Fucker Press
D: Christof Migone
Y: 2003

10 /

# Dylan Kendle

**Name:**
Dylan Kendle

**Occupation:**
Graphic Designer

**Location:**
London, UK

**Website:**
www.dylankendle.com

**Biography:**
Dylan Kendle was born in
England in 1971. He has
worked extensively in
moving image and print
over the last decade,
predominantly within
the advertising, music
and film industries. His
work is often featured
in design books and
periodicals and has
been seen in shows at
the Barbican, the ICA
and the Design Museum.
Awards have included
D&AD, Creative Circle
and a nomination for
Designer of the Year
for the Trainspotting
title sequence done
in conjunction with
Jason Kedgley.

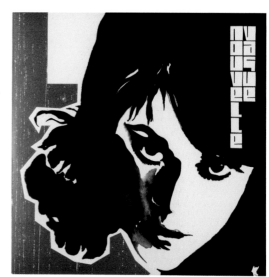

01 /

**Can you talk about your design education?**
I did a foundation course followed by a degree in graphic design at Camberwell College of Art. The George pub on Wardour Street, in Soho, was also a significant venue for impromptu tutorials.

**Are you one of the many designers who came to design through an interest in record cover art?**
It wasn't the only reason but it certainly was a contributing factor. My father was a designer, and some of my earliest memories are of sitting at his drawing board. When I realized there was little call for Spitfire pilots any more, design was pretty much all I wanted to do. That said, music was and is a big part of family life so there was always a lot of vinyl around and the sleeves always fascinated me.

**When you're not doing record sleeves what sort of work are you doing?**
My work covers a pretty wide remit. I've directed TV commercials, music videos and film title sequences, and I've worked on installations. I've also worked with ad agencies as a consultant, and on more traditional branding projects.

**Tell me about your role within Tomato - does a lot of collaborative work go on within Tomato?**
It does, though the overall dynamic and responsibilities shift on a job-by-job basis. I joined Tomato fresh from college, then left 18 months later. I'm back in the studio now after 10 years and have been working with different teams as well as consolidating old partnerships. It's been nice to re-associate, it feels similar to a family in many ways, with both the generous support structure and the inevitable dysfunctional aspects.

**A lot of your work looks analogue - it doesn't look as if it's done with a computer. Can you talk about how you work?**
It's important for me to connect physically with the work I do. For many people, there's a default process that doesn't exist outside of the machine, and whilst that can work for some, it feels a bit detached to me. I often do this with motion work too, using real shots or manually generated material when CG or stock would be quicker, easier and more cost effective. I don't have a distrust or dislike of digital processes, but I believe that in a world that is becoming progressively virtual it's important to augment this with the analogue and the tangible. It's not something I set out to do on every job and you have to be careful that it doesn't become a cheap veneer or a pastiche of patina. But processes excite me, both old and new, appropriate and other- wise, and I think that particularly with cover art - a market with shrinking budgets and increasingly homogenized layouts and packaging - that designers have to be ever more inventive.

**When Nouvelle Vague approached you, had they seen something you'd done previously?**
At the time, I was Peacefrog's (Nouvelle Vague's record label) in-house creative director, and had looked after most of their releases for a couple of years. The band was happy to let the label guide them, with the proviso that they got to sign off everything.

**You've worked with the illustrator Julie Verhoeven on the Nouvelle Vague cover-versions album, Bande A Part. How did that come about?**
We were looking for illustrators for Bande A Part and Julie had previously expressed an interest in working with the label. When we mentioned the project she was very positive about both the proposition and the direction that I wanted to push it, so we just kind of got on with it. The band weren't originally convinced but, fortunately, in the end they were persuaded. We were lucky she was available.

**A lot of your music-related work is involved with creating the visual output for a label, where the artists are anonymous - it's about creating a graphical look for an entire label. Is this different from creating a look for a band?**
I've been fortunate with my clients. With Vertical Form, for instance, I was involved from the outset and given carte blanche, and everything feels much more like a body of work because of that relationship. The label was a curatorial slice through experi- mental electronica, and the artwork took a similar course in as much as it was a series of visual experiments developed from a single motif and perspective. Fortunately the artists were (happily) faceless and so we were really creating a position from scratch. In my limited experience, bands are a bit harder work - not because they're more difficult as people, but because generally there are more of them to please and there are (understandably) creative egos and financial forces at work. Additionally, unless you work with them from the start you're dealing with a visual heritage that can sometimes be hard to either discard or embrace.

**What other music designers do you admire?**
Apart from my mates' work, which obviously I love...It's really tricky, I have eclectic taste. My two favourite sleeves are Jimi Hendrix's Electric Ladyland part 1 (UK release), which I recently discovered was designed by David King - it's beautiful psychedelia with an old-school gloss laminate; and then New Order's Blue Monday 12" - which really needs no explanation. Both are great sleeves, not only do they hold personal memories, but they perfectly reflect their contents in addition to capturing the spirit of the period.

**What do you say to young designers who want to do sleeve design?**
Don't base your mortgage on it. ■●

01 /
A: Nouvelle Vague
T: Guns of Brixton
F: 10" Vinyl
L: Peacefrog
D: Dylan Kendle
I: Giles Deacon
Y: 2004

02 / 03 /
A: Nouvelle Vague
T: Nouvelle Vague
F: 12" Vinyl
L: Peacefrog
D: Dylan Kendle
I: Giles Deacon
Y: 2004

02 /

03 /

04 /
A: Nouvelle Vague
T: Love Will Tear Us
   Apart
F: 10" Vinyl
L: Peacefrog
D: Dylan Kendle
I: Giles Deacon
Y: 2004

04 /

05 / 06 / 07 / 08 /
A: Nouvelle Vague
T: Bande A Part
F: CD
L: Peacefrog
D: Dylan Kendle
I: Julie Verhoeven
Y: 2006

05 /

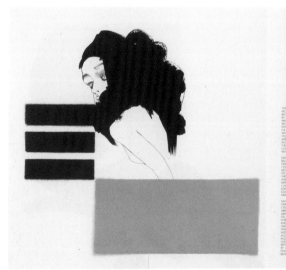

06 /                        07 /

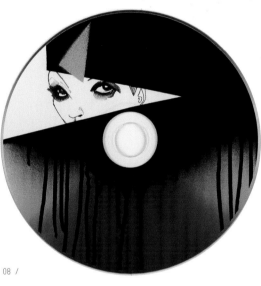

08 /

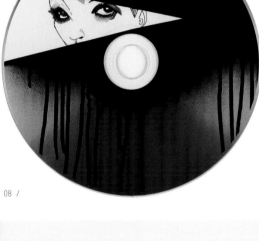

09 /
A: Nouvelle Vague
T: Bande A Part
   Sampler
F: CD
L: Peacefrog
D: Dylan Kendle
I: Julie Verhoeven
Y: 2006

10 /
A: Nouvelle Vague
T: Ever Fallen in Love
F: 10" Vinyl
L: Peacefrog
D: Dylan Kendle
I: Julie Verhoeven
Y: 2006

09 /

10 /

11 /
A: Nouvelle Vague
T: The Killing Moon
F: 10" Vinyl
L: Peacefrog
D: Dylan Kendle
I: Julie Verhoeven
Y: 2006

12 /
A: Nouvelle Vague
T: Bande A Part
   Sampler
F: CD
L: Peacefrog
D: Dylan Kendle
I: Julie Verhoeven
Y: 2006

13 /
A: Nouvelle Vague
T: Bande A Part
   (Limited Edition)
F: CD
L: Peacefrog
D: Dylan Kendle
I: Julie Verhoeven
Y: 2006

11 /

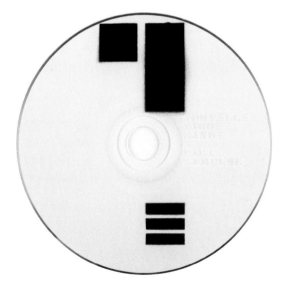

12 /

13 /

14 / 15 /
A: Idjut Boys
T: Press Play
F: CD
L: TIRK
D: Dylan Kendle
Y: 2004

16 /
A: Einóma
T: Milli Tónverka
F: CD
L: Vertical Form
D: Dylan Kendle
Y: 2003

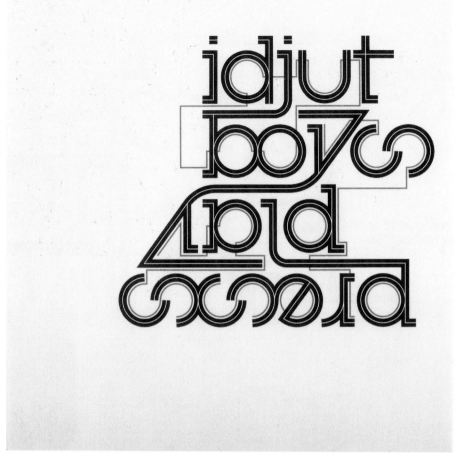

14 /

15 /

Dylan Kendle          Graphic Designer                                                    London,
                                                                                          UK

16 /

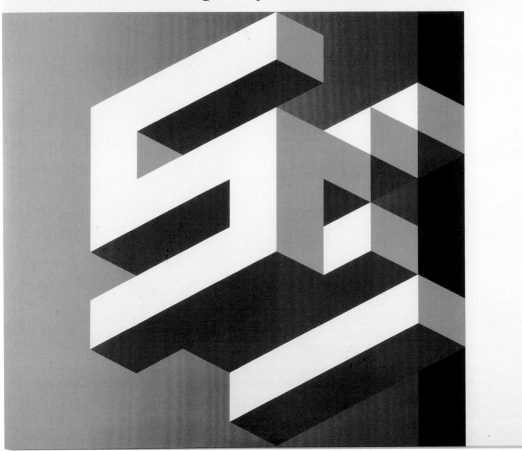

17 /

Dylan Kendle          Graphic Designer                                        London,
                                                                              UK

19 /
A: Jello
T: Voile
F: 12" Vinyl
L: Peacefrog
D: Dylan Kendle
Y: 2002

20 /
A: Various
T: 10.100.02
F: 12" Vinyl Box Set
L: Peacefrog
D: Dylan Kendle
Y: 2001

21 /
A: Joe Lewis
T: The Return of
   Joe Lewis
F: 12" Vinyl
L: Peacefrog
D: Dylan Kendle
Y: 2005

19 /

20 /

Bjorn Copeland /
Black Dice

Artist /
Musician

New York,
USA

286

# Bjorn Copeland /
# Black Dice

**Name:**
Bjorn Copeland

**Occupation:**
Artist and
Musician

**Band:**
Black Dice

**Location:**
New York, USA

**Website:**
www.blackdice.net

**Biography:**
Bjorn Copeland is a
member of Black Dice.
The band formed in
the spring of 1997
in Providence, Rhode
Island. Their sound has
been described as a
'loud, chaotic mix of
early eighties-sounding
thrash and harsh noise
experimentation'. In the
summer of 1998 the band
relocated to NYC. It
is now a three piece
comprising Bjorn
Copeland, Eric Copeland
and Aaron Warren,
and the trio's sound
has evolved into a
psychedelic mélange
referencing Afrobeat
and breakbeat. The
band's evocative and
vibrant cover art is
by Bjorn Copeland.

01 /

287

Bjorn Copeland /
Black Dice

Artist /
Musician

New York,
USA

**Have you had any formal training as a designer or illustrator?**
I went to Rhode Island School of Design for undergraduate studies. I majored in sculpture. We started Black Dice during this time, so the band presented an alternative to the more formal curriculum. I have a studio practice I maintain, and I show at certain galleries throughout the year.

**Do you agree with Tim Gane of Stereolab when he says that his records are not finished until the sleeve is done?**
The cover art is hugely important. We've always tried to use it as a way of contextualizing what we do. A lot of work goes into our artwork.

**How does the sleeve design process work for Black Dice?**
Usually I bring in ideas to Eric [Copeland] and Aaron [Warren], things I've been working on in my studio. Sometimes there are tons of drafts, and other times it comes together really quickly. I'm still computer illiterate, so our friend Rob Carmichael helps me format the art to fit the label/printing needs.

**Anyone coming across a Black Dice cover would instantly make the connection with independent music. But there's also a fine art aesthetic at work that lifts Black Dice sleeves above normal indie cover art. Do you agree?**
There's a lot of effort on the band's part to make new-sounding music, and have fresh-looking visuals to accompany it. We don't want to be like everybody else, so if it distinguishes itself in any way, it's working on some level.

**What are the key visual influences at work in Black Dice cover art?**
We almost never talk about visual art as a band. We talk more about TV, movies and junk food. These sorts of imagery seem to be most influential. There are certainly artists and movements that I appreciate and am interested in, but those things don't really seem to filter into our group aesthetic too much.

**Are you influenced by album cover art from the past?**
Album art has always appealed to me personally, and to the rest of the band as well. A lot of the bands we went to school with in Providence made amazing packaging for their tapes and 7"s.

**There are lots of bands who take an active interest in their cover art, but not many who actually do the art themselves. Can you think of any bands who do their own cover art successfully?**
Forcefield, Boredomes, Lightning Bolt, Animal Collective and Gang Gang Dance.

**Your work appears on a number of labels. Does the attitude to cover art vary from label to label, or do you always insist on creative freedom in this area?**
The label releasing it doesn't really factor in very much. Although I did feel inclined to push things a bit with Broken Ear Record since it was released on a major label abroad.

**Do you sometimes wonder how it would be to have outsiders design Black Dice covers?**
We've never considered that. We enjoy doing it ourselves.

**Where do you stand on the MP3 question? Will there come a time when Black Dice cover art will be animated and paired with sound files for downloading?**
We've never talked about it. We're still tape and 'zine guys. A little old school at this point.
■●

Bjorn Copeland /
Black Dice

Artist /
Musician

New York,
USA

288

01 /
A: Black Dice
T: Creature Comforts
F: CD
L: DFA/Fatcat
D: Bjorn Copeland
Y: 2004

02 /
A: Black Dice
T: Broken Ear Record
F: CD
L: DFA/Astrawerks
D: Bjorn Copeland
Y: 2005

02 /

03 /
A: Black Dice
T: Beaches and Canyons
F: CD
L: DFA/Fatcat
D: Bjorn Copeland
Y: 2002

03 /

Bjorn Copeland /
Black Dice

Artist /
Musician

New York,
USA

04 /
A: Black Dice
T: Ball
F: 7" Vinyl
L: 31G
D: Bjorn Copeland
Y: 2001

04 /

05 /
A: Black Dice
T: Manoman
F: 12" Vinyl
L: DFA
D: Bjorn Copeland
Y: 2006

05 /

06 /
A: Black Dice
T: Wolf Eyes
   Collaboration
F: LP
L: Fusetron
D: Bjorn Copeland
Y: 2003

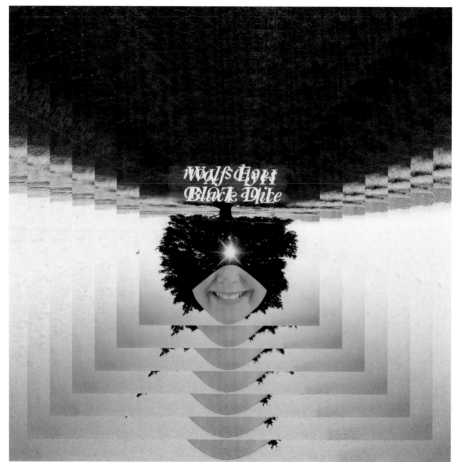

06 /

Bjørn Copeland /
Black Dice

Artist /
Musician

New York,
USA

293

07 /

A: Black Dice
T: Roll Up b/w Drool
F: 12" Vinyl
L: Paw Tracks
D: Bjørn Copeland
Y: 2007

07 /

Bjorn Copeland /
Black Dice

Artist /
Musician

New York,
USA

08 /
A: Black Dice
T: Wastered
F: LP
L: Paw Tracks
D: Bjorn Copeland
Y: 2004

08 /

09 /
A: Black Dice
T: Smiling Off
F: 12" Vinyl
L: DFA/EMI
D: Bjorn Copeland
Y: 2005

09 /

296

Tom Recchion

Graphic Designer /
Musician

Pasadena,
USA

# Tom Recchion

**Name:**
Tom Recchion

**Occupation:**
Graphic Designer and
Musician

**Studio:**
1111. Currently
creative director
for EMI Music, North
America. Art and music
studio is The Forest.

**Location:**
Pasadena, USA

**Website:**
http://profile.myspace.
com/tomrecchion

**Biography:**
As an art director/
graphic designer Tom
Recchion has created
CD packages for Robert
Wyatt, Terry Riley,
Captain Beefheart &
His Magic Band, David
Lynch and Julee Cruise,
Prince, The Carl
Stalling Project, Lou
Reed/John Cale, REM,
Merle Haggard, Alanis
Morissette, The Beach
Boys, Brian Wilson and
Van Dyke Parks, Hermann
Nitsch and many others.
He is the co-creator of
the Los Angeles Free
Music Society [LAFMS]. He
occasionally writes for
The Wire and has many
recordings released.
These include Chaotica,
I Love my Organ and
Soundtracks To a Color:
Gold & Black.

01 /

**You straddle both the independent sector and the world of major labels. Can you talk about the difference in your approach to both ways of working?**
In the time I've been designing there's been a shift in the needs of clients and an ebb and flow of restrictions. Certainly when you work for independent labels, commercial constraints are less of an obstacle, but the overall project can be just as demanding, rigid and difficult. It's all imaging when it comes right down to it. The very nature of graphics is that it is work you're creating for someone's vision of himself or herself, so it's a very touchy and delicate process. Nowadays commercial releases have many more voices in the mix than they did when I first started designing music packaging. One has marketing people, sales, creative directors, executives, managers and then the musicians. In the late 1980s I was lucky to have worked at Warner Bros. Records, when Mo Ostin and Lenny Waronker ran it, and before the music companies became more corporate. They understood the importance of a package in a different way and gave the art director/designer a deeper partnership in the development and the look of the release. So our connection to the artist was direct and immediate. Very few committees were involved, depending on the artist and the type of release it was. R&B had very different requirements than, say, a jazz or an 'alternative' band. Even when I worked for someone like Prince, I worked directly with him to develop the design,

though there was often an intermediary with certain people. The 'smart' bands were the ones who appointed one member to be in charge of the visuals. That way the process was more efficient and less complicated. REM and Los Lobos, though very big and complicated projects, were very fulfilling to design for because of my direct relationship with Michael Stipe and Louie Pérez. Many times the clients become difficult and highly demanding and I've found there's not always a lot of difference between an independent and a major. Actually some of the easiest clients were for majors and same goes for the most difficult.

**Can you give an example?**
I spent a beautiful and long day doing a photo session with the great jazz singer Jimmy Scott, after which he said, 'Well, thank you, I'll see the final CD in the stores.' I said, 'No Jimmy, you have to approve the final design.' He said, 'I trust that you know what you are doing.' Now that is a really good client. Dr. John was just as easy going. So I've had 2 easy jobs in 25 years.

**In your opinion, what is currently the major label view on sleeve design? Is it still valued?**
There were always commercial constraints and considerations to be met, but the design world often looked to music packaging for innovations. The majors have lost that positioning and it's now the indies that are creating new ideas. They seem to be willing to spend the extra money on die cuts, special papers,

PMS inks, embossing, debossing, foils, etc. The majors are counting pennies to stay alive, so there's not nearly the freedom to be as creative as there used to be. The role of marketing has also gained importance in the overall process, so has sales; so these two aspects have a very big influence on what the final piece looks like. Before the birth of the CD, when I was designing LPs, we were often told not to let the artist's name appear below the top two thirds of the cover. With the advent of the CD it's even more difficult. America held onto the eco-unfriendly long box because they just couldn't deal with the loss of visibility in the stores. Now with digital downloads becoming the main way people are buying music, packaging isn't even a consideration for every release. Some releases have digital booklets. This is a new and somewhat exciting form for design. Now you can work at low-res for the screen and the new size format is flexible, up to 8.5" x 11".

**You are also a musician and design the covers for your own records. How does this compare with working with other musicians? Are you a 'difficult client'?**
Designing my own releases is the most painful and difficult design to create. I've tried to create my own visuals, but for my most recent project, Sweetly Doing Nothing, I saw something artist Jonathon Rosen had created for a film we were working on, and a lot of the music was from a performance we had done for MOCA (Museum of Contemporary Art,

Los Angeles), so it seemed natural to use some of Jonathon's work for the package. Prior to seeing his pictures I was stumped, partially due to being overloaded with work, but also I just couldn't drum up any ideas. Chaotica (my 3rd solo release) came rather quickly and for I Love my Organ (my 4th solo release) I knew I wanted to put my organ into the bushes and have it photographed. Actually I'm a big fan of putting people and things in amongst a bunch of greenery. The rest of the package was filled with phallic symbols. The Extended Organ package was born out of artist Paul McCarthy's (our vocalist) suggestion that the cover be my house since that's where we recorded it. Through a few discussions the idea of dividing everything into mirrors of one another and splitting all the images in two developed. We wanted the interior shots to have a stark empty feel of a Kubrick composition.

**It's easy to see what the role of an album cover is within major labels. It is to grab the attention of the record-buying public and to send out a carefully targeted message about who the artist is. But what is the role of the cover in the independent or underground scene?**
You're exactly right. I trust my instinct when it comes to my work. Designing for the majors is much more complicated than it used to be, as I've stated, but the indies still have that spontaneous freedom to be experimental. Audiences have become more and more specialized so I've discovered there are specific

references and visual cues that communicate the subtleties to various groups that go beyond my awareness.

**Does the word 'branding' crop up in major label discussions?**
'Branding' seems like a relatively new term when it comes to music packaging. In the past, connections to advertising strategies were scoffed at by my fellow art directors and designers. Those words reeked far too much of commercialism and even while working at Warner I knew that each art director and designer tried to bring something new to the project and not design something that was conforming to the same kind of rules that one used to create a cereal box. However, these days majors operate in this way and even young musicians, who are really concerned about identity know this language. I mean, this was always a concern, it just seems much more shallow and facile these days.

**Are you a sleeve design fan? Did you do what so many of the contributors to this book have done and grow up staring in wonder at record covers?**
I used to spend hours looking at covers. I'm not sure what it was about them. But I have always been good at sensing what the music was going to be like on records by their covers. I recall taking the bus or hitchhiking up to Pasadena from my parents home in Alhambra, CA to the cool record store or Free Press Book Store and spending hours looking especially at the imports. Jimi Hendrix's Smash Hits was my first import. A friend brought it back from a

trip to London for me. It cost $13 at the time. I still have it. It has a glossy cover coating that American LPs didn't have, which made it all the more exotic. But in that store in Pasadena, I recall walking in one day and seeing on the top rack the cover of the first King Crimson record.

**Ah, yes, that cover affected so many designers.**
I was astounded, not only that it was painted in watercolour, but also that it had no type on it and it just literally screamed off the shelf. I immediately bought it and was hooked. Revolver was a great cover. Of course, Sgt Pepper's. Dr. John's first album, Gris-Gris, used to scare the hell out of me. As a kid I used to hang out at a local music store and spend hours after school listening to records in the private listening rooms and gawking at the covers. Each one revealed something different. I still love cover design and can spend hours in stores just looking.

**The legal downloading of music will soon surpass sales of CDs – what does this mean for cover art, in your opinion?**
We're just in the infancy of what the new digital package will become. At EMI we create 'digital booklets', which is a reshaping of the existing booklet and it stops at that. I am pushing for imbuing the digital releases with more content, but this is just the beginning. Once the integration of our TVs and Internet and once most of our at-home entertainment is delivered digitally, I can see whole sets of links, motion graphics,

filmic ideas, lyrics, articles, bios or new visual content being created to support a release. Another factor is the increasing distillation of the star structure. Majors aren't creating superstars any more. TV seems to be doing more of that work. But as audiences, and technology, become increasingly specialized, the whole experience of music packaging could become something completely hybridized and customizable to fit the desires of the user. I know lots of people who could not care less if their music has a package around it, but for those of us that do I can imagine that we'll be able to get an abundance of art and visuals that make up a 'package'.

**What about green issues?**
Right now there's interest in being green. So eco-conservation is creating a demand for a simpler and non-plastic biodegradable package. There are releases by many labels that feature a potato-starch product for the disc tray and put it in a digipak form. It almost seems like what we're moving back to is what we had with the LP: a front and a back with a label and maybe one more panel for a photo or notes. But I can see packaging, as we know it becoming increasingly reductive for the majors. I think they care less and less about it. Personally I think it's time to focus on catalogue packaging that offers a scholarly treatise on musicians and creates special packaging that offers consumers a physical product that outshines the common jewel case. ■●

■□○ 

Tom Recchion

Graphic Designer /
Musician

Pasadena,
USA

299

01 /
A: Various
T: LAFMS: The Lowest
   Form of Music
F: CD Box Set
L: Cortical
   Foundation,
   RRRecords
D: Tom Recchion
P: Chip Chapman,
   Tom Recchion,
   Fredrik Nilsen,
   Mark Takeuchi,
   Don Lewis,
   David Arnoff and
   many others
Y: 1996

02 /
A: The Doo-Dooettes
T: Picnic on a Frozen
   River
F: 7" Vinyl & CD
L: Cortical
   Foundation,
   RRRecords
D: Tom Recchion
Y: 2001

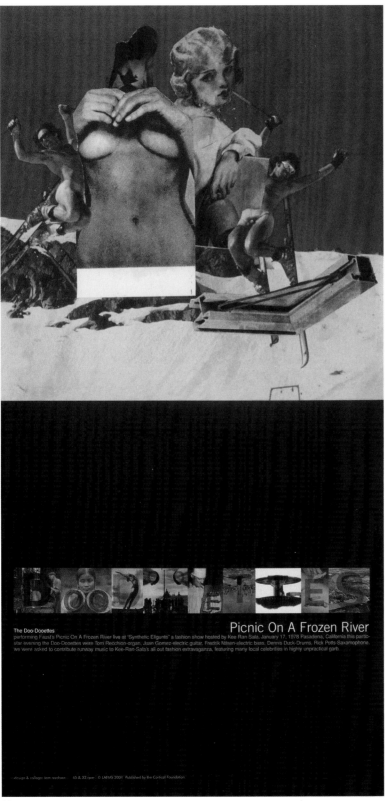

03 / 04 / 05 /
A: Extended Organ
T: XOXO
F: CD
L: Birdman
D: Tom Recchion,
   Joe Potts &
   Paul McCarthy
P: Fredrik Nilsen
Y: 2000

03 /

04 /

Tom Recchion

Graphic Designer /
Musician

Pasadena,
USA

302

06 / 07 / 08 / 09 /
A: Various
T: LAFMS: The Lowest
   Form of Music
F: Individual CD
   inserts
L: Cortical Foundation,
   RRRecords
D: Tom Recchion
Y: 1996

06 /

07 /

08 /

09 /

Tom Recchion

Graphic Designer /
Musician

Pasadena,
USA

304

10 / 11 / 12 / 13 /
A: Various
T: LAFMS: The Lowest
   Form of Music
F: Individual CD
   inserts
L: Cortical Foundation,
   RRRecords
D: Tom Recchion
Y: 1996

10 /

11 /

Tom Recchion          Graphic Designer /          Pasadena,
                      Musician                    USA

12 /

13 /

Tom Recchion

Graphic Designer /
Musician

Pasadena,
USA

306

14 / 15 / 16 / 17 /
18 / 19 /
A: Various
T: LAFMS: The Lowest
   Form of Music
F: Booklet
L: Cortical Foundation,
   RRRecords
D: Tom Recchion
Y: 1996

14 /

15 /

16 /

17 /

18 /

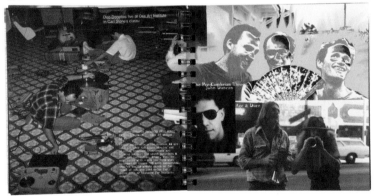

19 /

Tom Recchion          Graphic Designer /                                    Pasadena,
                      Musician                                              USA

20 / 21 /
A: Airway
T: Beyond the Pink
   Live
F: 7" Vinyl
L: Cortical
   Foundation,
   RRRecords
D: Joe Potts, Tom
   Recchion
Y: 2001

20 /

21 /

Tom Recchion

Graphic Designer /
Musician

Pasadena,
USA

22 /
A: The Doo-Dooettes
T: Think Space
F: 7" Vinyl
L: Cortical
   Foundation,
   RRRecords
D: Tom Recchion
I: Joe Recchion
Y: 2001

23 /
A: Tom Recchion
T: Chaotica
F: CD
L: Birdman
D: Tom Recchion
Y: 1996

24 /
A: Tom Recchion
T: 78 rpm
F: 10" 78 rpm
   vinyl record
L: Poo-BahRecords/
   LAFMS
D: Tom Recchion
Y: 2007

22 /

23 /

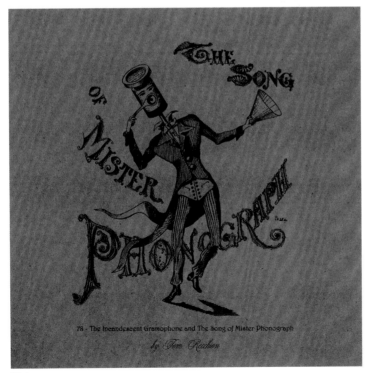

24 /

25 / 26 / 27 / 28 / 29 /
A: Tom Recchion
T: I Love my Organ
F: CD
L: Birdman
D: Tom Recchion
Y: 2004

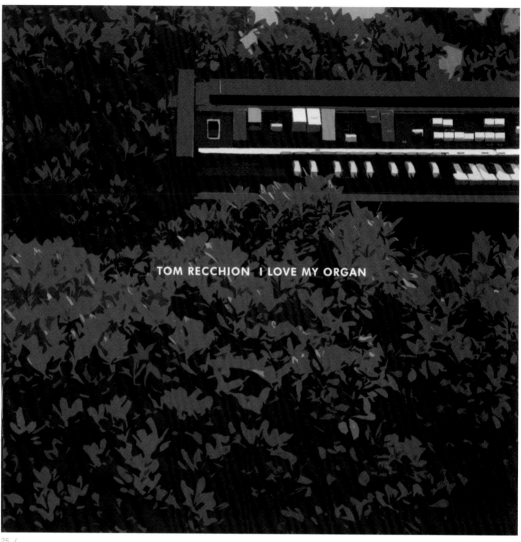

TOM RECCHION  I LOVE MY ORGAN

25 /

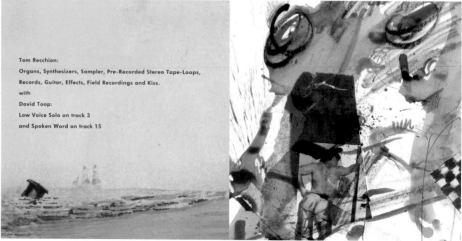

Tom Recchion:
Organs, Synthesizers, Sampler, Pre-Recorded Stereo Tape-Loops,
Records, Guitar, Effects, Field Recordings and Kiss.
with
David Toop:
Low Voice Solo on track 3
and Spoken Word on track 15

26 /

313

Tom Recchion

Graphic Designer /
Musician

Pasadena,
USA

1. I Love My Organ  2:59
2. Terry Riley In Rome  2:37 - for Terry Riley
3. Martian Kiss  1:49
4. F & T (RIFS #3)  4:27 - for Ferrante & Teicher
5. Dubby Struts In Trenchtown (RIFS #2)  6:12
6. Narcotic  7:01 - for William Bazinski
7. Ectoplasm  3:41 - for Steve Thomsen
8. It Walks Through Walls  2:27 - for Jad Fair
9. Forced To Waltz Forever  3:12
10. The Perpetual Motion Clock Factory  1:11
11. The Flea Circus  2:30
12. Psst-samba  3:21
13. Truckers Carousel  2:27
14. The First Thing To Crawl On Land  7:46 - for Brian Eno
15. It Just Stood There, Pulsating, Glowing In The Dark,
Hovering Slightly Above The Ground, Trying To Speak  5:53
- for Creed Taylor & Kenyon Hopkins

27 /

28 /

29 /

# Bibliography

## Books

Aldis, Neil and James
Sherry Heavy Metal
Thunder: Album Covers
That Rocked the World
Chronicle Books, 2006

D-Fuse
VJ: Audio-Visual Art +
VJ Culture
Laurence King
Publishing, 2006

Hoare, Philip
and Chris Heath
Pet Shop Boys: Catalogue
Thames & Hudson, 2006

Levy, Joe
The 500 Greatest Albums
of All Time
Wenner Books, 2005

McPherson, Mark
and Funkstörung
Isolated: Funkstörung
Triple Media
!K7 Records & Die
Gestalten Verlag, 2005

Morrow, Chris
Stir It Up! Reggae Album
Cover Art
Thames & Hudson, 1999

Müller, Lars (ed.)
ECM: Sleeves of Desire
(Edition of Contemporary
Music Sleeves of Desire:
a Cover Story)
Lars Müller Publishers,
1996

Poynor, Rick
Vaughan Oliver: Visceral
Pleasures
Booth-Clibborn Editions,
2000

Robertson, Matthew
Factory Records: The
Complete Graphic Album
Chronicle Books, 2006

Schraenen, Guy
Vinyl Records and Covers
by Artists
Museu D'Art Contemporani
de Barcelona (MACBA),
2005

Scott, Grant, Barry
Miles and Johnny Morgan
The Greatest Album
Covers of All Time
Collins & Brown, 2005

Shaughnessy, Adrian
Radical Album Cover Art:
Sampler 2
Laurence King
Publishing, 2000

Shaughnessy, Adrian
Radical Album Cover Art:
Sampler 3
Laurence King
Publishing, 2003

Shaughnessy, Adrian
Sampler: Contemporary
Music Graphics
Laurence King
Publishing, 1999

Steinweiss, Alex,
Jennifer McKnight-Trontz
and Steven Heller
For the Record: The
Life and Work of Alex
Steinweiss
Princeton Architectural
Press, 2000

Takumi, Matsui
In Search of the Lost
Record: British Album
Cover Art of 50s to 80s
Graphic-sha Publishing
Co., Ltd., 2001

Thorgerson, Storm
Eye of the Storm: The
Album Graphics of Storm
Thorgerson
Sanctuary Publishing,
1999

Trunk, Jonny
The Music Library:
Graphic Art and Sound
FUEL Publishing, 2005

Various
Japanese Independent
Music
Sonore, 2001

Various
Music Graphics (A visual
collection of Japanese
Music Graphics)
Pie Books, 2006

Young, Rob
Essay by Adrian
Shaughnessy
Warp: Labels Unlimited
Black Dog Publishing,
2005

Young, Rob
Rough Trade
Black Dog Publishing,
2006

## Articles

Grimes, Christopher
'Sleeveless in
Cyberspace'
FT Magazine, May 13
2006, pp 36-37

Morley, Paul
'The Magic Circles'
The Guardian, August 1
2003

Mulholland, Neil
'Guaranteed
Disappointment:
Punk Graphic Design at
the Festival Hall'
Dot Dot Dot 13, 2006,
pp 111-126

Mulholland, Neil
'Label of Love'
Creative Review, March
2007, pp 50-52

Waters, John L
'Reason and Rhymes'
Eye, Spring 2007,
pp 18-23

'Cover Stories'
The Guardian Weekend,
September 18 1999,
pp 13-16

## Magazines

Mojo Classic: The
Greatest Album Covers,
Volume 2, Issue 3
EMAP Metro Ltd., 2007

Idea, July 2005

# Index

# Thanks & Credits

Designed, written
and edited by
Adrian Shaughnessy

Additional design by
Sam Renwick

Editorial assistance
Angelina Li

Photography by
Angus Muir

Artwork by
Tea Design

Typeface:
Simple Regular
and Simple Bold

Special thanks to:
Klas Augustsson,
Steve Byram,
Bjorn Copeland and
Black Dice,
Constellation,
Taylor Deupree,
Lawrence English,
James Goggin,
Thaddeus Herrmann,
Kim Hiorthøy,
Julian House and
Jim Jupp,
Jeff Jank,
Allon Kaye,
Dylan Kendle,
Jan Kruse,
Jason Kedgley,
Jan Lankisch,
Christof Migone,
Mondii and Cheason,
Rune Mortensen,
Rick Myers,
Mattias Nilsson,
Mathias Pol and
Nicolas Motte,
Tom Recchion,
Marc Richter,
Masato Samata,
Michaela Schwentner,
Ralph Steinbrüchel,
John Twells,
Magnus Voll Mathiassen,
Jon Wozencroft.

Thanks to:
Zoe Antoniou,
Felicity Awdry,
Laurence King,
Jo Lightfoot,
Laura Willis.

Special thanks
to Dan Simmons for
heroic dedication. And
additional thanks to
Ian McLaughlin and Tom
Browning for 'tea' and
sympathy at critical
moments.

For Jamie Shaughnessy

Published in 2008
by Laurence King
Publishing Ltd
361-373 City Road
London EC1V 1LR
Tel +44 20 7841 6900
Fax +44 20 7841 6910
E-mail: enquiries@
laurenceking.co.uk
www.laurenceking.co.uk

A catalogue record
for this book is
available from the
British Library.

ISBN 978 1 85669 527 5

Printed in China

LAURENCE KING